British Watercolours

AT THE

VICTORIA AND ALBERT MUSEUM

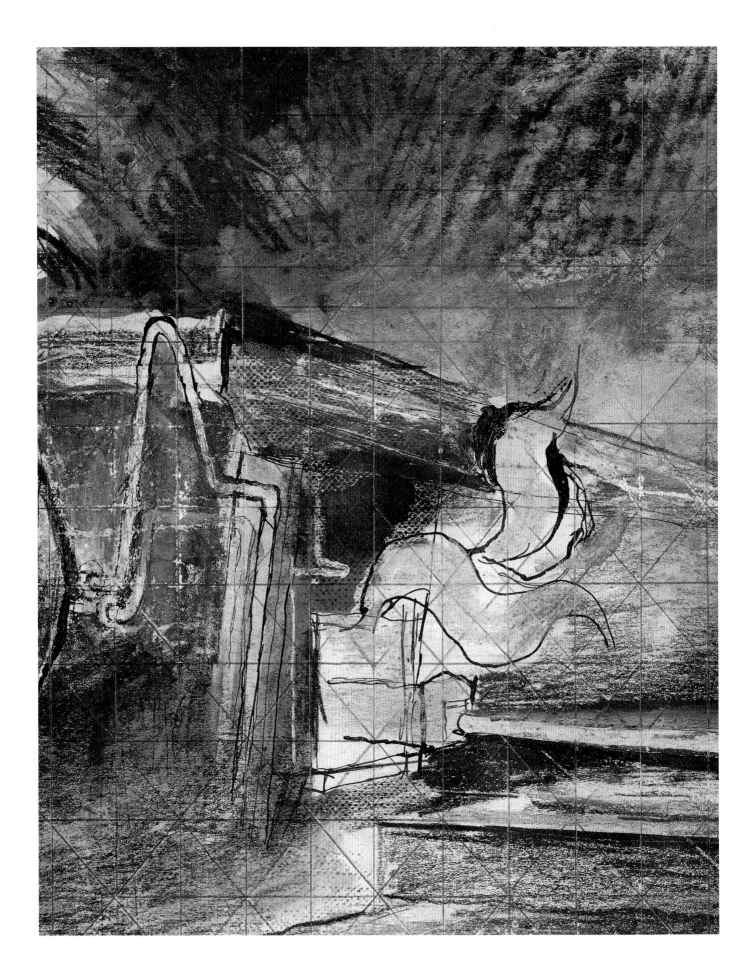

RONALD PARKINSON

British Watercolours

AT THE

VICTORIA AND ALBERT MUSEUM

V&A PUBLICATIONS

First published by V&A Publications, 1998

V&A Publications
160 Brompton Road
London SW3 1HW

© The Board of Trustees of the Victoria and Albert Museum 1998

Ronald Parkinson asserts his moral right to be identified as the author of this book

Designed by Yvonne Dedman

ISBN 1 85177 2510

A catalogue record for this book is available from the British Library

Printed in Hong Kong

FRONTISPIECE
Blast Furnace by Graham Sutherland (detail from plate 92)

JACKET ILLUSTRATIONS
Front: *Warkworth Castle, Northumberland* by J.M.W. Turner
(detail from plate 43)
Back: *An Illustration for the 'Tour of Dr Syntax in Search of the Picturesque'*
by Thomas Rowlandson (plate 18)

Contents

The book is dedicated to my friend
Brian Gray,
who introduced me to the
splendours of the Scottish landscape
and who has been a constant
source of encouragement.

ACKNOWLEDGEMENTS

This volume, drawing exclusively on the National Collection of British Watercolours in the Victoria and Albert Museum, is based on the researches of my predecessors at the Museum as well as my own responses to the works of art. I am especially indebted to Lionel Lambourne, whose catalogue of the watercolour collection was published in 1980. I would also like to thank my colleagues in the Department of Paintings, Prints and Drawings: Susan Lambert, Sharon Fermor and Janet Skidmore; Jo Wallace and Nick Wise in the V&A Picture Library; and my editors Miranda Harrison and Moira Johnston.

Introduction

THE VICTORIA AND ALBERT MUSEUM houses the National Collection of British Watercolours, which includes many of the greatest and most famous works of art in that medium. They are on view to visitors to the Museum, either in one of the regular displays in the galleries – watercolours of course are damaged by exposure to light, both natural and artificial, so the displays change every six months or so – or on application in the V&A Print Room.

The medium of watercolour has always been considered especially British, and the history of the V&A collection of paintings began as early as 1857 with the munificent gift by the collector John Sheepshanks. Significantly this included nearly 300 watercolours by contemporary British artists. Following his example, the widow of the collector Richard Ellison gave in 1860, and later bequeathed in 1873, a total of 100 fine watercolours by contemporary British artists, most remaining in their original elaborately gilded frames.

The V&A watercolour collection is so extensive, assembled since 1857 by gift, bequest and purchase, that it is only possible in this book to give a sample of its breadth and depth. While the book includes some of the most important and celebrated watercolours ever painted, by the leading artists in the medium – notably Constable, Turner, Gainsborough, Girtin, Sandby, Cozens, Cotman, Crome, De Wint, Varley, J. F. Lewis and Samuel Palmer – it also contains illustrations of, and commentaries on, masterpieces by such lesser-known painters as Henry Bowler, George Price Boyce, Frederick Cayley Robinson and Thomas Miles Richardson.

The range of thematic material is equally broad, from landscape in Britain and abroad, the popularly accepted subject-matter for watercolourists both professional and amateur, to satirical comment on contemporary life and the careful depiction of flowers and animals. The historical range is considerable, from the wonderful sixteenth-century botanical studies by Jacques Le Moyne des Morgues (plate 1) to the extraordinary work by Andy Goldsworthy created some 400 years later in 1991/2 with the liquid from a melting snowball (plate 100).

The collection also demonstrates the wide variety of use to which artists put the medium of watercolour, from the rapid small sketch made on the spot and recording – more or less accurately – the scene and the atmospheric conditions, to the large highly finished painting made in the studio and intended to be publicly exhibited in a gold mount and frame.

Watercolour was – and remains – the ideal medium for painting landscape out-of-doors, the equipment being small, light and compact, and the end result quick drying. But it also lends itself to the swift and evocative recording of effects of natural light and atmosphere, particularly important in the rapidly and

constantly changing weather conditions in northern European countries. One of the earliest European artists to realise the expressive open-air possibilities of watercolour was the great German painter Albrecht Dürer. On his travels in the 1490s and 1520s, he filled sketchbooks with drawings of anything that interested him: this included botanical and ornithological studies and landscapes, many of which he coloured.

The preparation and use of watercolour – powdered pigment bound with vegetable gum (and sometimes sugar or honey) and mixed with water – were examined in Edward Norgate's treatise *Miniatura, or the Art of Limning* written in the early 1620s, one of the earliest books on painting in English. By that time watercolour had been established as the medium for painting portraits in miniature for over 100 years. But an even earlier and related use of watercolour was to illuminate manuscripts, from seventh-century Irish work, such as the famous Book of Kells, onwards. The nature of an illumination, an outline drawing filled in with colours, determined the style of most watercolours in the seventeenth and eighteenth centuries, whatever their subject.

In the seventeenth century, such Dutch and Flemish artists as Cuyp and Van Dyck produced watercolours which were much admired and collected in Britain. Included in the magnificent collections of old master drawings made by connoisseurs in the years shortly after about 1690 – by Jonathan Richardson and the Duke of Devonshire, for example – were landscape watercolours. Subjects ranged from the careful study of individual plant forms, through country scenes with people working the land, to distant and panoramic views. Their apparent 'truth to nature', careful observation of local colour and the effects of light and atmosphere, greatly appealed to British artists.

Edward Norgate noted in the 1620s that landscape painting was 'an art so new in England', that he 'cannot find it a name, but a borrowed one, and that from … the Dutch … for to say the truth the art is theirs'. The Dutch word *landscap*, the derivation of which is unclear, was anglicised as 'landskip', or 'landscape'. At the same time, the principal French painters working in the Italianate style, Claude Lorrain and Gaspard Poussin, also sketched out of doors in watercolour. The balanced structures of their landscape compositions provided a model for their successors in Britain.

Topography (literally the drawing of a place) was another early use of the watercolour medium. An initial exponent was Wenceslaus Hollar, one of the many continental artists who settled in Britain in the seventeenth century. Born in Prague, he was brought to London in 1636 by the Earl of Arundel, a leading patron and collector of art. Hollar introduced to Britain the practice of tinting pencil or pen drawings in which Dürer had excelled, and produced views of towns and cities with their buildings carefully delineated. In 1668 he was sent to Morocco by the government to draw the fortifications at Tangier, and he also made a series of drawings of London and its environs which is a main source of

our knowledge of the city in the seventeenth century. His audience wanted information rather than aesthetic pleasure, but Hollar set a high standard in both for his successors to emulate. In 1665 he met Francis Place, who modestly told the engraver and biographer George Vertue that Hollar was 'a person I was intimately acquainted withal, but never his disciple … which was my misfortune'. Place travelled extensively in Britain and Ireland, making drawings in Hollar's manner, often in a panoramic format for engraving – sometimes by himself – on commission by London printsellers. This is indicative of the comparatively lowly professional status of the watercolourist in the 60 years around 1700.

It was also common for an artist to work for a patron, a gentleman antiquary or natural historian. Grimm (plate 8), for example, worked for Gilbert White illustrating his famous *Natural History and Antiquities of Selbourne*; John 'Warwick' Smith even adopted the name of his patron, the Earl of Warwick. One Moses Griffith was the personal manservant of Thomas Pennant, whom he accompanied around Britain, making watercolours of buildings, trees and plants, portraits and views. Among the earliest specialities of British watercolourists were the depictions of birds and animals, plants and flowers. The seventeenth century was a great age of scientific discovery, including the classification and study of species which laid the foundations for the achievements of the following 200 years. Observation and recording of flora and fauna date from the Middle Ages, for illuminated manuscripts, designs for tapestry and embroidery and the compilation of 'bestiaries'. The tradition of the latter was continued by Francis Barlow in his illustrations to Aesop's *Fables* of 1666. But more typical of the period between 1650 and 1750 was the zoological, ornithological or botanical watercolour as a visual scientific resource, as in the work of Charles Collins and Thomas Bewick or George Edwards, who was primarily a naturalist rather than a painter (plate 3). Another specialised genre to develop during this time was sporting painting, represented here in one of the earliest watercolours of a hunting scene in England by Pieter Tillemans (plate 2).

In the London art world of the second half of the eighteenth century, both Paul Sandby and his elder brother, Thomas, were prominent figures and were involved in the planning of a national academy, in emulation of French and Italian examples, as early as the beginning of the 1750s. They were both founder-members of the Royal Academy in 1768, and of the first 22 artists the only watercolourists. Significantly, Thomas was appointed the first professor of architecture, and Paul's work in the medium of watercolour was considered more appropriate than oils for the minor genres in the hierarchy: landscape, still life and portraiture (plate 22).

Watercolourists, both amateur and professional, submitted their works to the annual Royal Academy summer exhibition. They were usually hung separately from the oils, alongside the miniatures, engravings and sculptures. But instead of having to work for engravers or printsellers, patrons or connoisseurs, artists now

had the opportunity to present their paintings directly to a purchasing public. Consequently, when watercolours were hung in close proximity to oil paintings, they inevitably appeared insipid in comparison. In order to compete, watercolour artists began to use heavier body-colour and worked on a larger scale.

On 30 November 1804, a group of ten artists met at the Stratford Coffee House on Oxford Street to discuss the foundation of an exhibiting society for painters in watercolour. William Frederick Wells seems to have been the prime mover. By the opening of their first exhibition in April 1805, six more members had been invited. Half of the membership were about 40 years old, and a few – Rigaud, the Varleys, Holworthy and Havell – were in their 20s. Three represented the older generation: Nicholson (aged 51), Shelley (54) and Pocock (64). The exhibition in rooms in Lower Brook Street comprised 275 watercolours by the 16 artists; public admission was by catalogue costing a shilling (five pence), and prices of works ranged from three to thirty pounds. An amazing number of visitors, nearly 12,000, attended the 1805 exhibition, rising to nearly 23,000 in 1809. The watercolours were predominantly landscapes, no less than 42 by the young John Varley. The aim was to overcome the prejudice of the Royal Academy towards the watercolour medium, giving, in the words of the first exhibition catalogue, 'a better arrangement, and a fairer ground of appreciation than when mixed with pictures in oil'. The exhibitions of the Society promoted the more official status of watercolour and marked the beginning of its nineteenth-century apotheosis.

While the medium of watercolour triumphed in the public arena, its history was to develop in several directions, some based on traditional practice and some in decisively new ways. The use of watercolour for a preparatory sketch or study, intended as the basis for a 'finished' oil painting, continued. But watercolour was increasingly recognised as an independent and important medium in its own right. Constable's *Stonehenge* (plate 40) or David Cox's *The Challenge* (plate 57), for example, were publicly exhibited as finished works of art in their own right and have an impressive grandeur which could hardly be surpassed by treatment in oil paints. The special qualities of watercolour, particularly its translucence and brilliance, were exploited by such artists as John Ruskin, whose view of *Zermatt* (plate 51) captures the diaphanous clarity of the Swiss mountains in a way that a painter using oil pigments could not achieve. Even the great Turner, who sometimes diluted his oil paints to a considerable extent in order to create the transparent and luminous effects of watercolour, could not have approached, in oil, the sensational radiance possible in such watercolour work as *The Lauerzer See* (plate 45).

Watercolourists were, and still are, able to convey a spontaneity and intimacy that are denied the more laboured work demanded of the painter in oils. It is difficult, for instance, to imagine the diaphanous quality of *A Farmhouse Bedroom* by Eric Ravilious (plate 88) achieved in oil rather than watercolour. The medium

has other advantages. Working in oil paints requires a great deal of time and preparation and expense. Watercolour allows a greater degree of freedom, not only in the handling of the pigments but a degree of psychological release; if work on paper proves unsatisfactory to the artist, the sheet can be torn up and thrown away, while a comparatively expensive, prepared and stretched canvas is more reluctantly discarded. This also brings us back to the role of the watercolour as preliminary study. David Hockney's 1967 study (plate 97) for example, is one of several examining the surface of swimming pools: the ripples created by a gentle breeze and the spectacular disturbance caused by a diver. The visual research undertaken by Hockney in such watercolours resulted in the final, utterly confident, painting in oils. At the same time, such preparatory watercolour sketches and studies as this for *A Bigger Splash* by Hockney are admired by us for their intrinsic qualities as well as their art-historical interest. There is something about the watercolour sketch that brings us closer to the artist's first moment of inspiration, a moment that we can feel we are sharing.

The 'Golden Age' of British watercolour painting is usually supposed to have been between about 1750 and 1850, and certainly that period witnessed the boom in the medium's popularity. However, despite many of the greatest practitioners flourishing at that time, the success of watercolour did not wane. While the majority of works included in this book date from that period, later nineteenth-century and twentieth-century painters are also illustrated and discussed. The examples include Helen Allingham's sunny and tranquil images of English rural life in the 1880s, the aestheticism of Burne-Jones and Ellen Clacy in the same decade, Paul Nash and William Roberts recording the horrors of the First World War, Russell Flint's dashing virtuosity in the 1920s, David Jones's mystical works of the 1930s, Piper and Sutherland in the 1940s, Allen Jones's frankly erotic figures in the 1960s and his contemporaries Paolozzi, Tilson and Hockney, and Bridget Riley's sensational exploration of the possibilities of line and colour in the 1970s.

For the first catalogue of the national collection of British watercolours, published in 1876, Samuel Redgrave (brother of Richard, the first curator of paintings at South Kensington) supplied an historical introduction. He ended his essay with a criticism directed at contemporary watercolourists. He felt that they were using to too great an extent opaque white in their works to give a more solid effect, but in the process losing the delicate translucence of pure watercolour. While it is true that the brilliance and transparency of watercolour were the medium's principal delights, today we are more catholic in our taste and can appreciate more willingly the wide-ranging possibilities of the art. I hope this book goes some way in introducing not only the magnificent V&A collection but the supreme and various achievements of generations of watercolour painters over 400 years.

<div align="right">RONALD PARKINSON, 1998</div>

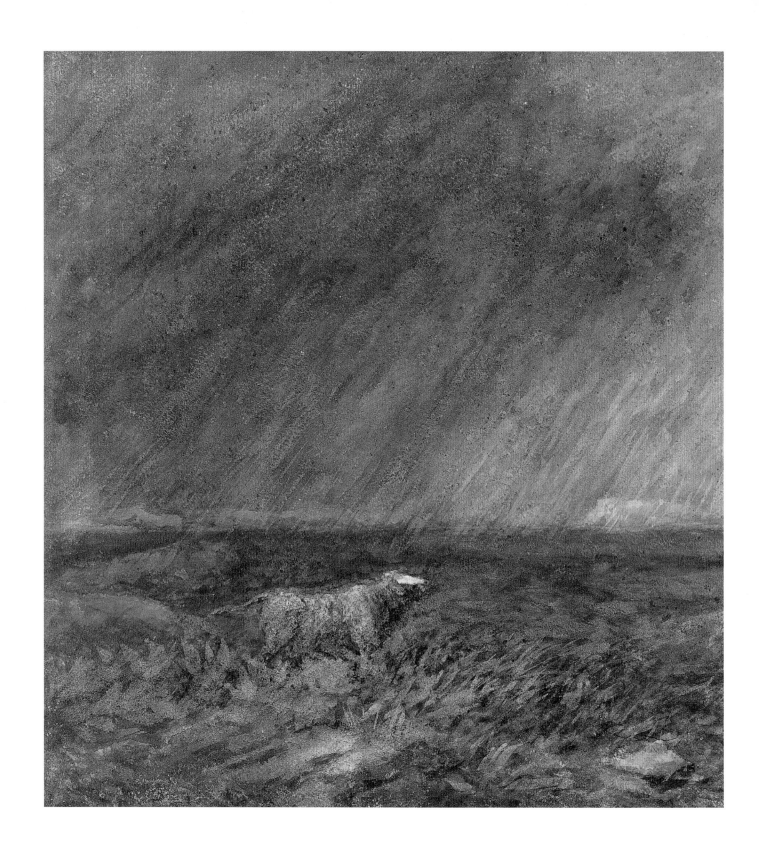

Above: The Challenge: A Bull in a Storm on a Moor by David Cox (detail from plate 57)

THE PLATES

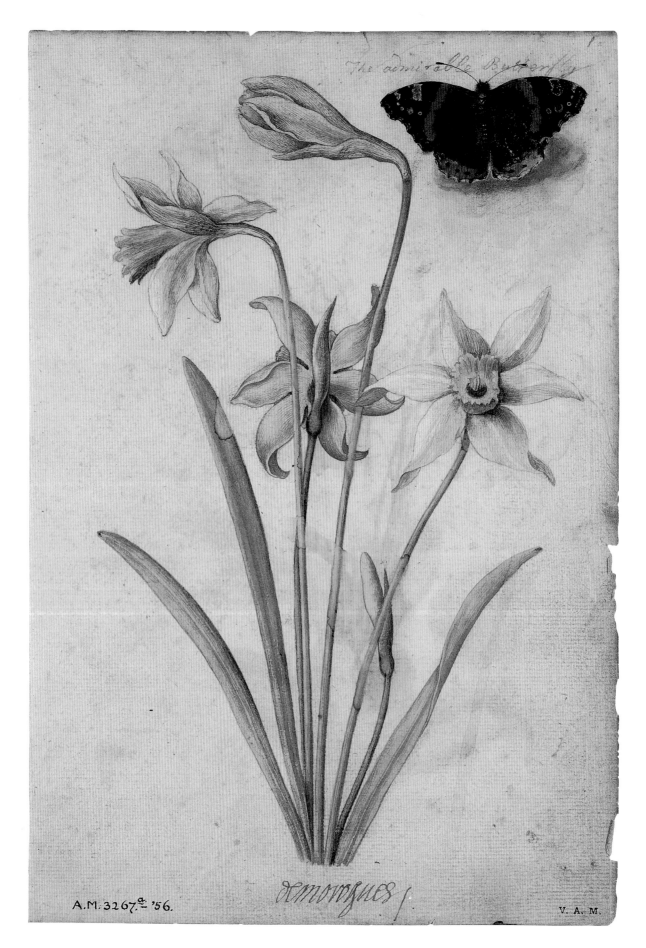

The admirable Butterfly

demorgues

1. JACQUES LE MOYNE DES MORGUES (1533?–1588)

Daffodils and a Red Admiral Butterfly, early 1580s

27.4 x 19.1 cm. Purchased 1856. 3267a-1856

———————

One of 59 studies in the V&A collection of flowers, fruits and butterflies, this watercolour, despite its modest composition, is perhaps the most beautiful, although it is impossible to choose the 'best' from such a wonderful series of drawings. The artist was a French Huguenot, who was probably born in Dieppe, a famous artistic centre for cartographers and illuminators. Almost nothing is known of the first 30 years of his life, until he joined the expedition in 1564 to the Huguenot settlements in Florida, on the east coast of North America, as a draughtsman. His job was to map the coast and harbours, the rivers and towns. The expedition was a disaster, but Le Moyne survived. For a travelling watercolourist, Le Moyne's experience was exceptional. Not only did he travel to America and escape the Indians and Spaniards there, but he hid under a bush while he watched a friend hacked to death by Spanish soldiers. His rescue, along with the other very few French survivors of the massacre, resulted in the French finding the smaller vessels from the expeditionary force and sailing them home, finally arriving on the coast of Wales in 1566.

That was not the end of the story of Le Moyne's dramatic life. Back in France, he was forced to flee to England during the notorious St Bartholomew Day massacres. There he secured the patronage of Sir Walter Raleigh and Sir Philip Sydney. The latter encouraged the artist to work on his masterpiece, *La Chef des Champs*, published in 1586. The beautiful set of watercolours in the V&A collection is closely related to the images in that book. The images are tranquil and concentrated, not at all reflecting the turmoil of the artist's career.

Le Moyne stayed in London for the rest of his life. Given the unusual nature of his life and career, he probably would not be very surprised to know that the 59 watercolours by him were principally bought by the Museum because of the fine late sixteenth-century brown calf covers in which they were bound. The album was dismantled some years ago so that each of the pages may be seen as great watercolours in their own right.

2. PIETER TILLEMANS (1684–1734)

View of a Park with Huntsmen and Deer, c.1720?

17.7 x 22.3 cm. Bequeathed by the Rev. Alexander Dyce, 1869. D.557

———————

The artist was born in Antwerp and came to London in 1708 with a commission from a dealer to copy old master Dutch and Flemish paintings. He was one of the first pupils at Sir Godfrey Kneller's academy of painting and worked as a scene-painter at the Haymarket Opera House. He is principally remembered, however, as a topographical draughtsman and watercolourist employed for example to produce about 500 drawings for John Bridges's *History of Northamptonshire*, published in 1719.

This watercolour is one of the earliest hunting scenes, in which he was to specialise in later years. Indeed, he and John Wootton were the leading painters of sporting pictures in the first half of the eighteenth century. As one of the most popular pursuits of the century, hunting was a much-painted subject. The setting is probably Richmond Park; he lived in Richmond for many years. It is an excellent example of his work, precise and attractive, depicting a peaceful landscape with a stream and parkland, the scene only disturbed by the intervention of the two huntsmen with their dogs (one drinking water in the foreground) and deer, the nearest pair running while the others graze. The composition is easy on the eye, with the framing tree on the left balancing the figures on the right, but otherwise not wholly conventional; the great clump of trees in the centre must be the result of observation of a real scene rather than artistic invention. It also has a vitality and spontaneity, which Tillemans was rarely able to communicate in his oil paintings, partly due to the immediacy of the watercolour medium.

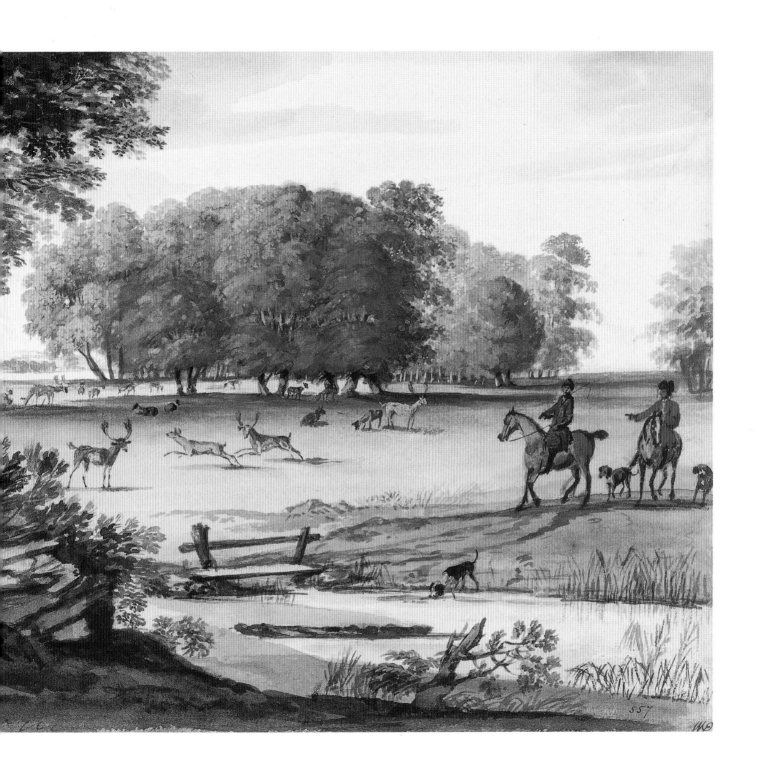

3. GEORGE EDWARDS (1694–1773)

A Golden Thrush from Bengal, 1740s?

25.4 x 21.6 cm. Purchased 1935. P.68-1935

———————————

Little is known of this artist's early life, before his travels in the Netherlands, Norway, Belgium and France between 1716 and 1731. In 1733 he was appointed librarian to Britain's Royal College of Physicians, on the recommendation of Sir Hans Sloane. Sloane (1660–1753) was the most distinguished physician of his day – he was first physician to King George II – and was also a keen botanist. He bought the manor of Chelsea in 1712 (Sloane Street and Sloane Square taking his name) and established the Chelsea Botanic Garden. But he is principally remembered for virtually creating what was to become the British Museum.

Edwards prospered through his contact with Sloane. He was elected a Fellow of the Royal Society and a Fellow of the Society of Arts. His masterpiece was *A Natural History of Uncommon Birds and Animals*, published in four volumes between 1743 and 1751: he dedicated the book to God. This watercolour was not used for publication, although a similar image of the subject appears in the book. It was probably intended as a work of art in its own right, to satisfy the increasing demand in the eighteenth century for detailed records of natural and unusual phenomena: landscapes, flowers and fruits, animals and birds. But Edwards, like the greatest ornithological illustrators, was not only intent on recording the appearance of the species. He fills the picture space with a dramatic composition that shows the bird in characteristic action, in a clearly imagined landscape setting. He also exploits the brilliant colours of the bird's plumage and beak to great visual effect, and he never allows his lively brushwork to be restricted by the necessity to depict the details expected by the ornithological collector.

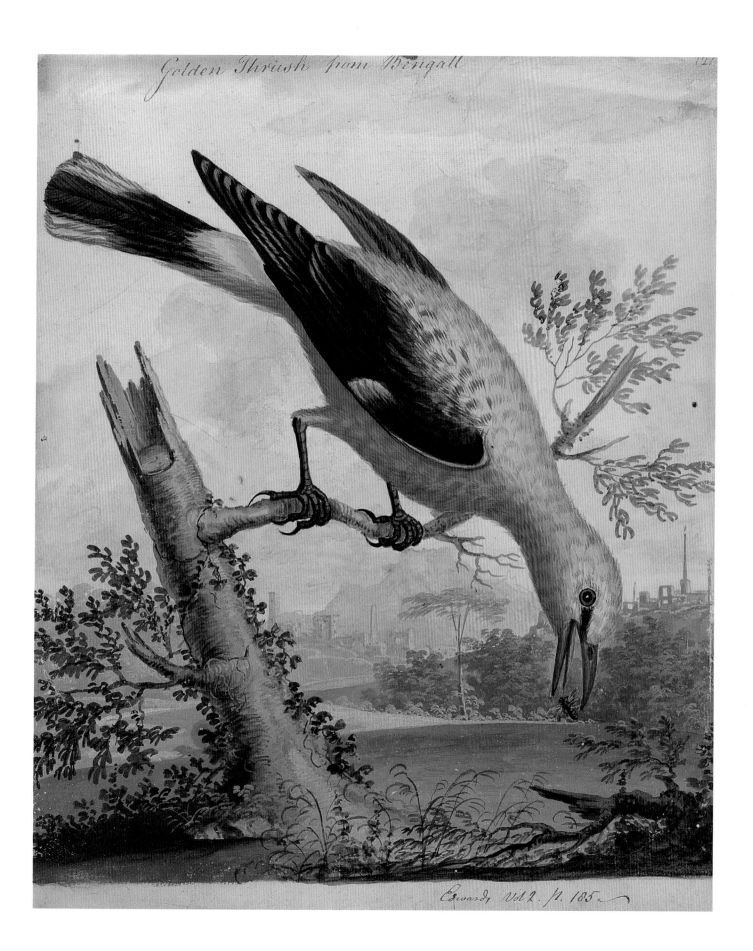

Golden Thrush from Bengall

Edwards Vol 2. Pl. 185.

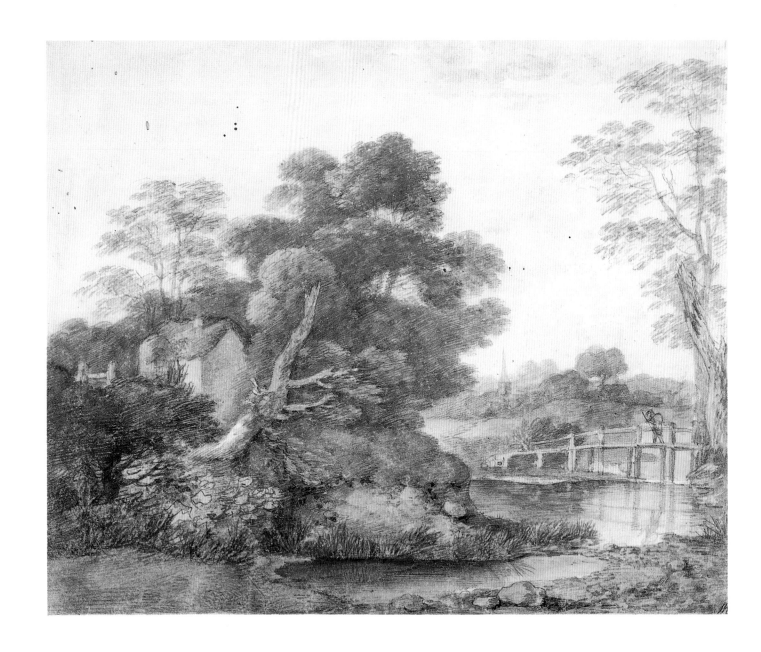

4. THOMAS GAINSBOROUGH R.A. (1727–1788)

Landscape with Cottage and Stream, c.1750

29.9 x 36.2 cm. Dyce Bequest 1869. D.676

This is one of the very few watercolour drawings to have survived from Gainsborough's early period in his native Suffolk. He made his drawings and watercolours either for publication as engraved prints, or for sale or presentation to patrons and collectors. This watercolour was almost certainly intended for sale, probably through his London dealer, Panton Betew, who stocked Gainsborough's work in the 1750s. It is highly finished and retains the original double lines drawn as a framing border around the pictorial image.

All the elements of a picturesque landscape are here: the tree stumps, the rustic bridge, the thatched cottage, the distant church spire and the labourer crossing the river with his

sack and staff. The colours are pale, subtle shades of green, yellow and ochre, and the sky a limpid blue. The foliage is rapidly rendered with diagonal loops by both the brush with watercolour and the pencil. The grasses in the foreground, at the bank of the river, are more vigorously treated, giving even more the effect of a living organism. It is a wonderful example of Gainsborough's ability to combine the medium of watercolour with the use of pencils of various strengths to create a soft and at the same time carefully detailed image. The reflection of the bridge on the river's surface, for instance, is rendered with light pencil strokes over the watercolour, thus achieving the desired shimmering effect.

The watercolour was purchased, probably in the late eighteenth century, by George Frost, an 'ardent admirer' of Gainsborough, according to one obituary of Frost, and a great friend of Constable; Frost wrote to Constable in 1807: 'You know I am extravagantly fond of Gainsborough perhaps foolishly so'. It was subsequently owned by the collectors William Esdaile and Alexander Dyce, who bequeathed it to the V&A.

5. *(overleaf)* FRANCIS COTES R.A. (1726–1770)

Purley Hall, Berkshire, 1756

Signed and dated by the artist *F. Cotes delt. 1756.*
37.1 x 53.7 cm. Purchased 1932. P.35-1932

One of the earliest categories of subject-matter for watercolourists (along with portraits in miniature, botanical and ornithological studies) was the topographical view of a country house. Francis Cotes was a founder-member of the Royal Academy and is today principally known as a portrait artist in oils and crayons. But he also produced topographical watercolours, of which the one in the V&A is a fine example. The watercolour is highly finished, with the figures – presumably the owners of the house proudly gazing at their extensive property – perhaps adding an extra, human, dimension to the meaning of the image.

The unusually low horizon with its distant sloping hills is broken by the towering trees in the foreground. Most of the trees are evidently newly planted, their slender trunks making a pattern of vertical lines on both left and right. The older tree, with its trifurcated trunk, dominates the composition and frames the subject of the watercolour, the great house. The contemporary reaction to nature, here in 1756, connects the eighteenth-century desire to tame the garden landscape by introducing man-made elements (such as the urns on plinths) with the simultaneous enjoyment of being in contact with nature in the company of the family – the husband and wife and their children – and their dogs.

6. JONATHAN SKELTON (c.1735–1758)

Tivoli: The Great Cascade, 1758

Signed and dated (on the back) *Great Cascade at Tivoli J. Skelton 1758*.
50.7 x 36.3 cm. Purchased 1925. P.12-1925

From the few dated drawings that survive, we know that Skelton was working in Croydon, Surrey, in 1754, and London and Rochester in 1757. He went to Italy in 1757 and died in Rome – at a very young age even for the eighteenth century – nearly two years later. From his death until an auction sale in London of 84 of his watercolours, as late as 1909, Skelton seems to have been forgotten. The V&A purchased this, one of his finest watercolours, with another equally fine view of Rome with St Peter's in the background, at a later auction; together they cost the Museum £27.

Skelton mentions the Tivoli subject in a letter to William Herring written in Rome on 7 June 1758. Herring was the artist's patron, resident in Croydon. 'Since my return from Tivoli', he wrote, 'I have begun two pictures, one of them I have finished to an hour or two, the other is better than half way'. These were oil paintings, referred to as a project in an earlier letter to Herring, but the Tivoli Cascade watercolour here is probably a study for the second one.

The wonderful views in and around Rome were depicted by many visiting British artists, whose works were often the equivalent of our postcards or holiday photographs today, albeit more expensive and of a higher aesthetic quality. Skelton combined his work out-of-doors in front of the scene itself, usually in watercolour on paper but possibly also in oil on paper or canvas, with an evident love of the works of such old master painters as Claude and Gaspard Poussin of more than a century earlier.

Skelton's watercolour painting is distinguished by its delicacy of colour and line. He worked first in pen and ink delineating the composition, then applied the watercolour with his brush, often using fresh and bright pigments, and sometimes finished the work with more detailed pen drawing for the foliage and architectural details. The result is, as here, a painting of jewel-like richness.

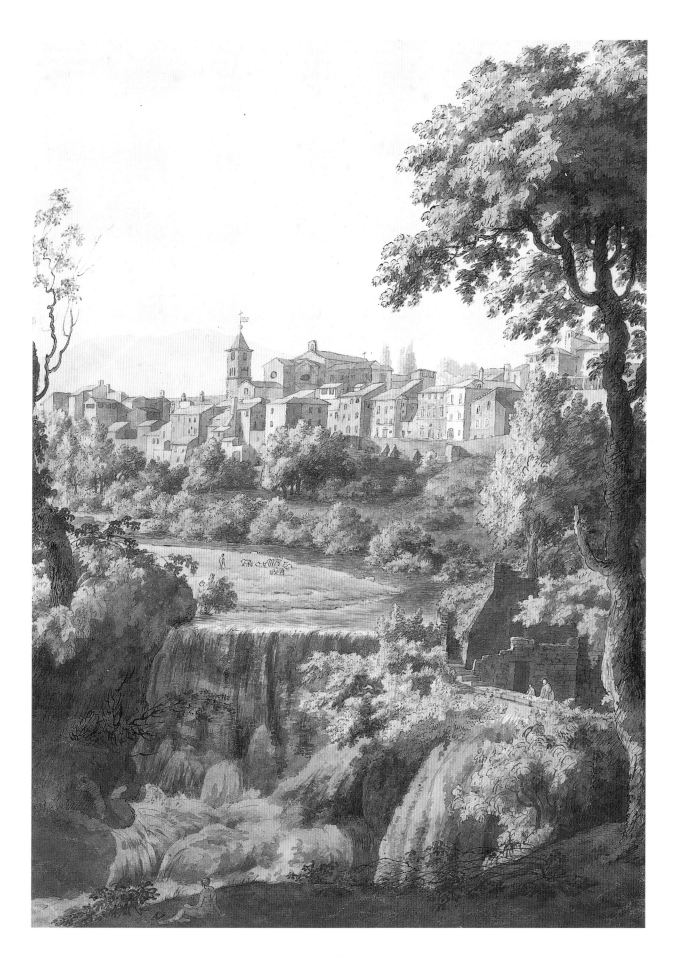

7. SAMUEL HIERONYMOUS GRIMM (1733–1794)

The Macaroni, 1774

Signed and dated by the artist *S.H. Grimm fecit 1774.*
17.2 x 14.7 cm. Purchased 1939. P.39-1939

The phenomenon of the 'Macaroni' arose in the middle of the eighteenth century: they were wealthy young men who affected the elaborate style of dress they had seen on the continent during their 'Grand Tour' of Europe. The name was probably taken from the Macaroni Club, a fashionable dining society that catered for such young men and specialised in foreign foods such as macaroni. Horace Walpole wrote in a letter of 6 February 1764 that the club was 'composed of all the travelled young men who wear long curls and spying-glasses'. Another dimension in this watercolour may be connected with the second use of the Italian word *maccherone*, meaning a fool. It is possible that the principal figure is the third Duke of Queensbury (1698–1778).

Grimm was born in Switzerland and settled in London in 1765. He specialised in topographical landscapes (see plate 8), but occasionally produced caricatures and humorous subjects that mocked the extremes of high society of his day.

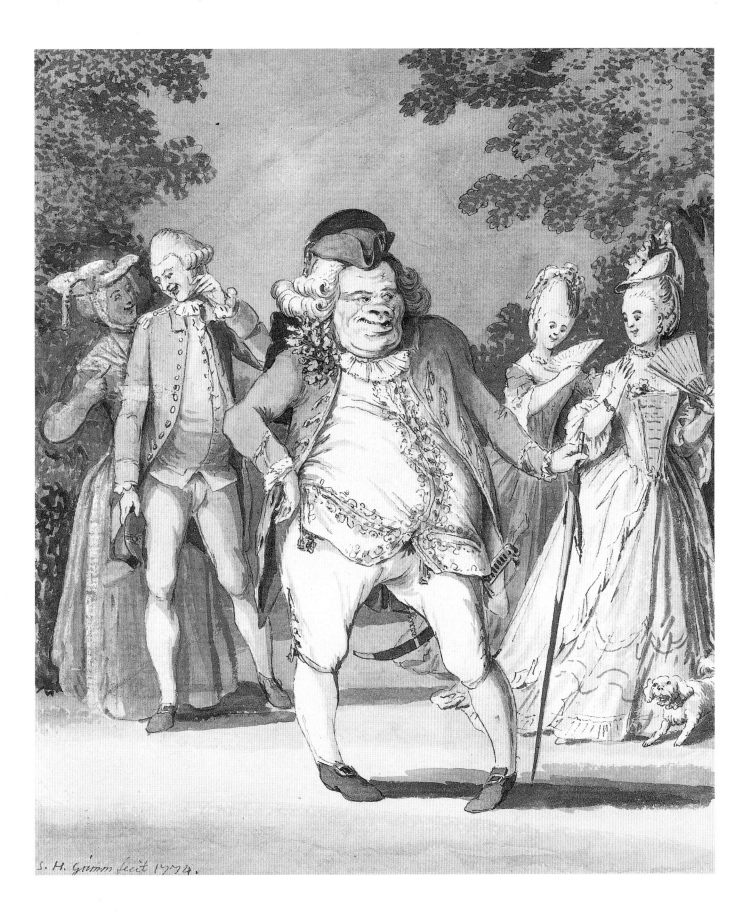

S. H. Grimm fecit 1774.

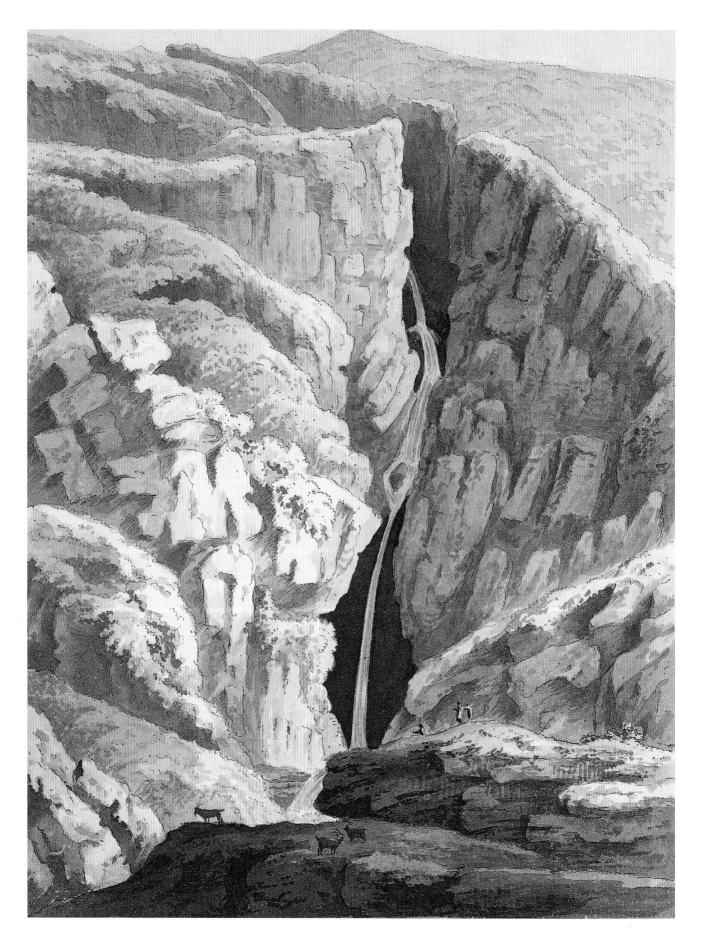

8. SAMUEL HIERONYMOUS GRIMM (1733–1794)

Cascade on the Road from Machynlleth to Dolgelly, prob. 1777

23.8 x 17.7 cm. Purchased 1920. P.27-1920

Grimm, like several of his contemporaries, worked as an illustrator for topographical historians and antiquarians, sometimes accompanying them on tours around the country to make drawings on the spot. This watercolour was probably made when he visited Wales with the writer Henry Penruddocke Wyndham (1736–1819), who had been working on a book first published anonymously in 1775, titled *A Gentleman's Tour through Monmouthshire and Wales in July and August 1774*. An expanded version published under his name in 1781, which added materials collected in June, July and August of 1777, was illustrated by Grimm, who accompanied Wyndham on this latter tour.

There is a coolness of colour and delicacy of touch in Grimm's topographical watercolours that may owe something to his Swiss birth and upbringing. His technique was usually to make a careful outline drawing in pen and ink and then complete it by gently washing it with watercolours. In using this method, he is similar to Francis Towne (see plates 12 and 13).

9. JOHN ROBERT COZENS (1752–1797)

A Cavern in the Campagna, Rome, 1778

Signed and dated *John Cozens 1778.*
41.5 x 61 cm. Bequeathed by William Smith, 1876. 3020-1876

———

This is one of the most original watercolours of the eighteenth century. Inspired by the writings of Edmund Burke, who in his seminal book *On the Sublime and Beautiful* (1756) explains 'why darkness is terrible', Cozens explored the visual and emotional possibilities of caves. A cavern fulfills all the necessary requirements of a sublime experience: darkness, vastness, a sense of infinity and a threat of imminent danger.

Unlike his other more conventional Italian views, where he depicts the fresh and sunny openness of the countryside around Rome and elsewhere, this is a painting of the dank and gloomy oppression of quite a different scene – the landscape of, literally, an underworld. Most of the sheet is given over to the dark and craggy rocks, with only the entry to the cavern revealing the light of the sky. The overall effect of the composition is mysterious and evokes a primarily emotional rather than an aesthetic response, which must have been what Cozens intended.

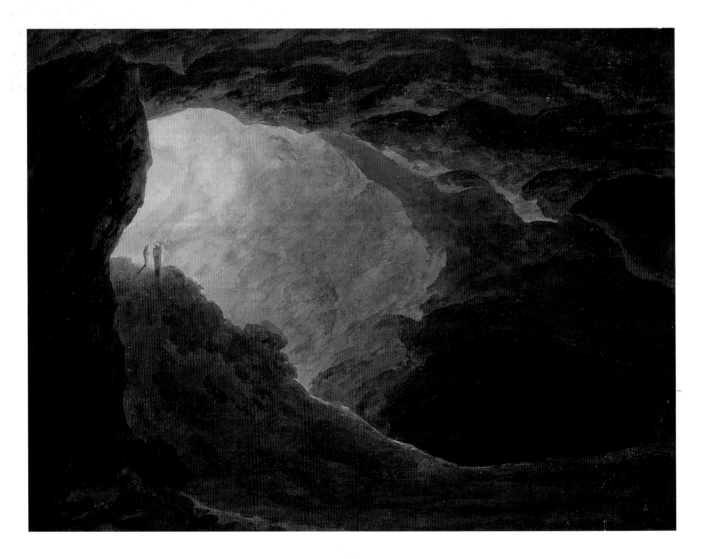

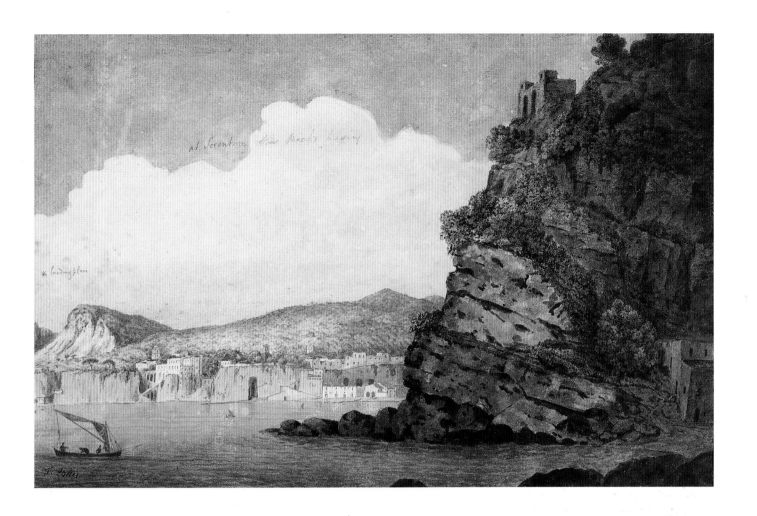

10. THOMAS JONES (1742–1803)

At Sorrentum, the Rocks, 1778

Signed *T. Jones* and inscribed (in the sky). 29 x 43 cm. Purchased 1976. P.1-1976

Jones was a pupil of the celebrated painter Richard Wilson, also born in Wales, and was in Rome and Naples from 1776 to 1783 writing his *Memoirs*, which remain by far the best source of information about the artists, patrons and connoisseurs in Italy at the time. On his return to London he seems to have given up painting professionally, and almost nothing is known of his later years. He painted landscapes in the style of Wilson but is better known today for his remarkable oil sketches, which were only 'discovered' in the 1950s. They are fresh, closely observed and informal, sometimes depicting little more than a section of the wall of a humble house with laundry hanging from a window. This watercolour, one of the most beautiful of all his works, shows the original quality of his art: it gives the visual sensation similar to that of a snapshot, the image of something seen, admired and immediately recorded.

We know the specific date from a page in one of the artist's sketchbooks, which shows another view of Sorrentum, inscribed '17 November 1778'. His *Memoirs* also imply that he was at Sorrentum on that day.

Before the V&A acquired it, the watercolour was owned by a descendant of the artist.

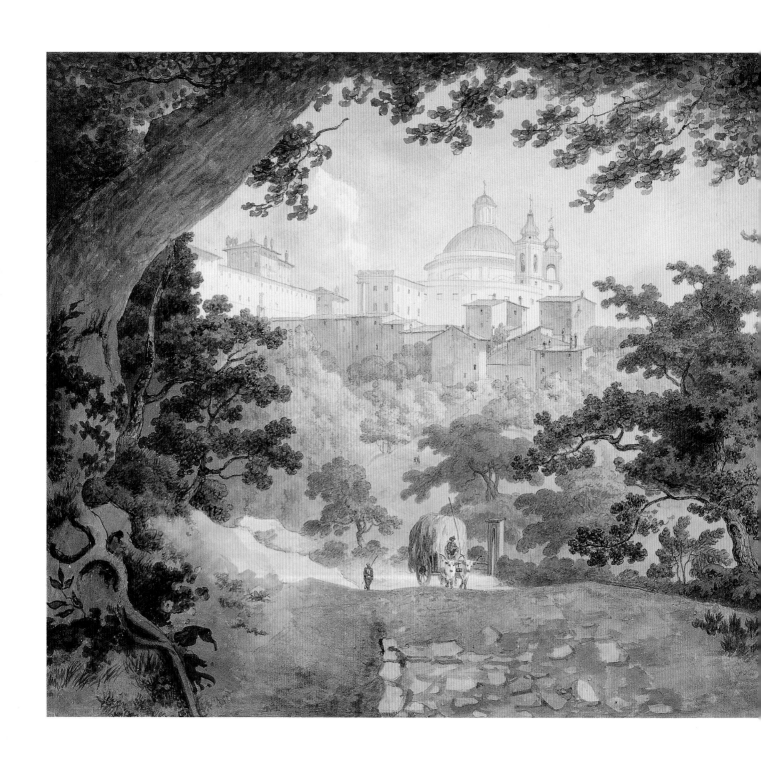

11. WILLIAM PARS A.R.A. (1742–1782)

The Palazzo Chigi, Ariccia, near Albano, c.1780

49 x 58.8 cm. Given by E. Daniell. A.L. 5725

Pars, after studying at the Royal Academy, followed the trend of travelling on the continent to make topographical drawings and watercolours for publication as prints for connoisseurs. He first went to Greece, commissioned by the Society of Dilettanti, between 1764 and 1766, and his work was eventually published in volumes two and three of Stuart and Revett's famous *Antiquities of Athens* (1789 and 1795) and in volumes one and two of *Ionian Antiquities* (1769 and 1797). He accompanied Lord Palmerston to Switzerland and Austria in about 1770 and settled in Rome in 1775, again commissioned to draw and paint views for the Dilettanti. He died, at the comparatively early age of 40, after suffering a severe cold brought on by his sketching in the open air.

Apart from his untimely death, Pars's career was typical for a watercolourist in the second half of the eighteenth century. But many of his watercolours are far from typical. Later works, such as this one, are pale in tone and delicate in handling, giving a light of limpid freshness that evokes an early morning atmosphere rather than the heat of a central Italian midday sun. The gigantic tree on the left, with its curved trunk, frames the view to the palace along with the smaller trees on the right. The rich green foliage contrasts with the pale blue sky, the white and various subtle shades of grey and ochre of the palace, and its surrounding buildings. His pen and ink give the architectural details, and he adds a further visual dimension by making a pattern – of which Mondrian might have approved – of the dark shapes of the many windows, sometimes symmetrically opened in the wall and sometimes placed at random. In the centre of the composition the brightest colour appears, in the red of a small figure's jacket and of another's breeches.

12. FRANCIS TOWNE (1739–1816)

The Source of the Arveiron: Mont Blanc in the Background, 1781

Signed and dated *F. Towne delt 1781 No. 53*. 42.5 x 31.1 cm. Purchased 1921. P.20-1921

———————

Towne visited Italy in 1780, returning to England in 1781 and staying in Switzerland *en route*, where he made this watercolour. It was his only tour abroad. The artist inscribed the back of the original mount of the watercolour: *Light from the right hand/no.53/The source of the Arviron with the part of Mont Blanc/drawn by Francis Towne Septr. 17th 1781.* The Arveiron is a torrential tributary of the River Arve, in the Haute-Savoie, and would have appealed to painters – and tourists – in search of the 'picturesque' and the 'sublime' in landscape.

What is so extraordinary about Towne's career is that he started as a coach-painter in London, devising decorative panels with the owners' coats of arms surrounded by elaborate borders of flowers. He graduated to showing flower and landscape paintings at the Society of Artists – before the establishment of the Royal Academy in 1768 as the principal exhibition venue for contemporary artists – and then moved to Exeter, Devon, where he seems to have made a good living first as a coach-painter, then as a drawing-master. In some ways, it was a very conventional career. But his style of working in watercolour, as is shown in this painting, is distinctive and utterly different from that of his contemporaries.

His technique was to apply pale but striking colour washes over a very precise pen and ink outline. It has been suggested that his aesthetic impulse was that of the makers of Japanese colour prints; of course, Towne could never have seen a Japanese block-print, but his flat planes, subtly progressing into the background, are very similar. The apparent simplicity of treatment also presages the work of twentieth-century watercolourists such as Eric Ravilious (see plate 88).

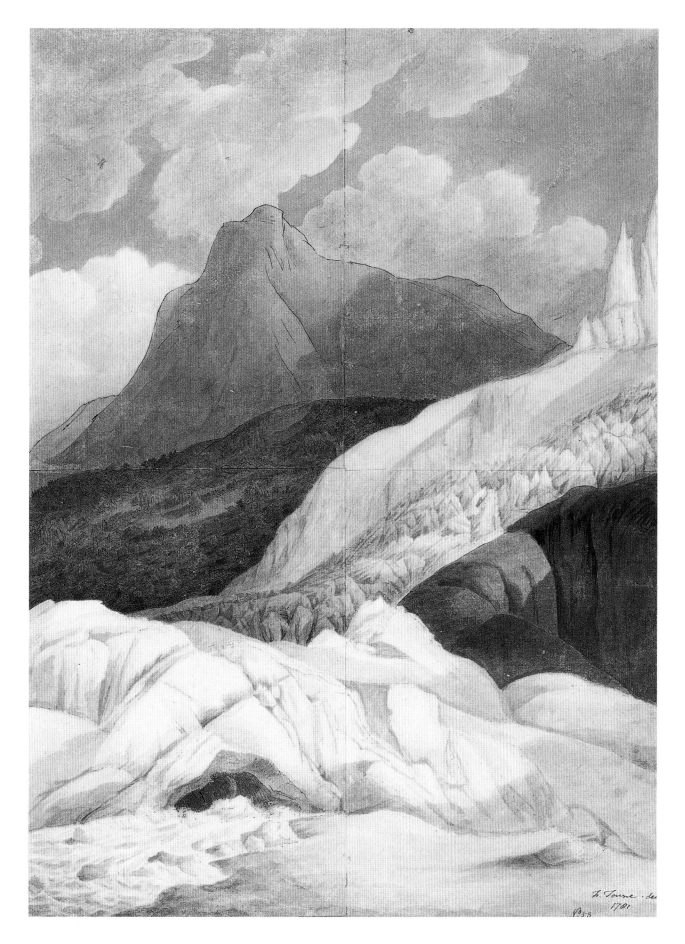

F. Tourne. de
1781
N° 53

13. FRANCIS TOWNE (1739–1816)

Part of Ambleside at the Head of Lake Windermere, 1786

Signed and dated *F. Towne delt 1786 No.11.*
15.7 x 23.8 cm. Given by Mrs Fanny Jane Elizabeth Douglas, 1924. P.24-1924

The watercolour is inscribed by the artist on the back of the mount *No.11 Morning light from the right hand 8 O.Clock. Part of Ambleside at the head of the Lake of Windermere drawn by Francis Towne August 7th 1786 London July 5th Leicester Square 1791.* Towne did not always inscribe his watercolours with such exact details of time and date. He made three series of drawings and watercolours, both on commission and for independent sale: this explains the number eleven from the first series inscribed here. The artist must have been enchanted by the sheer beauty of the landscape of the Lake District, one of the most visually stunning areas in Britain; the lakes themselves, flanked by the hills and surmounted by the vast ever-changing sky, were depicted by Towne in his characteristically linear manner, but coloured with the utmost delicacy and subtlety, the picture planes slowly receding into the distance. He constructs an atmospheric image of the head of the lake, which at that point takes on the nature of a winding river, and simultaneously presents us with a composition of pure, abstract, visual pleasure.

The donor was the granddaughter of Towne's pupil John White Abbott (see plate 25), who copied several of Towne's works.

14. JOHN ROBERT COZENS (1752–1797)

View from Mirabella, 1782

25 x 37.4 cm. Given by J.E. Taylor, 1894. 120-1894

The original drawing for this magnificent watercolour is in a sketchbook; the sketch is fully inscribed by the artist 'From Mirabella the villa of Count Algarotti – On the Euganean hills 10 miles from Padua'. It is a superb example of pure watercolour by one of its leading practitioners.

The old tradition of topography – literally the accurate depiction of an actual place – gave way in the 1770s and 1780s to a demand for landscape watercolours that were beautiful in their own right. Cozens was one of the first to supply that demand. This painting is not so much a 'portrait' of Count Algarotti's villa, which only appears as a detail in the distance, as a celebration of the view itself, the vast stretches of land, the distant hills, and the sky, taking up more than half of the picture space, with its soft and slowly moving clouds.

Cozens visited Italy twice, first between 1776 and 1779 in the company of the writer Richard Payne Knight (see text for plate 16) and then in 1782, when this watercolour was made, with the 'Gothick' author and antiquarian William Beckford. His style and technique are only in part, and inevitably, influenced by the work of his father Alexander (plate 17) but are otherwise astonishingly original. His Italian watercolours, and his Swiss Alpine views, were a profound influence on both Girtin and Turner and on Constable, who owned a Cozens painting.

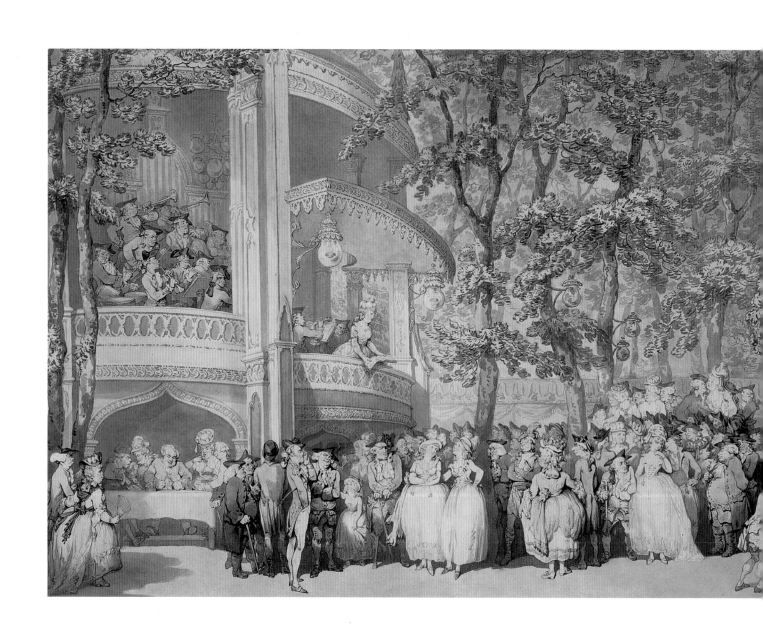

15. THOMAS ROWLANDSON (1756–1827)

Vauxhall Gardens, 1784

Exhibited at the Royal Academy, 1784.
48.2 x 74.8 cm. Purchased (with the aid of the NACF) 1967. P.13-1967

The artist entered the Royal Academy Schools in 1772 but left after a year and moved to Paris. On his return, his career was devoted to recording high and low life in England, most often in a comic and satirical manner. Some of his drawings and watercolours are among the greatest caricatures ever produced.

The Vauxhall Gardens were a fashionable resort, just south of the Thames, from the 1730s into the nineteenth century, where visitors could eat, drink, dance, listen to music, stroll in the groves, make clandestine assignations and enjoy the display of sculptures in the open air. It was realised in his own day that this scene of the Gardens and its visitors was Rowlandson's masterpiece.

Rowlandson shows the 'Orchestra', a structure in the Gothic style and one of the principal buildings on the site. An evening concert is in progress, the band crammed into an upper box, while in the next box a singer – Mrs Weichsel – performs with her accompanist at the keyboard. Below the band is one of the supper-boxes. The walls of many of these were decorated with oil paintings by such contemporary artists as William Hogarth and Francis Hayman; this box is supposedly occupied by Dr Samuel Johnson, his biographer, James Boswell, his friend Mrs Thrale and the novelist and playwright Oliver Goldsmith. This is unlikely; at the time of the drawing Goldsmith had been dead for ten years, and Johnson died in 1784. But the tradition gives an idea of the sort of clientele the Gardens attracted. The two women standing under the centre tree have been identified as the Duchess of Devonshire and her sister Lady Duncannon, the man to their right with the wooden leg and eye-patch is Admiral Paisley and towards the right of the painting the Prince of Wales whispers in the ear of his mistress, Perdita Robinson.

Although some of the people are drawn with exaggerated vivacity, the watercolour is not strictly a caricature. No one detail overwhelms the overall structure of the composition, and the atmosphere of the painting is one of elegance – despite the presence of some inelegant characters – and enjoyment.

16. THOMAS HEARNE (1744–1817)

The River Teme at Downton, Herefordshire, 1785/6

Possibly exhibited at the Royal Academy in 1785 or 1786. Signed by the artist *Hearne*.
32 x 35 cm. Given by William Smith, 1876. 2933-1876

———

Hearne made a series of large watercolours of Downton Castle and its grounds between 1784 and 1786 for the owner, the celebrated Richard Payne Knight (1750–1824) and exhibited some at the Royal Academy. Knight was a great collector and connoisseur, especially of classical coins and bronzes. He was also a writer, his main contributions to aesthetic theory being his 1794 poem 'The Landscape' and his *Analytical Enquiry into the Principles of Taste,* published in 1808. He was an enthusiast of the 'picturesque' style of painting and landscape gardening, which led to his employment of Thomas Hearne.

Knight had worked on Downton from the mid-1770s; he improved the grounds and more or less designed the Castle in the Gothic style but with a classical Greek interior. The principal feature of the grounds was the dramatic setting of the River Teme, among wooded hills, which Hearne depicts here. This watercolour has many of the essential elements of the 'picturesque': tall framing trees with their cascades of leaves, the artfully placed tree-stumps which support the rustic bridge, the river, the rocks and the winding path. It was this kind of topographical work that influenced Turner in his early years; Dr Monro, who had bought many drawings and watercolours by Hearne, showed them to Turner when he was employed as a copyist by Monro between 1794 and 1797.

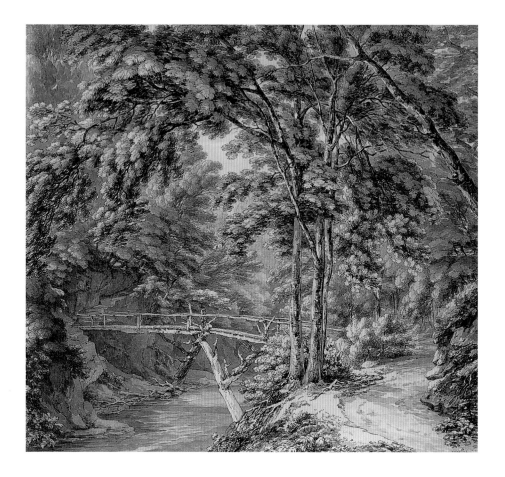

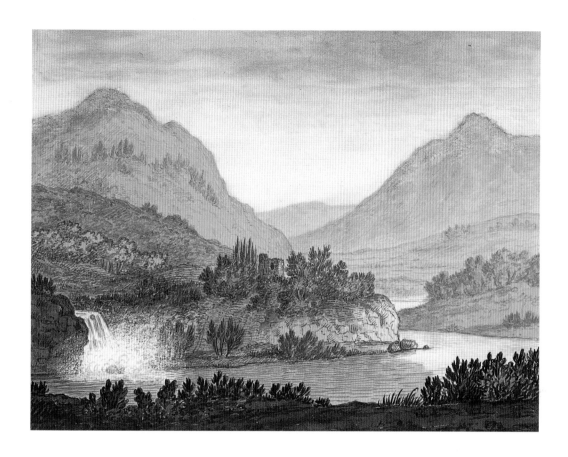

17. ALEXANDER COZENS (1717–1786)

Mountainous Landscape with a Castle and Waterfall, date unknown

17.8 x 22.9 cm. Purchased 1920. P.100-1920

———————

The artist's father was employed by Peter the Great in St Petersburg as the Czar's chief ship-builder, and Alexander was born there. Very little is known of his early background and training, but it must have been unusual. Designs for ships, marine charts, engravings imported from the Netherlands, and contact with Eastern art from China and Japan may all have formed part of his training – if indeed he received any. We do know he was in Rome in 1746, a more conventional place in which to study for an eighteenth-century painter. He was drawing-master at Eton College and wrote several treatises on aesthetics and drawing handbooks, most notably the *New Method of Assisting the Invention in Drawing Original Compositions of Landscape*, published in 1785/6.

In that book he presented his idea of the 'blot', the instant mark on a sheet which could inspire the artist. The theory was not new: Leonardo da Vinci had suggested the same kind of practice, and people have always seen 'pictures' in the flames in a fire-place or the clouds in the sky. The most recent use of the 'blot' theory has been in the psychological Rorschach tests, in which patients drop ink on a sheet of paper which is then folded in two and the consequent image is interpreted. The freedom of this random method of painting affected Cozens's more conventional watercolours; in this painting the dramatic contrasts between light and dark are emphatic, and the composition is an amalgam of the deliberate and the accidental.

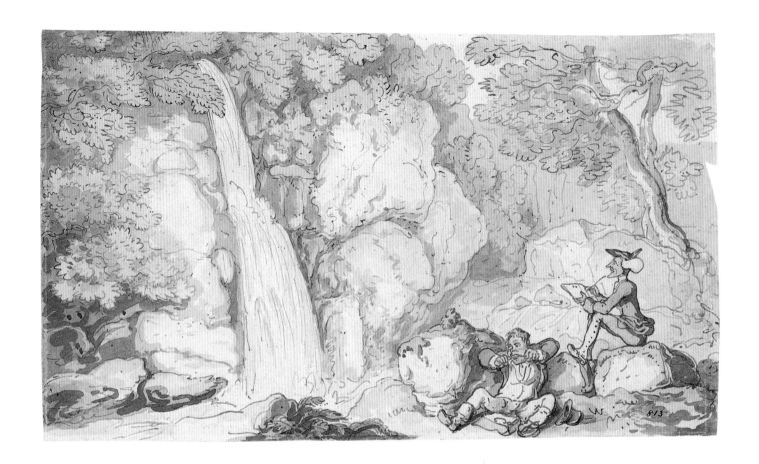

18. THOMAS ROWLANDSON (1756–1827)

An Illustration for the 'Tour of Dr Syntax in Search of the Picturesque'
c.1812

21 x 13.5 cm. The Rev. Alexander Dyce Bequest, 1869. D.813

The drawing illustrates the episode in book II, in which Dr Syntax is sketching the great waterfall at Ambleside in the Lake District, while his manservant Charles 'eats voraciously'. The cult in the later eighteenth century for amateur artists – mostly only tourists really – to travel with their sketchbooks and watercolour boxes in the Lake District was by the 1790s an object of ridicule. The many guidebooks instructed the painter-tourist where to get the best views from specific 'stations'. The number of visitors to the Lakes vastly increased after the publication in 1786 of William Gilpin's *Observations, relative chiefly to Picturesque Beauty, made in the year 1772, on Several Parts of England, especially the Mountains and Lakes*. His descriptions of specific views are vivid and inviting, and the sharpness of his 'observations' is remarkable.

Gilpin was an amateur artist but as accomplished a watercolourist as most of his professional contemporaries. A graduate of the University of Oxford, he took holy orders in 1746. For many years he ran a school in Surrey, then became vicar of Boldre in the New Forest in 1777. Every summer he made sketching tours, which produced the materials for his several illustrated books. The books were most influential with professional and

amateur artists and with collectors; they explained the basic principles of the kind of landscape painting known as 'picturesque'.

But it was the pretentiousness and pedantry of Gilpin and his readers that attracted the satirists, most notably the creator of Dr Syntax. Rowlandson made the watercolour drawings to be reproduced in etchings accompanied by a commentary in verse by William Combe (1741–1823). Here Dr Syntax sits on a rock, in raptures as he tries to convey with his pencil the 'picturesque' scene before him, while his servant, his eyes averted from the view, concentrates on his lunch.

19. *(overleaf)* EDWARD DAYES (1763–1804)

Buckingham House, St James's Park, 1790

Signed and dated *Edw. Dayes 1790.*
39.3 x 64.2 cm. Given by William Smith, 1871. 1756-1871

———————

This artist is generally considered the greatest of all the topographical watercolourists of the later eighteenth century. He was also a great teacher, most notably Thomas Girtin's master, and he exerted considerable influence on the young Turner. But his own works show a firm command of draughtsmanship and composition and a delightful, if conventional, use of colour. He himself had studied in the Royal Academy Schools and went on to exhibit there and elsewhere landscapes and architectural subjects.

His technique of watercolour was typical of the later eighteenth century. After making a careful outline drawing in pen and ink, then applying grey/blue washes with his brush, he would use the colours to finish the painting. In this watercolour he is challenging such artists as Rowlandson (see plate 15) to show a magnificent building, depicted in some detail, but upstaged by the presence of the foreground figures. This may be Dayes's masterpiece.

There is the expected and somewhat conventional delineation of the old Buckingham House, built for the Duke of Buckingham in 1705 as a country home outside the cities of London and Westminster. Occupied later by Queen Charlotte, the wife of King George III, it was transformed by John Nash into Buckingham Palace, which remains today the principal London home of the royal family. But the watercolour is dominated by the characters in the foreground. One can invent their personalities from Dayes's visual description: perhaps a father with his wife and children, two friends meeting, a flirtation between a young couple and a conversation between an older, presumably married, couple. The ensemble has the overall character of a *passeggiata*, a promenade, in splendid surroundings.

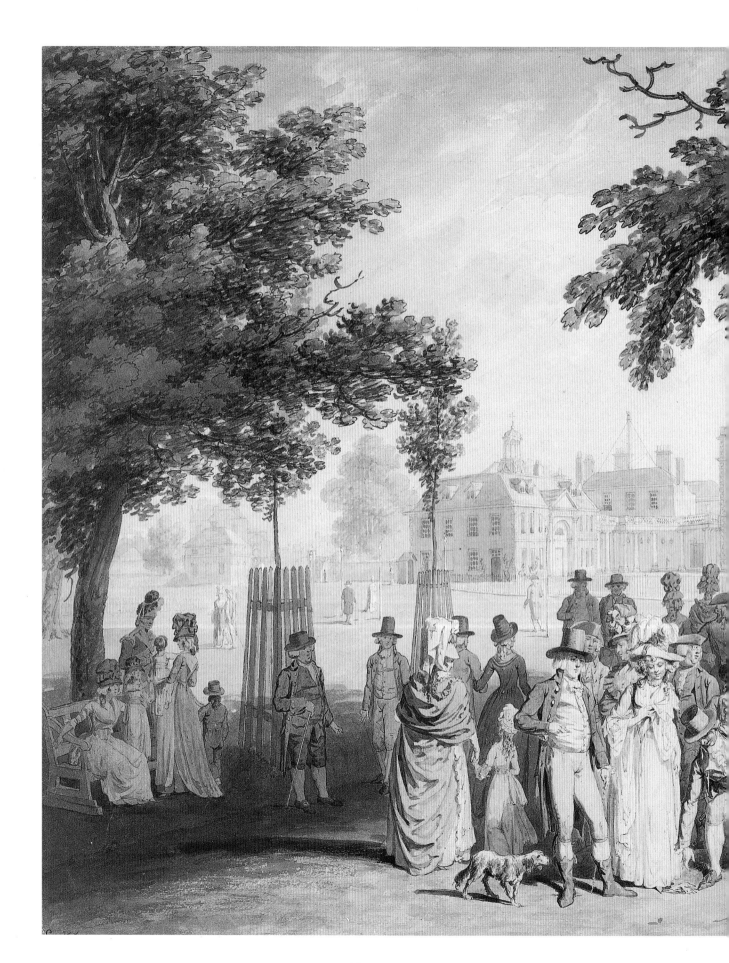

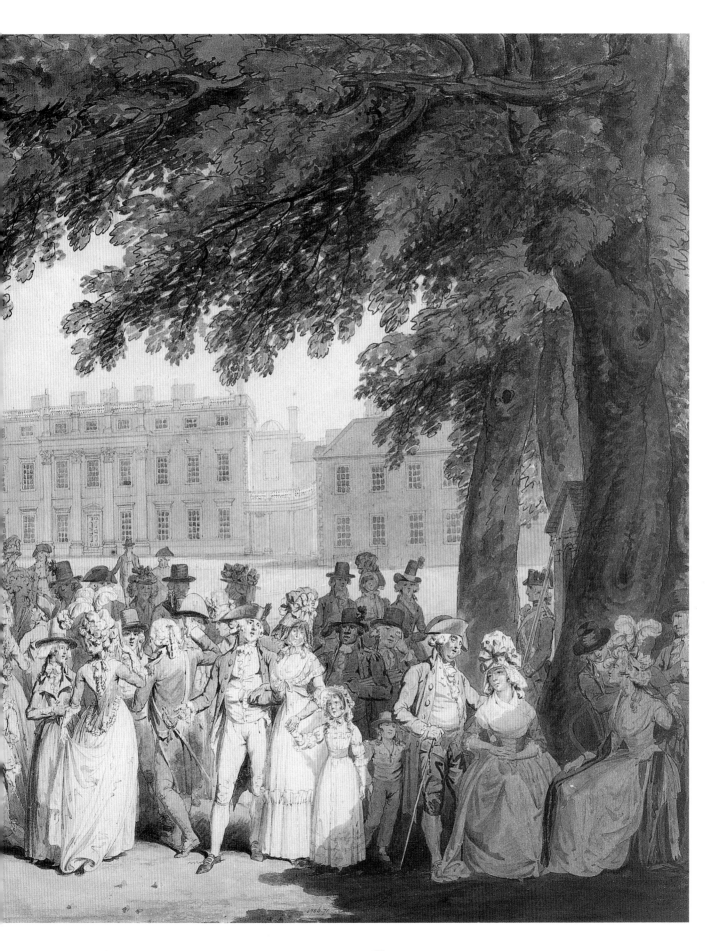

20. WILLIAM ALEXANDER (1767–1816)

The Emperor of China's Gardens, the Imperial Palace, Pekin, 1793

Signed *W A*. 23.5 x 35.5 cm. Bequeathed by William Smith, 1876. 2930-1876

After a conventional training with the watercolourist William Pars (plate 11) and the painter J.C. Ibbetson, and in the Royal Academy Schools from 1784, Alexander's career took an unusual turn when he accompanied the first embassy from Britain to China, led by Lord Macartney, as a draughtsman from 1792 to 1794. On his return to England he first taught at the Military College in Great Marlow, Berkshire, and then was appointed the first Keeper of Prints and Drawings at the British Museum. His subject-matter was antiquarian, classical and Egyptian and, of course, views and events in China.

At this time China was an almost unknown country to the British, although artefacts, notably porcelain, had been imported for over a century. For a young artist from England, the experience of China must have been overwhelming, and Alexander kept a journal (the manuscript is now in the British Museum) as well as making many drawings to record the visit. The embassy reached Pekin in August 1793, and it was then that Alexander made this astounding view of the gardens of the Imperial Palace, giving not only a record of the curious landscape, but of the buildings, boats and costumes that would have been so unfamiliar to an English public.

Alexander did not visit the East again, but he built his artistic career on the 1792-1794 tour. Engravings after his drawings and watercolours were published in the official account of Macartney's embassy (published 1797), he supplied illustrations for John Barrow's *Travels in China* (1804) and published his own books, notably *The Costume of China* in 1805.

He did not aim to be a great artist, but watercolours such as this have an accuracy, a direct appeal in their colouring and in the choice of their subject-matter, which remain visually remarkable.

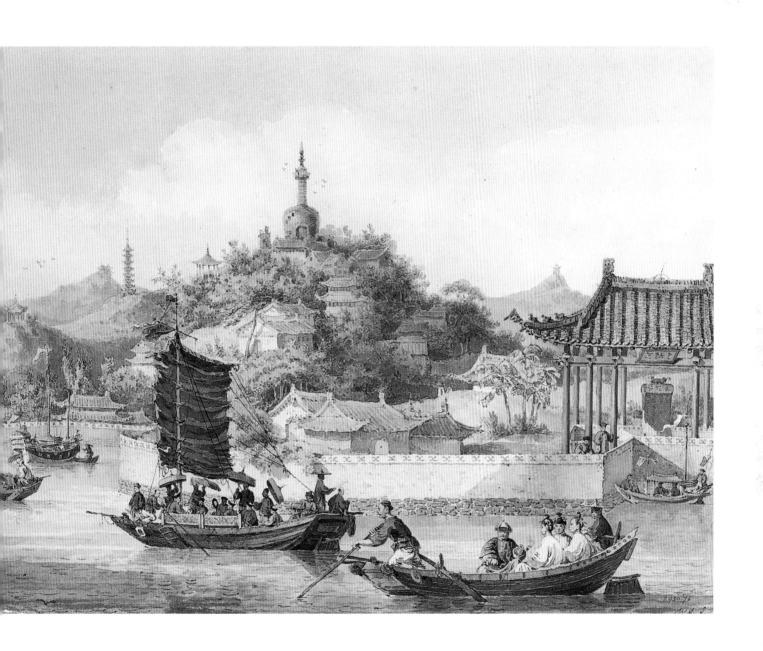

21. MICHAEL ANGELO ROOKER A.R.A. (1746?–1801)

Wookey Hole, near Wells, Somerset, prob. 1794

Signed *M.A. Rooker*. 36.5 x 26.4 cm. Given by Victor Rienacker, 1921. P.44-1921

———————

It seems that the artist visited Wookey Hole in 1794: there is a dated drawing of the scene, known now only through a photograph. The caves and cliffs, and the rushing stream, had long been famous as a natural curiosity and extensively visited by tourists, as they are today. By the later eighteenth century interest had vastly increased following the various publications extolling the 'picturesque' and the 'sublime'. Wookey Hole supplies both qualities in excess.

Little is known about Rooker's life: even his date of birth is unclear, although we know his father, Edward, was a professional artist. As a boy he entered the drawing competitions organised by the Society of Arts, winning a first prize in 1759 for artists under the age of fourteen. He was probably apprenticed to Paul Sandby who, it is supposed, called him 'Angelo', although it is more likely that his father had 'Angelo' in mind as an addition to 'Michael', which was an unusual name at that time. Rooker was one of the first intake of students at the newly founded Royal Academy in 1769. He was also one of the first painters to decide to devote his career to watercolours. The medium was not considered a suitable one for artists with any high ambition, and Rooker's early exhibits at the Royal Academy summer show were oils. He was one of the first group of painters to be elected an Associate of the Royal Academy.

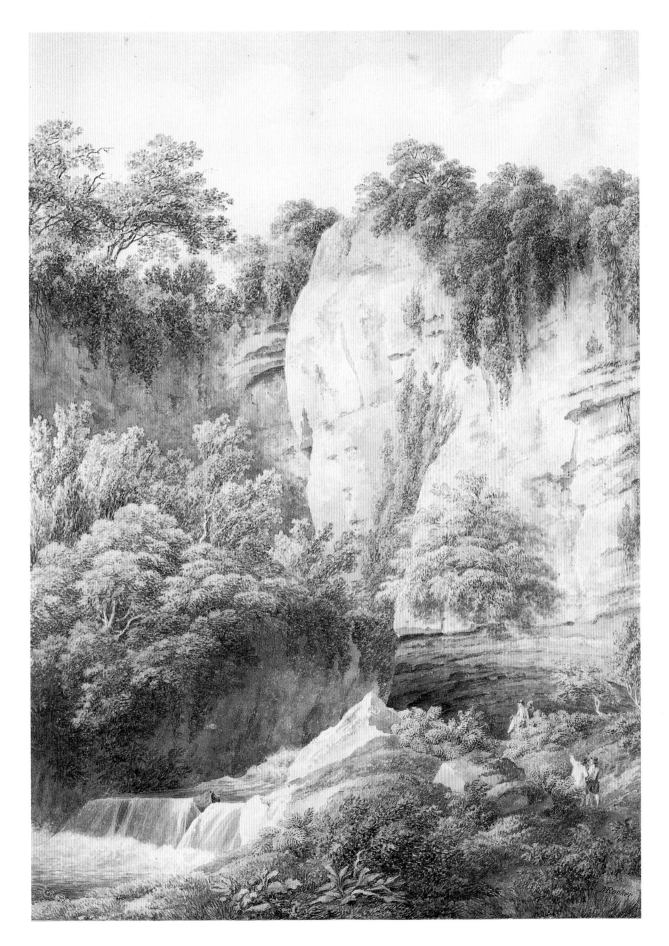

22. PAUL SANDBY R.A. (1730–1809)

An Ancient Beech Tree, 1794

Signed and dated *P. Sandby 1794*. 70.2 x 105.7 cm. Purchased before 1860. FA 383

One of Sandby's most powerful and striking works, this is in effect a 'portrait' of a magnificent tree. Its massive twisted trunk and its many branches dominate the composition and dwarf the figures in the foregound. The figures consist of two men, one holding a hat apparently filled with mushrooms, with a young girl and a man and a woman in a donkey cart riding on the path towards the river.

There are several drawings of ancient trees by both Paul Sandby and his brother, Thomas. Such trees, apart from their majestic appearance, were also natural objects of curiosity. For instance, a great beech tree in the grounds of Windsor Castle, where both artists worked, was supposed to have been so enormous that a woodman, his wife and four children, a sow and several pigs, lived in its trunk. When it was eventually cut down, the residue left on the wood by the burning of peat by the family provided the Sandbys with, so the story goes, a good supply of bistre pigment for their paintings and drawings.

The location of this painting has not been identified, but there is a similar landscape by Sandby in the Yale Center for British Art in New Haven, USA, which has been recognised as a view of Bridgnorth seen from the other side of the River Severn in Shropshire.

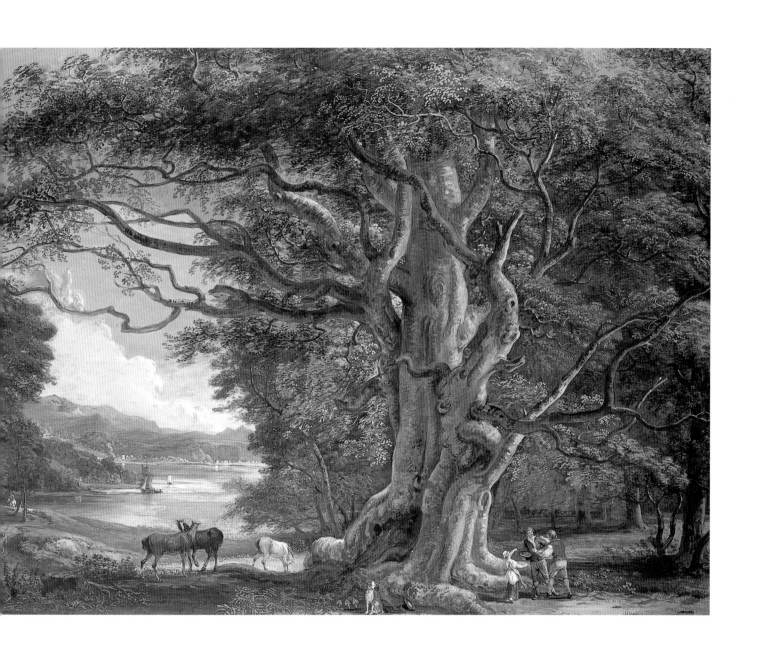

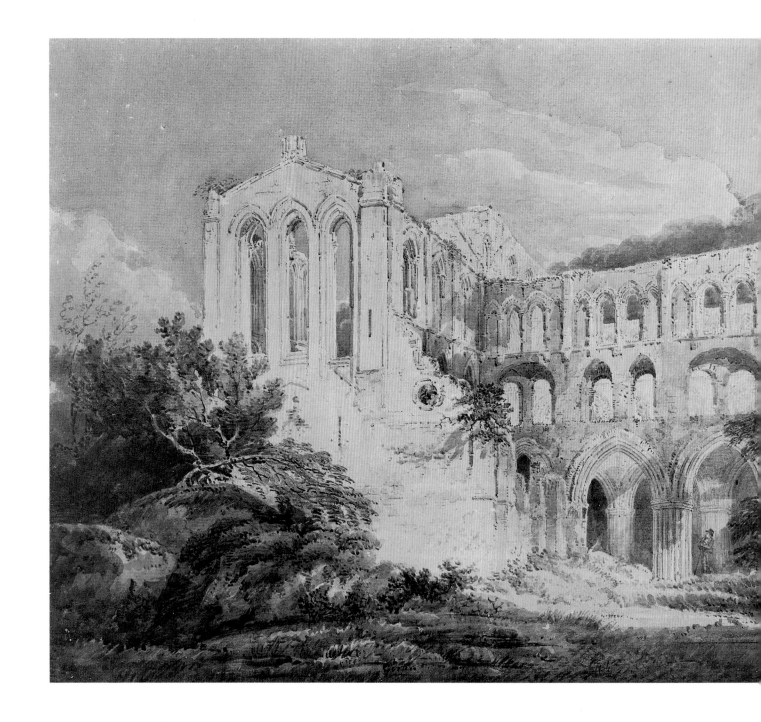

23. THOMAS GIRTIN (1775–1802)

Rievaulx Abbey, Yorkshire, 1798

Perhaps exhibited at the Royal Academy, 1798. Signed *Girtin*.
41.9 x 55.3 cm. Purchased 1860. FA 499

Turner's often quoted statement, that 'if Girtin had lived, I should have starved', sums up the importance of this artist's achievement in such a short working life. In only thirteen years, from his apprenticeship to the topographical watercolourist Edward Dayes to his premature death, he introduced a new and personal response to landscape painting.

An early project was working for the wealthy amateur antiquarian James Moore, illustrating volumes titled *Monastic Remains and Ancient Castles in England and Wales*. Moore travelled around the country making rather inept but accurate sketches and then employed professional artists such as Girtin to make watercolours suitable for engraving. It may be that Girtin accompanied Moore on one of his tours. He made his own first independent tour, to Scotland and the north of England, in 1796. In 1797 he toured the south-west counties of England, and in 1798 he visited north Wales. It must have been during the 1796 tour of the north that he visited Rievaulx, the colossal and magnificent ruined abbey in Yorkshire.

Girtin, like so many painters of the 'Romantic' period, was greatly attracted to ruined abbeys and castles. In this composition the sky and the foreground foliage serve to concentrate our attention on the beauties of the abbey itself. The tree on the left, for example, is bowed to the ground to give us a clear view of the three soaring lancet windows. Girtin, like Turner, renders the architectural details in an accurate but lively manner and bathes the building in a subtle light. The figure examining the building on the right introduces the human element and prevents the work being mere topography.

The watercolour was previously in the collection of the painter C.R. Leslie.

24. *(overleaf)* THOMAS GIRTIN (1775–1802)

Kirkstall Abbey, Yorkshire: Evening, 1800/1801

31.7 x 52 cm. Purchased 1885. 405-1885

This is one of the most famous and beautiful of British watercolours. Rather than a drawing washed with colours, this exploits the full possibilities of the watercolour medium. Girtin used – with apparent simplicity – washes of overlapping colours and small strokes of denser pigment. To describe it as a 'late' work is absurd, as the artist was only 25 years old, but it shows Girtin at the summit of his powers.

The soft light of early evening, and the consequently tranquil atmosphere, are wonderfully achieved. The band of light across the horizon silhouettes and enhances the majestic tower of the abbey and is reflected in the horizontals of the perimeter of the foreground field and the bank of the river. The silent remoteness of the abbey is emphasised by the activity in the foreground: while the cattle lie in the meadow, two figures stroll towards the gate, and another approaches them across the field. The whole effect avoids the artificiality which many such compositions convey. There are no *coulisses* (literally the wings of a stage) to frame the image of the abbey. Instead, the horizon stretches uninterrupted from left to right, broken only by the towers of the abbey itself.

Kirkstall, its abbey and village, seem to have been a favourite subject for Girtin, as he painted it several times.

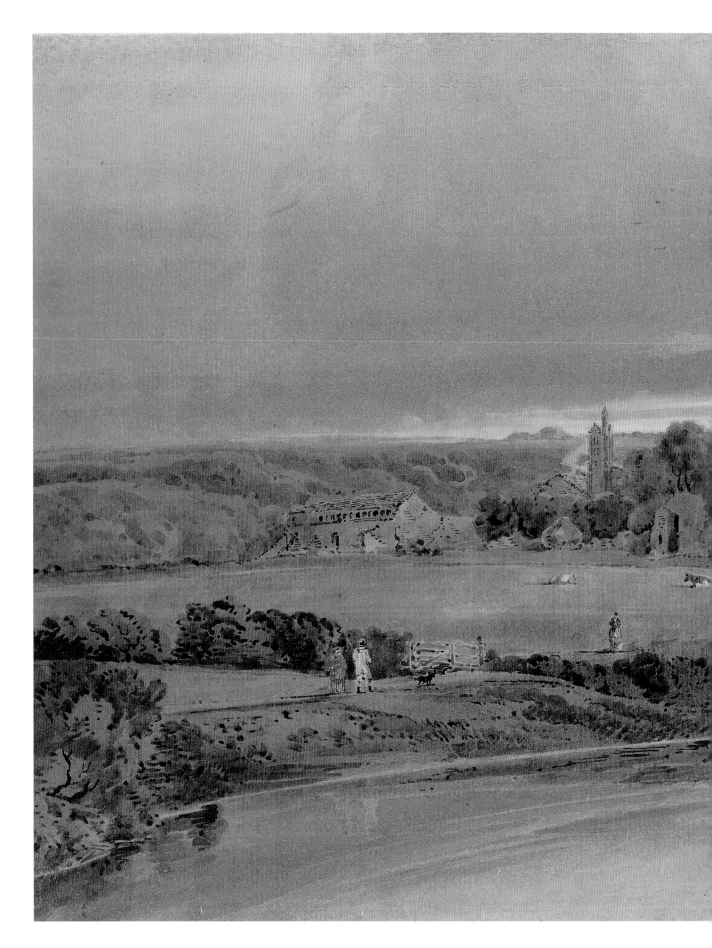

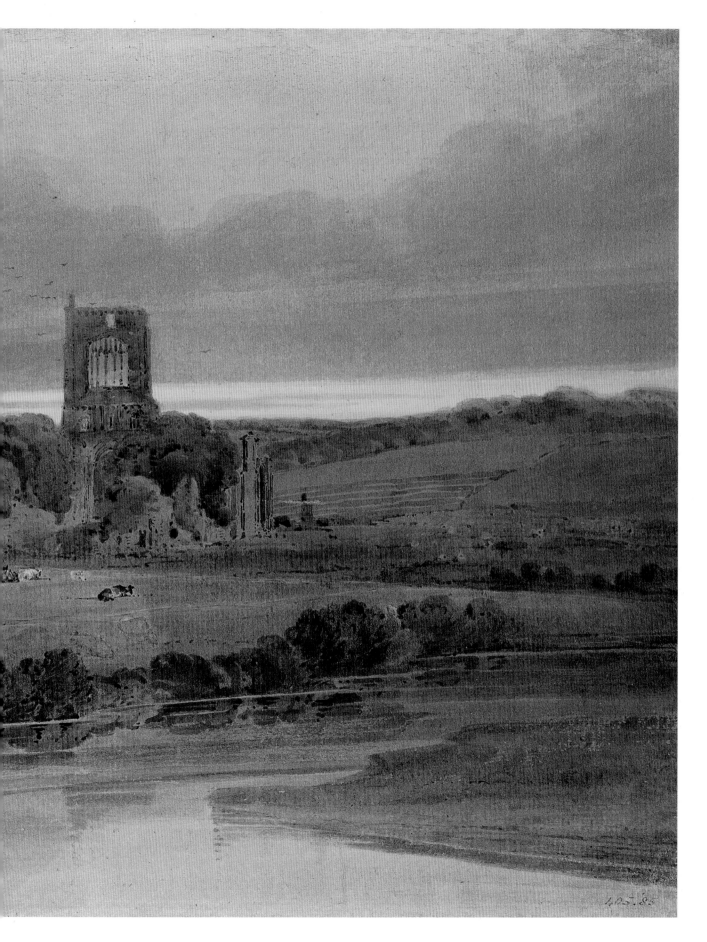

25. JOHN WHITE ABBOTT (1763–1851)

View near Canonteign, Devon, 1803

Signed and dated (on the back) *Canonteign, Devon. J W A Octr.5 1803.*
59.6 x 54.7 cm. Purchased (from a descendant of the artist) 1924. P.56-1924

Abbott, like most of his contemporaries, had ambitions as a painter in oils, more respected as a medium at the Royal Academy. Although he did exhibit landscapes in oil at the Academy, he is known today only for his watercolours, almost all of which are scenes in Devon. Abbott was born and spent all his life in Devon. Apart from a sketching tour in 1791 to Scotland, the Lake District and Lancashire, he rarely travelled far from home. Once he had achieved mastery in the medium, the style of his watercolours did not change, and his *oeuvre* is of a consistently high quality and was for many years a favourite of collectors.

Like Francis Towne (plates 12 and 13), whose early work he seems to have imitated, Abbott used pale washes of colour over a pen or pencil outline. His most impressive achievements are, as here, the detailed studies of interesting trees or dense woodland. Closely observed, his trees and rocks are rendered with the pen in delicate, short hook-shaped strokes, giving a calligraphic effect. This technique lends his drawings great charm and vivacity. But the more striking element in his work is his use of watercolour. *Canonteign* is gently coloured with pale lemon, green and blue. These colours give the effects of light and shadow, the brilliant diagonal shaft of sunlight in the foreground set in dramatic contrast behind the dark rocks and foliage on the right.

The watercolour is painted, like many of his large drawings, on six separate sheets laid down on one piece of Whatman paper. This is evidence that the drawing was done on the spot, the watercolour almost certainly being applied later in the studio.

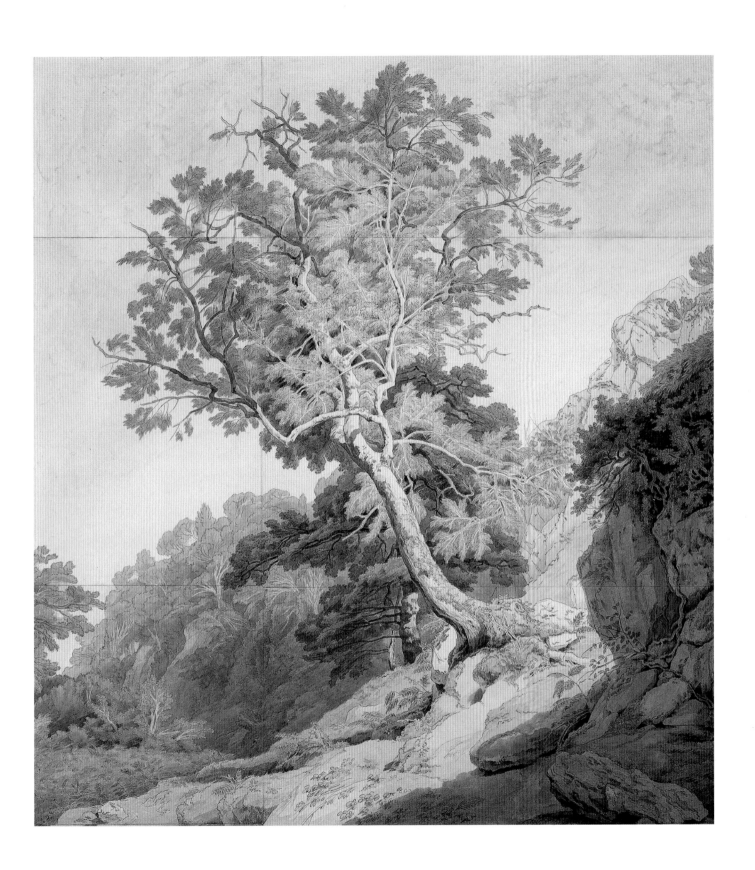

26. EDWARD FRANCIS BURNEY (1760–1848)

An Elegant Establishment for Young Ladies, c.1805

50.2 x 72.7 cm. Given by Thomas Agnew and Sons, 1930. P.50-1930

This famous caricature shows women's education reduced to the level of lessons in deportment and dress, music and dance, an education that is both superficial and self-indulgent. The artist implies that these were the only accomplishments thought necessary for a 'career' of marriage and motherhood. Indeed one girl, the finished product of such schooling, is seen through the window in the act of eloping with her suitor (though, as we know from the case of the impetuous Lydia in Jane Austen's *Pride and Prejudice,* elopement did not necessarily result in marriage).

Although the watercolour has the quality of a caricature, it only slightly exaggerates the barbarous physical constrictions and distortions imposed on young girls and women in the name of fashion and femininity. The tendency to fainting, general weakness and frailty, so prevalent among girls in the nineteeth century, was largely the result of constrictive clothing. There are documented cases of girls dying, or at least being disabled, by having their internal organs crushed by too-tight corsets. Burney achieves here a remarkable combination of a serious theme and a humorous intent.

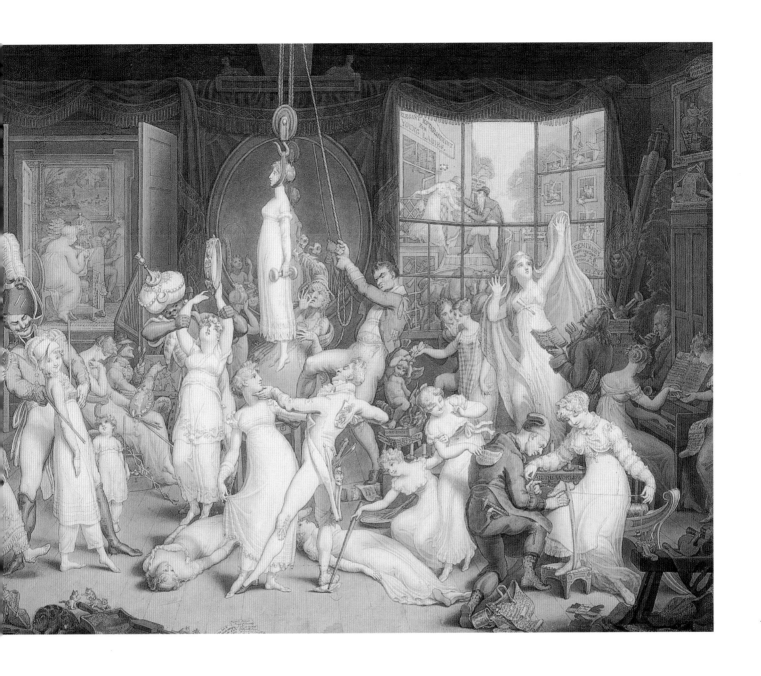

27. JOHN SELL COTMAN (1782–1842)

Chirk Aqueduct, 1806/1807?

31.7 x 23.2 cm. Purchased 1892. 115-1892

This is one of the most famous and beautiful of Cotman's watercolours, and its making is shrouded in mystery. The Chirk Aqueduct, over the Ceiriog Valley near Llangollen in Wales, was designed and built by the great engineer Thomas Telford between 1796 and 1801. But despite the fact that Cotman visited Wales on two occasions, in 1800 and 1802, there is no evidence that he went to Chirk and saw the aqueduct. Cotman's depiction of the structure is inaccurate, and it may well be that he adapted the image of a Roman aqueduct, perhaps from an engraving, and invented the background landscape.

After moving from his native Norfolk to London, for a conventional training at the private school of art conducted by Dr Monro, he returned to Norwich in 1806 and within a few years was elected the president of the Norwich Society of Artists. But such watercolours as *Chirk Aqueduct* are quite different from any work by his contemporaries, and he seems to have been ignored in the wider public and critical art world. After his death, for example, there was no published obituary in a national or local newspaper.

His watercolours are quite extraordinary. He translates the image of the aqueduct and its reflection in the river into an abstract composition of flat shapes and softly resonant colours. Try looking at the image upside-down: the representation of a specific location is lost, but the visual appeal of the watercolour survives. The splashes of watercolour on the bridge, the lively delineation of the fences, and the blotches of paint that express the foliage, are so fresh that it is hard to believe the painting is nearly 200 years old.

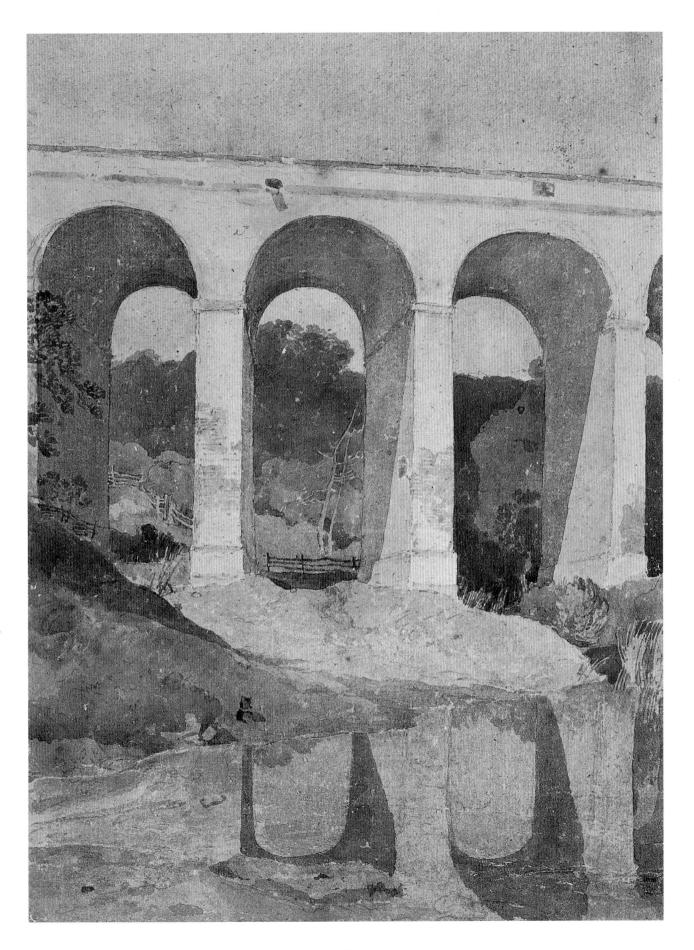

28. JOHN CROME (1768–1821)

Landscape with Cottages, date unknown

52 x 42.3 cm. Purchased 1877. 620-1877

The artist was born in Norwich and began his career as an apprentice to a painter of houses, coaches, carriage-panels and inn-signs and later became an independent drawing-master. But at the same time he copied landscape paintings, the work of old masters such as Hobbema and of modern British artists such as Richard Wilson, which were in a local collection. This gave him the ambition that resulted in the establishment in 1803 of the Norwich Society of Artists and the Norwich School. He became its president in 1808.

As with Constable, Crome's subjects were parochial, limited to the area around Norwich: the woods, the cottages, the lanes, the open heaths and – of course – the changing skies. He painted mainly in oils, exhibited at the Royal Academy as well as in Norwich and rarely worked in watercolour. But works such as this are accomplished and share some of the qualities of the oils: a sense of light and space, with subtle colours, especially cream, pale orange and light brown, often gives the effect of glowing autumnal sunshine rather than a bright and clear spring atmosphere. It is sometimes suggested that this golden tonality is due to the fading of the colours and the paper beneath over the years, and this may be so in a few cases, but not in this painting.

This is generally considered the finest of his watercolours. The lights and shadows are rendered in a most harmonious and lively manner, and the mood of the painting is affecting, the small figure with her basket perhaps approaching her home. The watercolour previously belonged to the writer on British art, Samuel Redgrave.

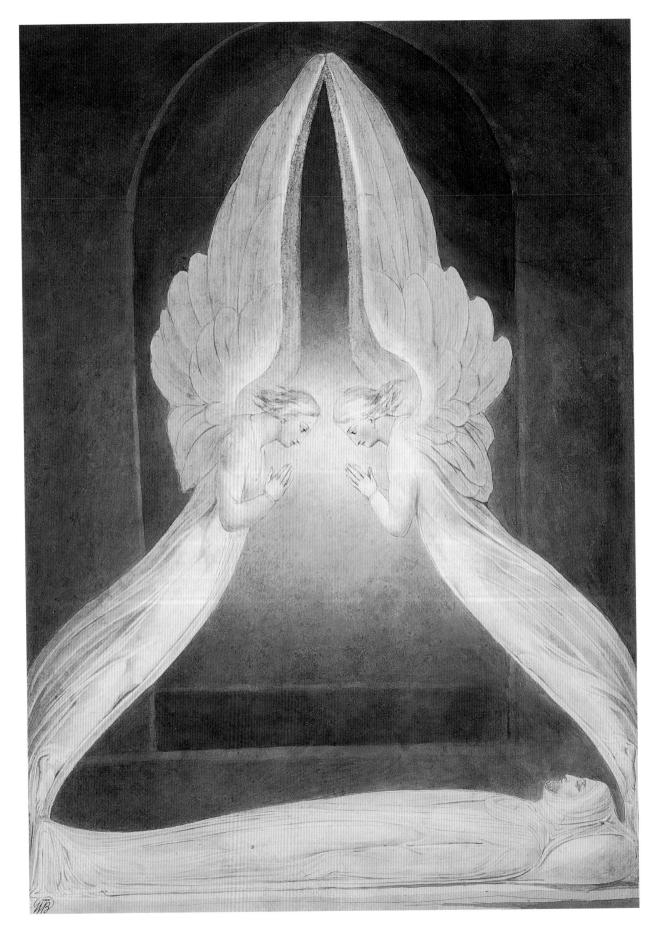

The Angels hovering over Jesus in the Sepulchre, c.1805

Signed *WB inv* and inscribed *Exod: C xxv. v.20.*
42.2 x 31.4 cm. Given by the heirs of Esmond Morse, 1972. P.6-1972

Thomas Butts, Blake's principal and most loyal patron, commissioned him to make some 80 watercolours of subjects from the Bible. As with the Milton subjects (plate 30), Blake presents a very unusual interpretation of a familiar subject. Instead of illustrating the passage from the Gospels of the New Testament describing Christ in the sepulchre, Blake refers to the prefiguration of the story related in the second book of the Old Testament, the Book of Exodus. The verse reads:

> And the cherubims shall stretch forth their wings on high, covering the mercy seat with their wings, and their faces shall look one to another; towards the mercy seat shall the faces of the cherubims be.

There has to be a connection between this image and the New Testament Gospel of St John (chapter 20, verses 11–12):

> But Mary [Magdalene] stood without at the sepulchre weeping: and as she wept, she stooped down, and looked into the sepulchre.
> And seeth two angels in white sitting, one at the head, and the other at the feet, where the body of Jesus had lain.

Blake's translation of the text into visual terms is characteristically unusual and startling. The calligraphic quality of the drawing, the utterly unconventional composition, and the strange light and colours, convey the intense mystery of the event. There is also a feeling of the ancient and hieratic, reminding us that Blake's earliest works, as an apprentice for seven years (1772–1779) to the engraver James Basire, were careful drawings of the medieval tombs in Westminster Abbey. Now, some 30 years later a mature artist, he produced an image, not antiquarian or topographical, but created almost entirely from his extraordinary imagination.

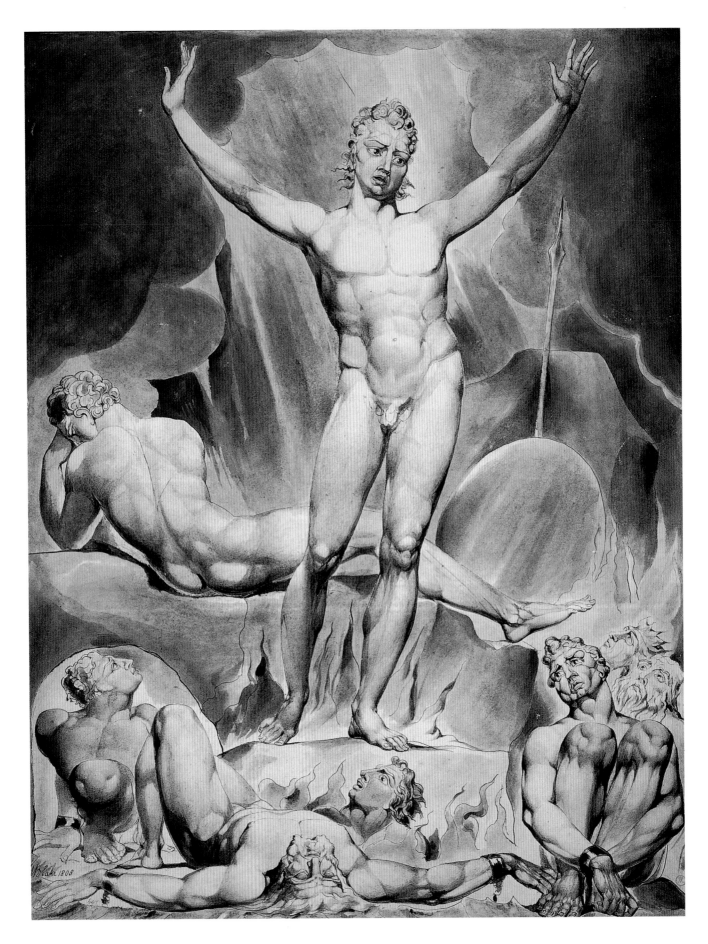

30. WILLIAM BLAKE (1757–1827)

Satan arousing the Rebel Angels, 1808

Signed and dated *W Blake 1808*. 51.8 x 31.2 cm. Purchased 1869. FA 697 (AL 6856)

———————

This illustrates lines 300–304 in Book 1 of John Milton's epic poem *Paradise Lost*, first published in 1667. Blake's subject-matter was always ambitious: he recreated in visual form some of the greatest works of European literature – the Bible, Dante's *Divine Comedy*, the plays of Shakespeare and Milton's greatest work. Blake had begun a series of Miltonic illustrations in 1801 in response to a commission from the Rev. Joseph Thomas for the poem 'Comus', followed by a series of small watercolours for *Paradise Lost* painted in 1807. But Blake's principal patron at this time was Thomas Butts, and the artist produced another *Paradise Lost* series in 1808 for him in a larger format. This watercolour is the first in the latter series.

Blake, inspired by Milton's text, represents Satan and his angel accomplices as beautiful in appearance, based on nude figures from antique sculpture and from Michaelangelo's drawings and paintings. Satan is shown in the pose of a resurrected Christ. This is typical of Blake's re-interpretation of familiar subjects.

The key line from the poem, which could be an alternative title for the watercolour, is 'Awake! arise, or be for ever fallen'. Satan, with the physical beauty that disguises his true evil, combined with his expression of sheer power, dominates the composition and the equally muscular figures of the fallen angels. This begins the story of the fall of man. Expelled from the presence of God and condemned to hell, Satan summons his legions for a conference to discuss their revenge. The climax is when Satan discovers the creation of Adam and Eve, the first human beings, and their existence in the Garden of Eden.

Blake, in a Michaelangelesque manner, unites a tremendous and terrifying subject with great beauty of line and colour.

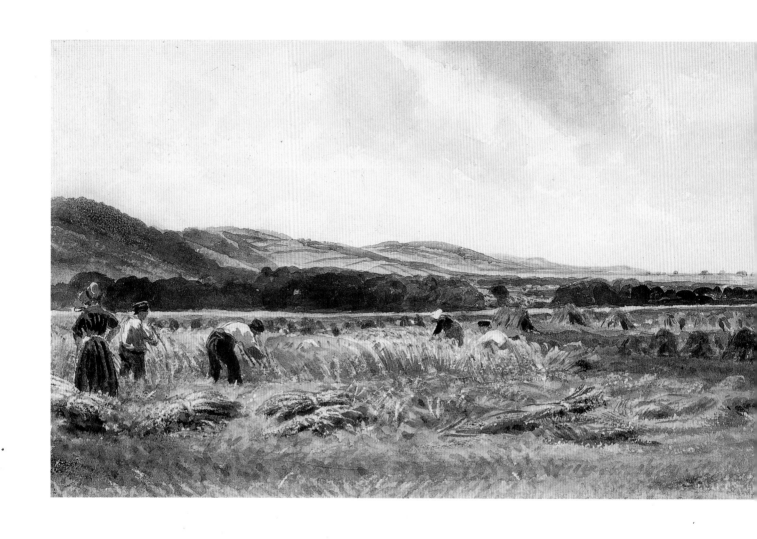

31. PETER DE WINT (1784–1849)

A Harvest Field, date unknown

24.8 x 43.7 cm. Given by the National Art Collections Fund
from the Herbert Powell Bequest. P.16-1968

Unlike most professional watercolourists, De Wint painted a number of works in oils. For some reason, although his watercolours found a ready market, his oil paintings failed to sell. After his death, his dealer was amazed to find in the attic of De Wint's London house what was in effect a private gallery of his unsold oils.

He was born in Staffordshire and moved to London to pursue his career, beginning with an apprenticeship to the eminent engraver J.R. Smith. Like Constable (who much appreciated De Wint's work, a feeling that was reciprocated), he felt that England could provide every landscape for which a painter could wish, although he did travel abroad once, to Normandy. As with so many of his contemporaries, including Turner, he was deeply influenced by the work of Thomas Girtin (plates 23 and 24), but he soon developed his highly individual style, which resulted in his becoming and remaining one of the most admired and prolific watercolourists, exhibiting over 400 works at the Old Watercolour Society alone.

His technique was quite different from that of the tinted drawings of the eighteenth century. With a brush heavily loaded with pigment, he darts across the usually roughly textured paper to give an immediate and sparkling effect. This watercolour demonstrates this technique and also two other bases of his art: his love of determinedly horizontal, panoramic compositions and his choice of the harvest as a subject. The wide expanses of the hay and cornfields of England, the horizon only sometimes – as here – broken by gently undulating hills, obviously held a profound appeal for him. Outside the cities the harvest, even well after the Industrial Revolution, was the most important time of the year. Anyone owning or working the land would discover just how much prosperity was theirs until the next harvest.

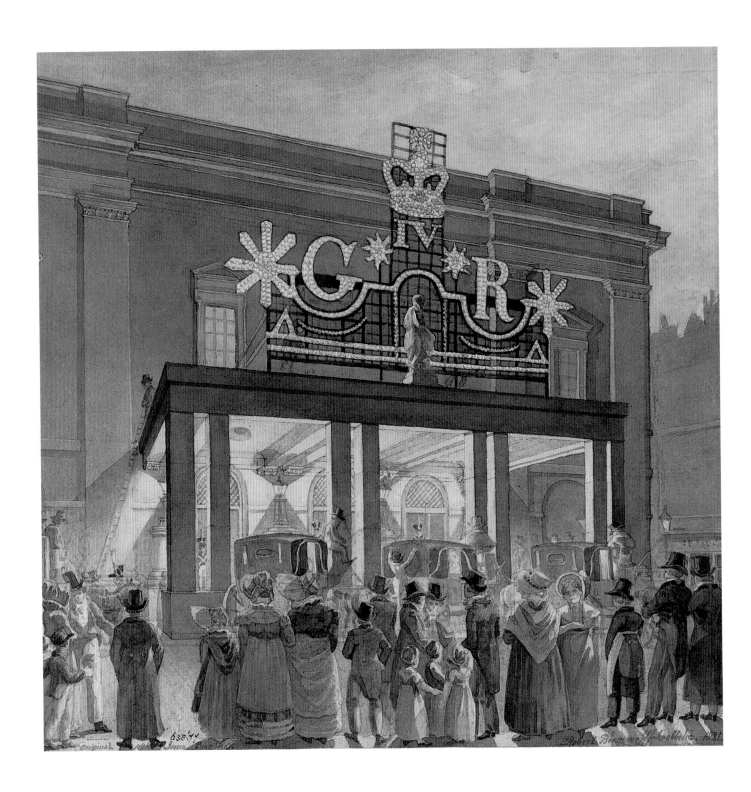

32. ROBERT BLEMMELL SCHNEBBELIE (active from c.1803; d.1849)

The Exterior of Drury Lane Theatre, 1821

Signed and dated *Original 18th June Evening Robert Blemmell Schnebbelie 1821.*
18.7 x 18.7 cm. 638-1877

This remarkable watercolour records the celebrations held at the Drury Lane Theatre on Monday 18 June and the following Monday, 25 June 1821, to commemorate the Battle of Waterloo and the impending coronation of King George IV. The four-hour entertainment consisted of plays, music, a masquerade, refreshments and a ball. The original playbill survives and makes enjoyable reading today. There was opera, involving the famous Madame Vestris, two comic songs by Mr Knight, a Monsieur Esbrayat (advertised as being a model at the Royal Academy) giving a weight-lifting act in which he carried a man in each hand around the stage, the display of a painting measuring 10,000 square feet, thousands of 'variegated lamps', and 'magic and recreative philosophy' by Monsieur Chalons.

Schnebbelie was the son of a topographical draughtsman, and at the Royal Academy between 1803 and 1821 he exhibited mainly architectural views, such as those of the Guildhall Chapel and the almshouses at Hackney in the V&A collection. But the Drury Lane Theatre seems to be his masterpiece; capturing the glamorous 'first night' atmosphere, the swift strokes of his brush record the preparations in the foyer and the anticipation of the audience in the foreground.

33. RICHARD PARKES BONINGTON (1802–1828)

The Corso Sant'Anastasia, Verona, with the Palace of Prince Maffei, 1826

Signed and dated *R P B 1826*.
23.5 x 15.9 cm. Bequeathed by William Smith, 1876. 3047-1876

———————

The Bonington family moved from Nottingham to France in 1817. Bonington had already established himself as an artist in England, but it was in Paris that he flourished, using the medium of watercolour in an original way which was greatly influential both in Britain and in continental Europe. His fresh and sketch-like approach to watercolour was noticed and admired during his short – really only eight years – working life. The only adverse criticism was that his watercolours appeared unfinished, but this quality became more and more appreciated, particularly by artists in France such as Delacroix, who was a friend of Bonington's and seems to have learnt much from him.

In April 1826 Bonington left Paris to visit Venice. His companion was the Baron Rivet, who kept a journal that supplies us with the details of their tour. *En route* the weather in Switzerland was especially bad: Rivet wrote that Bonington was 'in a dismal mood. He ought always to have someone with him to make him laugh'. It may be that the tuberculosis, which was the cause of his early death, was already having an effect. They were in Verona on 18 April, where Bonington made several drawings to be worked up later into finished watercolours. This watercolour, showing the grand Palazzo Maffei on the right, was also later translated into an oil painting.

His technique in this watercolour is characteristic. Considering the work was created from an earlier pencil composition rather than in front of the actual scene, the liveliness of the drawing, the vivacity of the figures and the brilliant colours, emphasised by the dark shadows in such a narrow street, are remarkable.

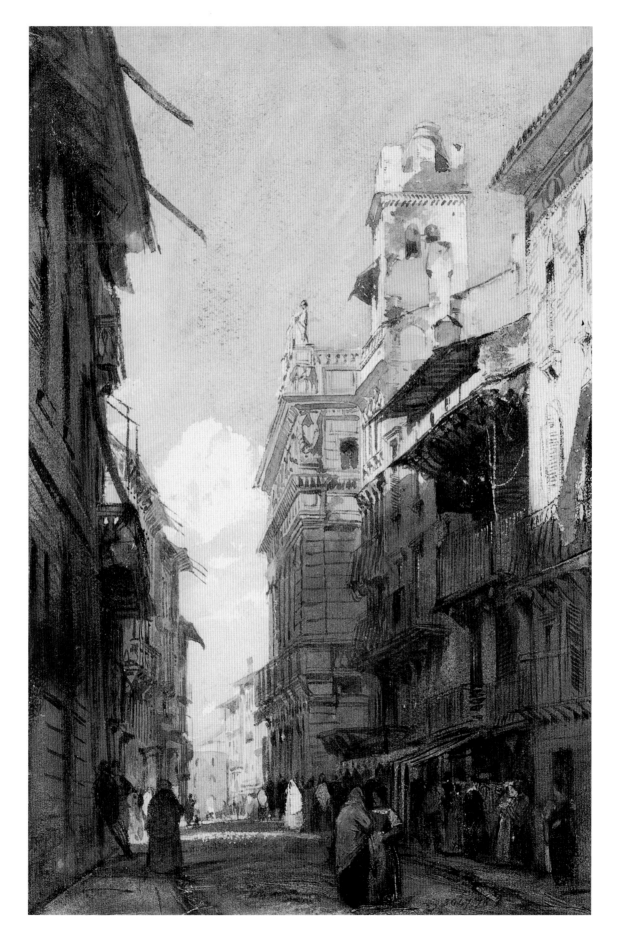

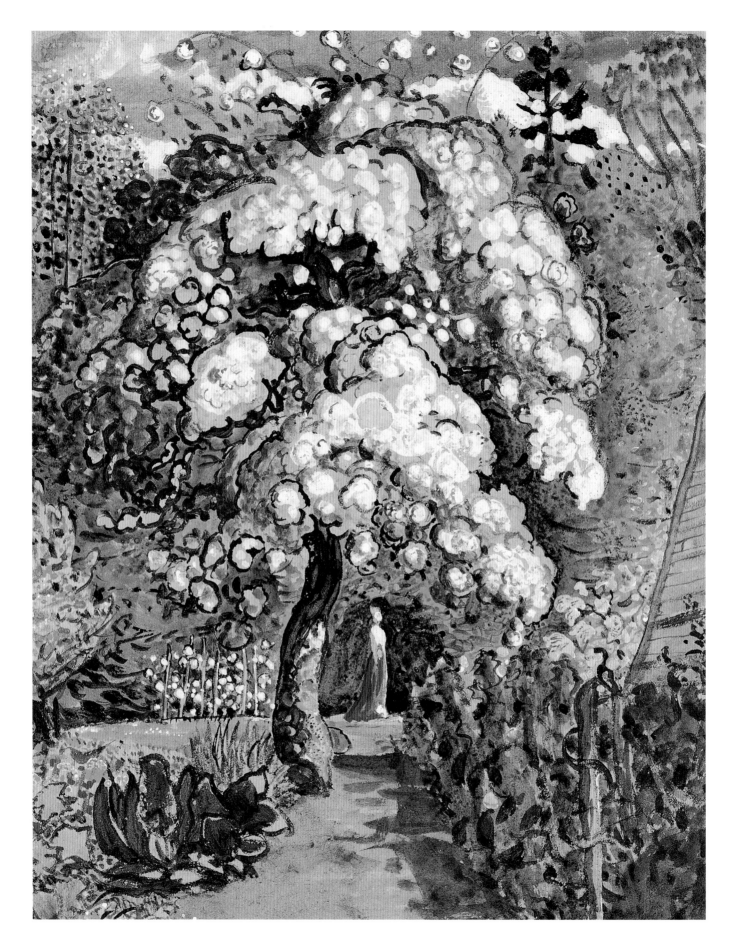

34. SAMUEL PALMER (1805–1881)

In a Shoreham Garden, c.1829

28.3 x 22.3 cm. Purchased from A.H. Palmer, the artist's son, 1926. P.32-1926

———————————

The artist was largely self-taught and extremely precocious; he first exhibited at the Royal Academy summer exhibition in 1819. At the age of sixteen he became friends with the painter John Linnell (whose daughter he was later to marry), who introduced him to William Blake. Blake's charismatic personality seems to have enchanted the young Palmer, who tried to emulate the older artist's visionary approach to painting and his lack of respect for conventional watercolour techniques. He was Blake's most important follower, but restricted his subject-matter to landscape, albeit landscapes endowed with a mysterious, religious, intensity.

This watercolour dates from his 'Shoreham Period', when he resided in that village in Kent between 1826 and about 1834. It is generally regarded as the time of his best work, and although his later watercolours have a special quality of their own, the Shoreham paintings convey a powerful and magical mood. Here Palmer transforms the apple tree in full blossom, which dominates the sheet with its exaggerated forms and dazzling colours, into a rapturous image, its dream-like atmosphere enhanced by the single figure in the centre of the composition.

35. SAMUEL PALMER (1805–1881)

Landscape with a Barn, Shoreham, Kent, c.1828?

Signed *Saml. Palmer fect.* 27.8 x 45 cm. Purchased 1937. P.88-1937

————————

Like plate 34, this watercolour belongs to Palmer's famous 'Shoreham Period'. Inspired by William Blake from their first meeting, when Palmer was nineteen years old, he interpreted even the humblest scenes, such as in this watercolour, with an elevated passion. In one of his sketchbooks, in 1825, he wrote about Blake's woodcuts of scenes illustrating *The Pastorals of Virgil* (first published in 1812, by Robert Thornton, who was John Linnell's doctor as well as a writer), noting that:

> There is in all such a mystic and dreamy glimmer as penetrates and kindles the innermost soul, and gives complete and unreserved delight, unlike the gaudy daylight of this world.

His words could be applied to his own paintings.

He called Shoreham his 'valley of vision', and it is evident in this drawing to what a tremendous extent Palmer was visually and emotionally involved with this Kent countryside. This is a lane one would love to walk down, entering a different world, Palmer's own world. From the old gnarled tree in the foreground, past the moss-covered thatched barn sheltering the carts and barrows, into the little areas of shade afforded by the short avenue of trees flanking the path, we reach the gate, through which we glimpse the path curving into the distance.

The painting originally belonged to Herbert Linnell, the son of Palmer's great friend, the artist John Linnell.

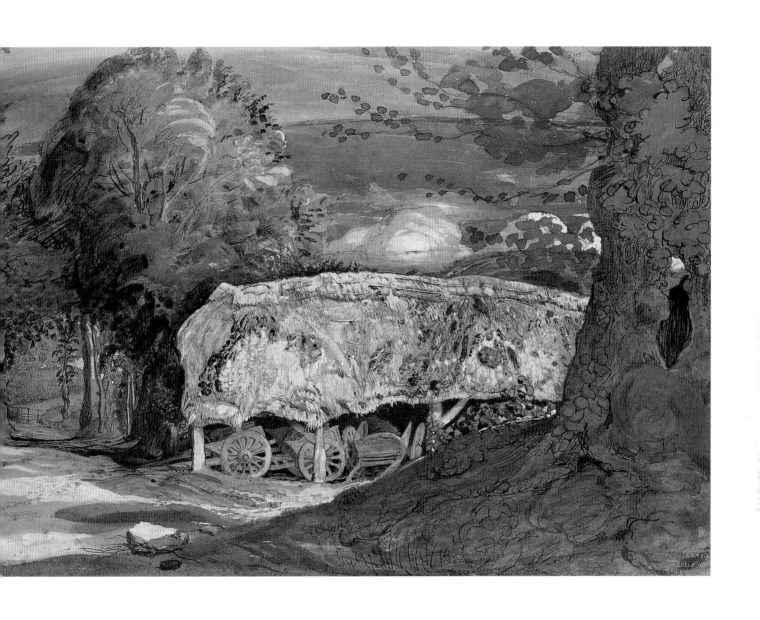

36. *(right)* WILLIAM ANDREWS NESFIELD O.W.S. (1793–1881)

Bamborough Castle, Northumberland, prob. 1832

Signed *W.A. Nesfield*. 53 x 70.2 cm. Ellison Gift 1873. FA 536

Like so many of the greatest British watercolourists, Nesfield had a very unconventional background. He was at school at Winchester, an undergraduate at Trinity College, Cambridge, before entering the army and serving in the Peninsular War and in Canada. As a watercolourist he was most famous in his own day for his representation of water itself, perhaps the most difficult element to paint in any medium, and he was particularly admired for his depictions of waterfalls and cascades. In the second volume of his *Modern Painters*, the art critic John Ruskin (plate 51) referred to 'Nesfield of the radiant cataract'.

Here Nesfield shows us the crashing waves on the coast of Northumberland, which we can almost hear, with the castle framed in the background against a stormy sky. He exhibited at the Old Watercolour Society, of which he was elected a member in 1823, over a period of nearly 30 years: this painting was probably the work shown there in 1832. He belonged to a younger generation that was experimenting with the watercolour medium and challenging the preconceptions of stereotypical late eighteenth-century images of landscape.

In this watercolour Nesfield was clearly influenced by the verve and daring of Turner's work. While he only approaches Turner's depth of feeling for the land and sea, and their relationship, Nesfield made an individual contribution to landscape painting. He also made a contribution to the landscape itself; he became a keen landscape gardener, working on the design of parks in London and the gardens at Kew.

37. *(overleaf)* MARY ELLEN BEST (1809–1891)

The Kitchen at Elmswell Hall, York, 1834

Signed and dated *Mary Ellen Best May 1834*.
25.4 x 35.6 cm. Purchased at the artist's great-granddaughter's sale, 1983. P.11-1983

In the nineteenth century Best was in the great tradition of amateur artists and seems to have specialised in domestic interiors. Each of her pictures is dense with telling detail. This comfortable farmhouse kitchen has as its focus the female labour that constructs and shapes it. To the left hang newly washed clothes; cups, dishes and a tea-pot are set out for a meal on a low table, whilst the woman herself attends to the baby's cot resting on a chair. The furniture is polished, the crockery is neatly ranged on the dresser; all is clean, neat and ordered, a paradigm of working-class domestic respectability. Not only is the subject remarkable in its innocent and accurate recording of an ordinary interior scene; the artist's treatment of pigment and lovingly close attention to detail is far from being amateur or naive.

The watercolour, accomplished in technique and rich in atmosphere, strikingly contrasts with the interior painted by another woman amateur, Ellen Clacy (plate 74).

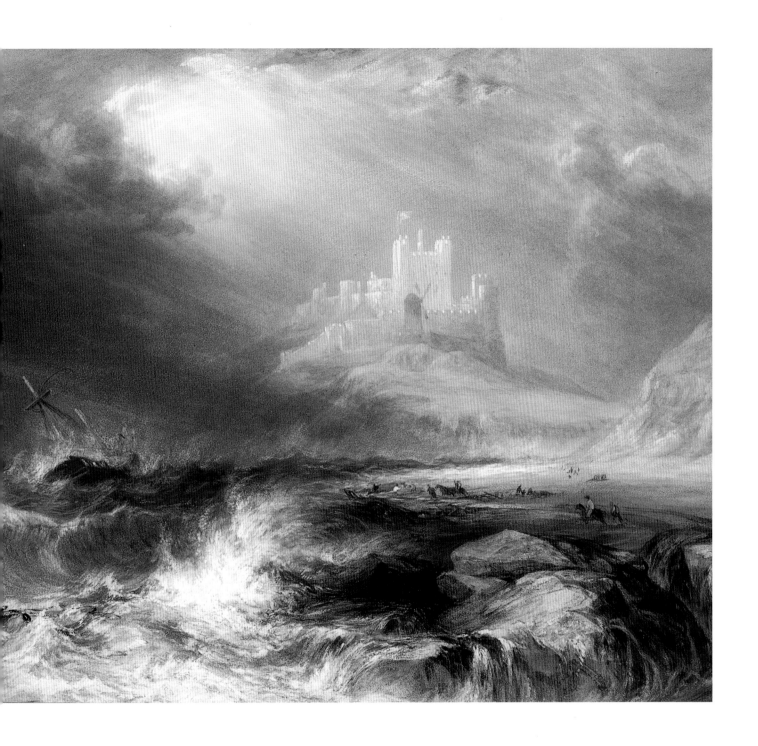

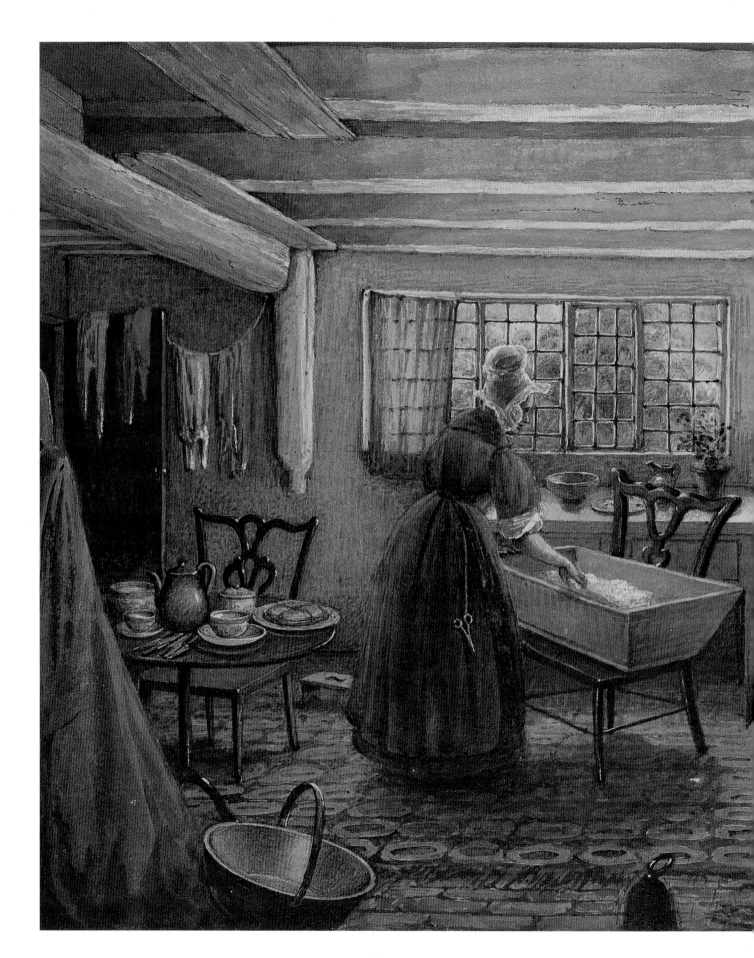

38. THOMAS SHOTTER BOYS (1803–1874)

The Pont Neuf, Paris, 1833

Signed and dated *Thos. Boys. Paris – 1833.* 38.4 x 75 cm. Purchased 1922. P.25-1922

Boys trained as an engraver, but then studied lithography – a newly invented and more immediate printing technique – with Bonington in Paris, probably from 1823, when he was twenty years old. This latter experience was evidently decisive, as he aimed to emulate Bonington's dazzling work in watercolour. Just as Turner mourned but profited by Girtin's early death, so must Boys have felt about Bonington. He exhibited for nearly 50 years at the New Watercolour Society and elsewhere in London, showing principally

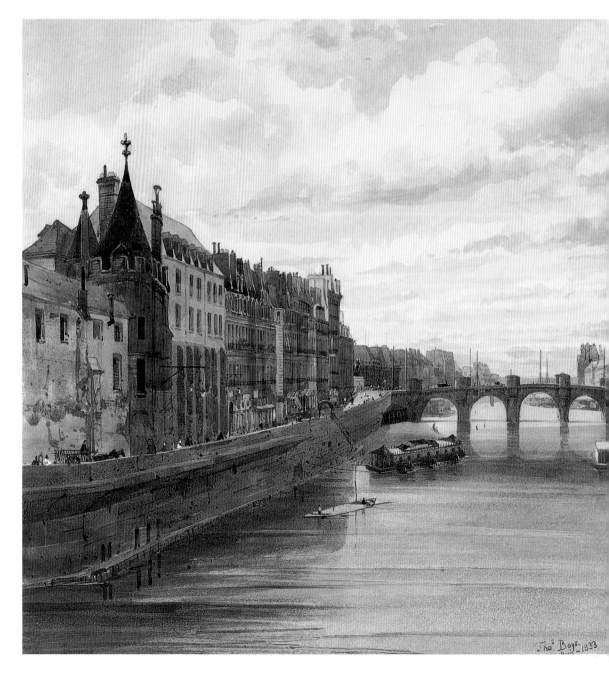

architectural views. These views are topographical, in that they depict with some accuracy the appearance of the place, but following Bonington the simple depiction of a building in its setting was not enough to satisfy his aesthetic intentions.

Famous today as a lithographer, he published his masterpiece, *London as it is*, in 26 magnificent plates in 1842. However his early watercolours of Paris are the most admired of his works today. With their radiant luminosity, which is equal to if not transcending the work of his mentor Bonington, watercolours such as this example present him among the greatest painters in the medium. He achieves here a perfect balance between the buildings huddled together on both banks of the Seine and linked by the great arch of the bridge, the pattern of canopies protecting the shop windows and the market stalls from the sun, the slow moving river with the shafts of light emphasising the horizontal format of the composition, and the dramatic sky.

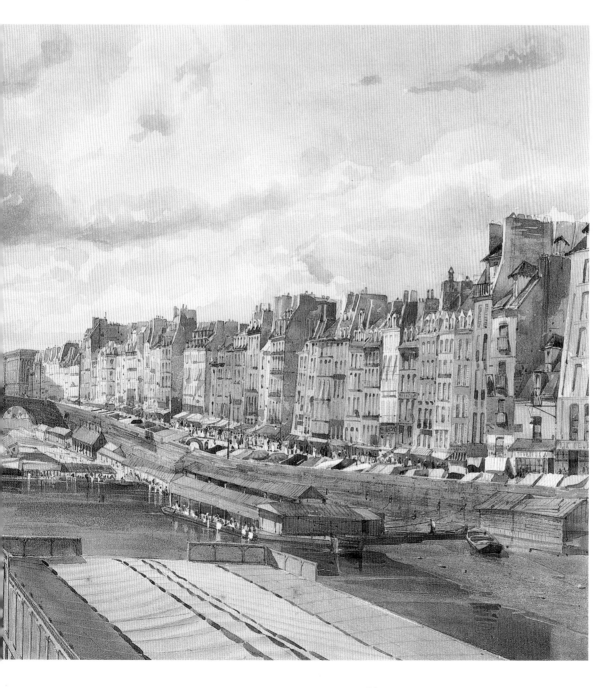

39. *(overleaf)* JOHN CONSTABLE R.A. (1776–1837)

Old Sarum, 1834

Exhibited at the Royal Academy, 1834. 30 x 48.7 cm.
Bequeathed by Isabel Constable, the artist's daughter, 1888. 1628–1888

Constable's closest friend was John Fisher, the nephew of the bishop of Salisbury. He visited the Fisher family on various occasions, first in 1811, then in 1820, 1821, 1823 and 1829. He made many drawings and watercolours of Salisbury, its great cathedral and the surrounding countryside. His spectacular masterpieces in watercolour depicted the two early sites near Salisbury: Stonehenge (plate 40) and Old Sarum.

This watercolour dates from his last visit to John Fisher in 1829; he made an oil sketch, also now in the V&A collection, and a large drawing dated 20 July which he later worked

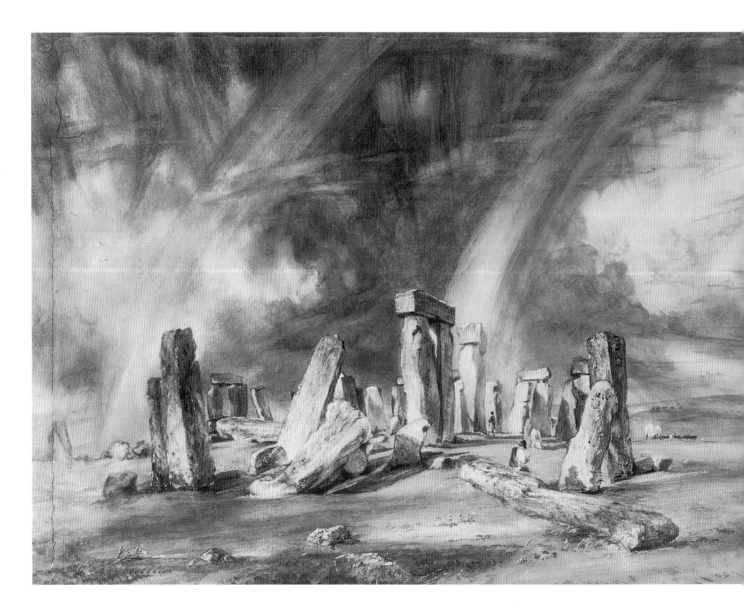

up into this grand painting intended for public exhibition. In the R.A. catalogue, the full title was *The Mound of the City of Old Sarum, from the south.*

The city of Old Sarum had fallen into decay by the sixteenth century and was of great interest to painters during the 'picturesque' period of the late eighteenth century and the 'Romantic' movement of the early nineteenth century. In many ways Constable belonged to the latter group, and this image of a once great city aroused his imagination. The composition was used for one of the mezzotints in his *English Landscape Scenery*, published in parts in the early 1830s, and Constable composed the accompanying text:

> We naturally look to the grander phenomena of Nature … sudden and abrupt appearances of light, thunder clouds, wild autumnal evenings, solemn and shadowy twilights … with variously tinted clouds, dark, cold and gray, or ruddy and bright, with transitory gleams of light … to heighten, if possible, the sentiment which belongs to a subject so awful and impressive.

40. *(left)* JOHN CONSTABLE R.A. (1776–1837)

Stonehenge, 1835

Exhibited at the Royal Academy, 1836. 38.7 x 59.1 cm.
Bequeathed by Isabel Constable, the artist's daughter, 1888. 1629-1888

After the artist had finished this watercolour, on 14 September 1835, he wrote to his friend and biographer, the painter C.R. Leslie, that he had 'made a beautiful drawing of Stonehenge; I venture to use such an expression to you'. The subject had fascinated Constable since his first visit to the historic site near Salisbury in 1820 with his friend John Fisher. Even today Stonehenge, despite its dismal modern tourist surroundings and the prohibition of close proximity to the strange standing stones, is impressive. For Constable, able to inspect the stones and their quasi-magical setting on the Salisbury Plain closely, the experience was unforgettable. This exhibited watercolour forms the climax of his interest. It was a sad time of his life: both his wife, Maria, and his closest friend, Fisher, had died, and his two eldest sons had left home.

He is perhaps expressing this personal unhappiness in the watercolour. The elemental quality of the stones and their dilapidation are exaggerated; they look more like a savage act of nature than the construction of man. The stones dwarf the figures of the few visitors looking at the site and pondering its significance, and the richly coloured sky is dominated by a glorious double rainbow. Constable had also written to the mezzotinter of his *English Landscape Scenery*, David Lucas, on 6 September 1835 that he was 'very busy with rainbows – and very happy doing them'.

In the 1836 Royal Academy Summer Exhibition catalogue, Constable appended the following lines to the simple title *Stonehenge*, which he probably composed himself:

> The mysterious monument of Stonehenge, standing remote on a bare and boundless heath, as much unconnected with the events of past ages as it is with the uses of the present, carries you back beyond all historical records into the obscurity of a totally unknown period.

41. JOHN CONSTABLE R.A. (1776–1837)

A Suffolk Child, prob. c.1835

18.5 x 13.7 cm. Bequeathed by Isabel Constable, the artist's daughter, 1888. 600-1888

———————

This is a figure study for the large oil painting *The Valley Farm*, exhibited at the Royal Academy in 1835 and now in the Tate Gallery. In the painting the figure is reversed and transformed from a young girl into an older countrywoman seated in a boat.

Having studied life-drawing at the Royal Academy early in his career, he made very few drawings of the human figure apart from those in the small sketchbooks. They were almost all intended for use in a projected oil painting for exhibition. This watercolour has a considerable amount of charm in its own right: the child looks up somewhat anxiously, her face cleverly framed by her bonnet, while she clutches what is presumably a small basket. The appeal of the image is made even greater by the fact that there is no indication of a landscape background, so our complete attention is focused on the girl herself.

Constable made a pencil tracing of the watercolour on the back of the sheet, in slightly more detail, to use for the oil painting. The title was perhaps the name used by the Constable family; it is written on the back of a later piece of card on to which the drawing was mounted.

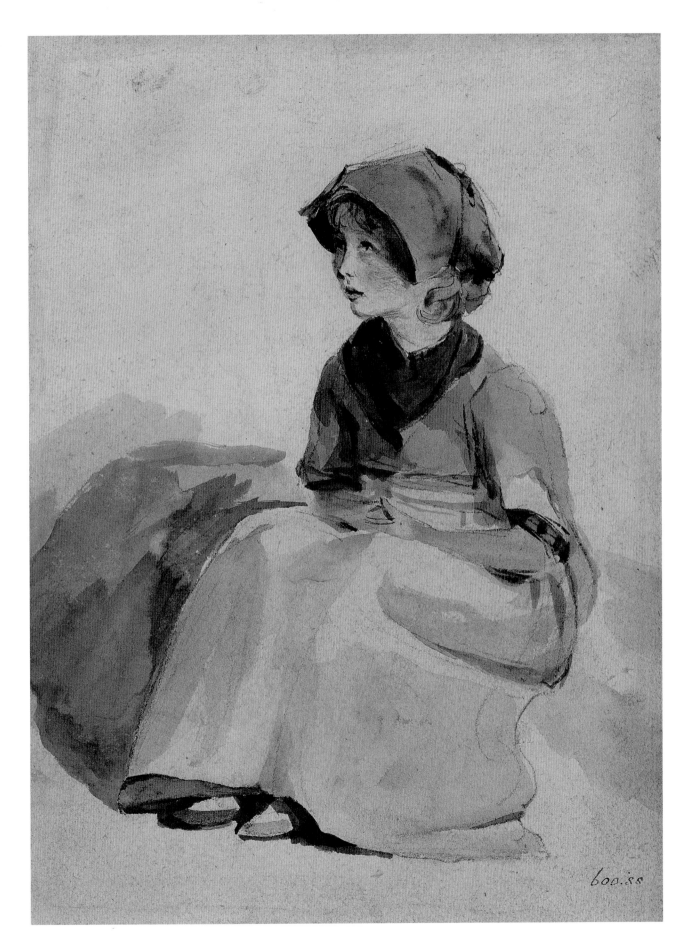

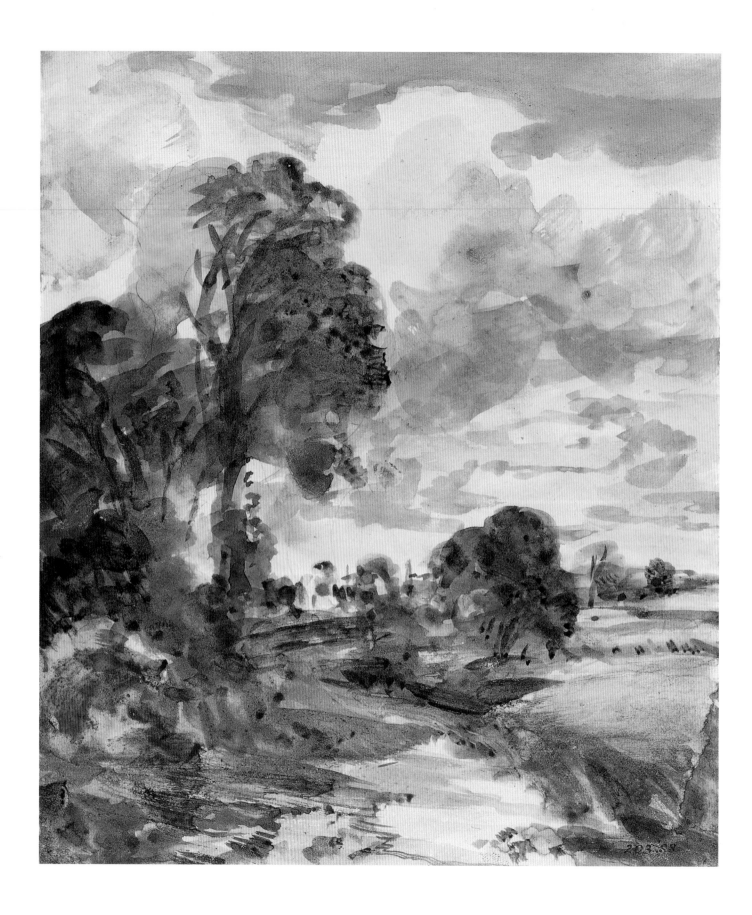

42. JOHN CONSTABLE R.A. (1776–1837)

Landscape Study: A Country Lane, c.1836

21.3 x 18.3 cm. Bequeathed by Isabel Constable, the artist's daughter, 1888. 203-1888

The location of this scene has never been convincingly identified, but it is a composition that Constable painted with various adaptations several times. For example, it is similar in some ways to the great exhibited oil painting *The Cornfield* of 1826, now in London's National Gallery, and almost identical to the so-called (incorrectly) *Stoke-by-Nayland* oil sketch of 1816 in the private collection of Mr and Mrs David Thomson. It is certainly a late watercolour, most probably painted in the year before Constable's death. Its ravishing colours and freedom of handling are remarkable, even for Constable. Over a rapid pencil sketch, his brush, loaded with very liquid watercolour, dances through the foliage and fields, and – especially – across the sky.

It is interesting that many commentators have discussed the later watercolours in the context of the personal sadness of his last years, which resulted in black moods, citing in particular the savage drawings in brush and dark sepia paint of the mid-1830s. But this watercolour has a rhapsodic and optimistic mood that is utterly different from the darkness of the works in sepia. Once again, at the end of his life, Constable has returned to his beloved Suffolk, to the Stour Valley with its river, streams, villages and winding lanes, scenes with which he associated the happiness of his boyhood and scenes which, as he wrote, 'made him a painter'.

43. JOSEPH MALLORD WILLIAM TURNER R.A. (1775–1851)

Warkworth Castle, Northumberland, 1799

50.8 x 75 cm. Exhibited at the Royal Academy, 1799. Ellison Gift 1860. FA 547

Turner made a sketching tour in the north of England in 1797; after studying ecclesiastical monuments in Yorkshire, he went further north into Northumberland, drawing the great castles such as Alnwick, Bamborough, Dunstanborough, Norham and Warkworth. This watercolour is based on a drawing in a sketchbook dating from his visit to Warkworth. The castle was built between the twelfth and fifteenth centuries on a curve of the River Cuquet.

By 1797 Turner was painting large and ambitious watercolours, intended not for patrons or for engravers of topographical views but for public exhibition. His aim was to give the same status to the medium of watercolour as that accorded to oil paintings. To the full title given in the Royal Academy exhibition catalogue: *Warkworth Castle, Northumberland – thunderstorm approaching at sunset*, he appended lines from James Thomson's famous and popular poem *The Seasons* (1726–1730):

> Behold slow settling o'er the lurid grove,
> Unusual darkness broods; and growing, gains
> The full possession of the sky; and on yon baleful cloud
> A redd'ning gloom, a magazine of fate,
> Ferment.

The painting was engraved many years later for the *Rivers of England*, published in 1826. It is perhaps an indication of the originality of style evident in this watercolour that Turner felt able to submit it to the engraver rather than to 'update' it.

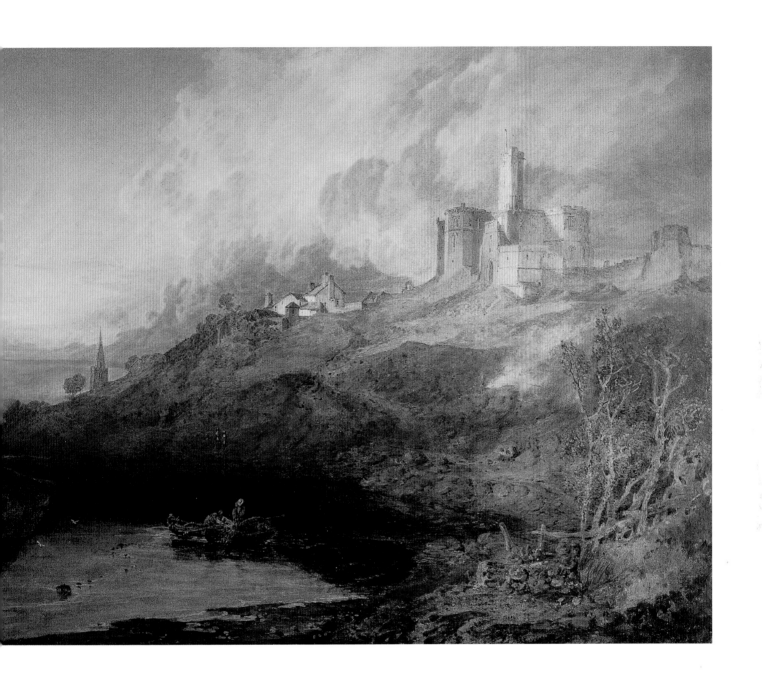

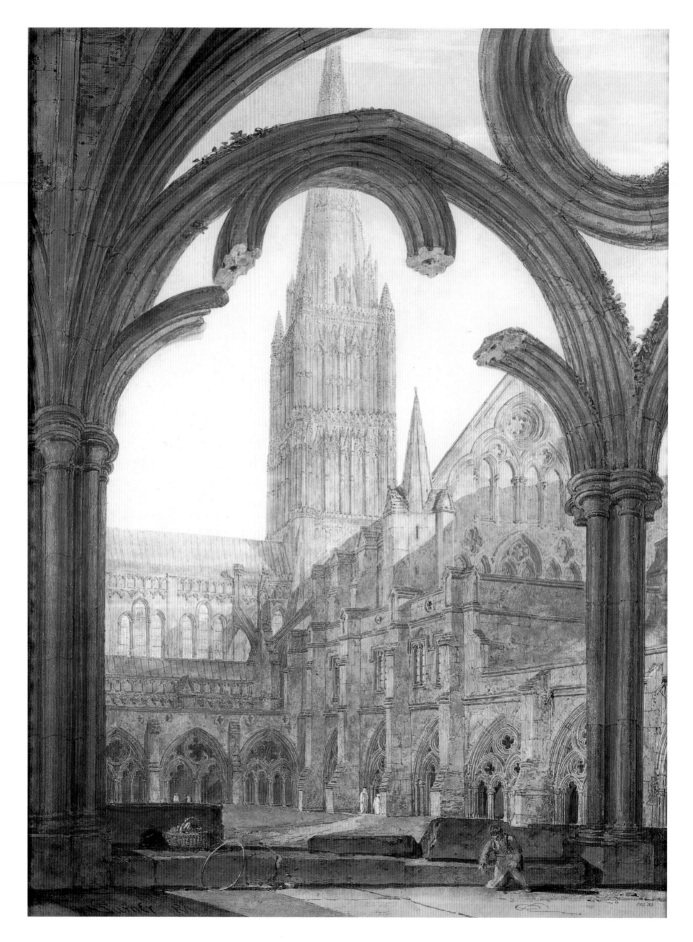

44. JOSEPH MALLORD WILLIAM TURNER R.A. (1775–1851)

South View of Salisbury Cathedral from the Cloister, 1802

Signed by the artist *J.M.W. Turner R.A.* 68 x 49.6 cm. Purchased 1883. 502-1883

Although Constable is more associated and was more intimate with the city and cathedral of Salisbury, Turner's watercolour has a quite different intention from that of Constable's work and gives an equally different effect.

The patron and amateur artist Sir Richard Colt Hoare commissioned Turner to make twenty topographical – that is, in effect, accurate – views of Salisbury, ten of which were to be of the cathedral, for a proposed history of Wiltshire that Hoare was writing. The project was never completed, and the book was never published. This watercolour remained in the Hoare family until their auction sale at Christie's in 1883, when it was purchased by the V&A. Turner made the first drawings during a visit to Hoare's country seat, Stourhead in Wiltshire, in 1795. These preliminary drawings made on the spot were worked up into highly finished watercolours, of which this is one, intended for the use of the engraver to translate them into plates for Hoare's book.

Turner had trained as a topographical artist with the architectural draughtsman Thomas Malton from the age of about fourteen, at the same time as he was studying at the Royal Academy Schools. While Constable had great difficulty with his views of Salisbury Cathedral because of the amount of intricate architectural detail required, Turner seems to have relished the challenge. He always found a view that was unconventional by the standards of the day, such as here, and sometimes introduced a human element that enlivened what would otherwise be a straightforward antiquarian study. Here, a young boy, presumably on his way home from the market with a basket of produce, has been playing with his toy hoop along the open passages of the cloister. Turner has adjusted the distances and perspective for greater visual effect: it is impossible to see exactly this image in reality. But the result is a stunning evocation of this great cathedral seen from an unusual location. His imaginative choice of view is, however, of necessity – given the demands of the commission – combined with a clear delineation of the magnificent stone-carving of the building. Also, he was able subtly to combine enough bright sunshine to reveal the architecture with a dramatic area of shadow that frames the central scene.

45. JOSEPH MALLORD WILLIAM TURNER R.A. (1775–1851)

The Lauerzer See, with the Mythens, later 1840s

36.8 x 54 cm. Henry Vaughan Bequest 1900. 980-1900

This panoramic view is one of Turner's last group of Swiss watercolours and perhaps the most magnificent. Unlike Constable, Turner was a great traveller, making sketching tours in Britain and Europe every summer, and he visited Switzerland several times: in 1802, 1836, 1841, 1842, 1843 and 1844. The watercolour was worked up in the studio, from a smaller one in a sketchbook used in Switzerland in 1843 and from his prodigious visual memory.

Turner seems to have decided to work up small sketchbook watercolours, made on the spot, into larger more finished works after the 1841 tour of Switzerland. He was 64 years old. By this time, his 'late' style was fully developed. The art critic and friend of Turner, John Ruskin (plate 51), recorded a conversation between the artist and his dealer Thomas Griffith concerning the sale of these late Swiss watercolours. Turner questioned the estimate the dealer had proposed (£84 for each work) and Griffiths replied, 'They're a little different from your usual style—but—yes, they are worth more. But I could not get more'.

These late Swiss watercolours are the climax of Turner's astonishing career, along with the late paintings in oil, which share many of the same qualities. The apparent careless application of paint and speed of execution hides the fact that they are carefully – even laboriously – thought out and meticulously worked. Earlier Swiss views had shown the rugged grandeur of the Alps, with terrifyingly vertiginous glaciers, dangerously narrow paths and dilapidated bridges spanning vast chasms. He thought Alpine scenery surpassed anything he had seen in Scotland and Wales. But the 1840s watercolours are radiant, almost dreamlike, and saturated in pure colours. In *The Lauerzer See*, the great land masses and towering white peaks seem to dissolve before our eyes, the lake and sky sometimes indistinguishable from solid matter. The chapel and fortification on the mount at the left merge together, and the figure in the centre foreground blends into his surroundings through the use of vibrant colour. Turner also achieved a spectacular effect with the variety of brushstrokes, ranging from small touches of intense colour to wide sweeps of paler washes.

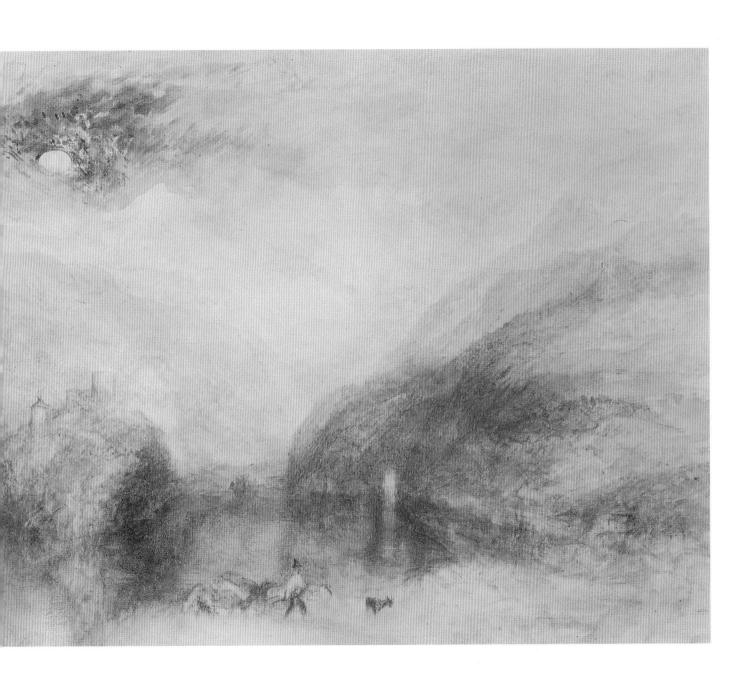

46. JOSEPH MALLORD WILLIAM TURNER R.A. (1775–1851)

A Gurnard, c.1839/40?

19.1 x 28 cm. Bequeathed by R. Clarke Edwards, 1938. P.18-1938

Turner was fascinated by the sea, perhaps because he was born and spent his childhood in East London by the River Thames; he died at home in his house by the Thames in West London. His paintings include many views of rivers and lakes, both here and abroad, and many of his greatest paintings are of the shore and sea. There are many sea fishing subjects, showing boats in stormy weather or fishermen unloading their catch. He represented the sea creatures in all their variety, and this study of a gurnard is a magnificent example. The gurnard belongs to the *triglidae* family and has a large head, mailed cheeks and three finger-like pectoral rays.

With complete assurance, with rapid strokes of the brush, he depicted the fish in all its strange beauty. It is his ravishing technique that creates this beauty out of marine ugliness. He probably used such studies for the sea pictures that include sea monsters.

The watercolour first belonged to the leading critic and writer on art of the day, John Ruskin, who was a friend and vigorous promoter of Turner's work. He exhibited it at the Fine Art Society in 1878, describing it as a study for 'the Slaver'; this is the famous painting of a slave ship exhibited at the Royal Academy in 1840, which includes images of marine monsters (now in the Boston Museum of Fine Art, Massachussetts).

The *Gurnard* seems to belong to a group of studies of fish made in Margate, Kent, which are difficult to date. The others in the group are of mackerel and are more conventional and detailed studies than that of *A Gurnard*. Of the studies of mackerel, Ruskin again relates an episode in Turner's life. He recorded that Turner had painted the fish as they lay on his Margate landlady's kitchen dresser: 'Just a dash for three more. Cook impatient'.

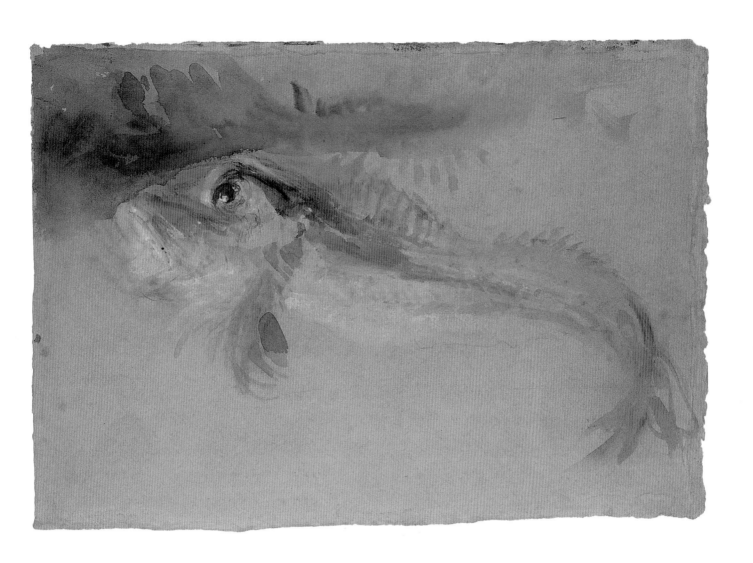

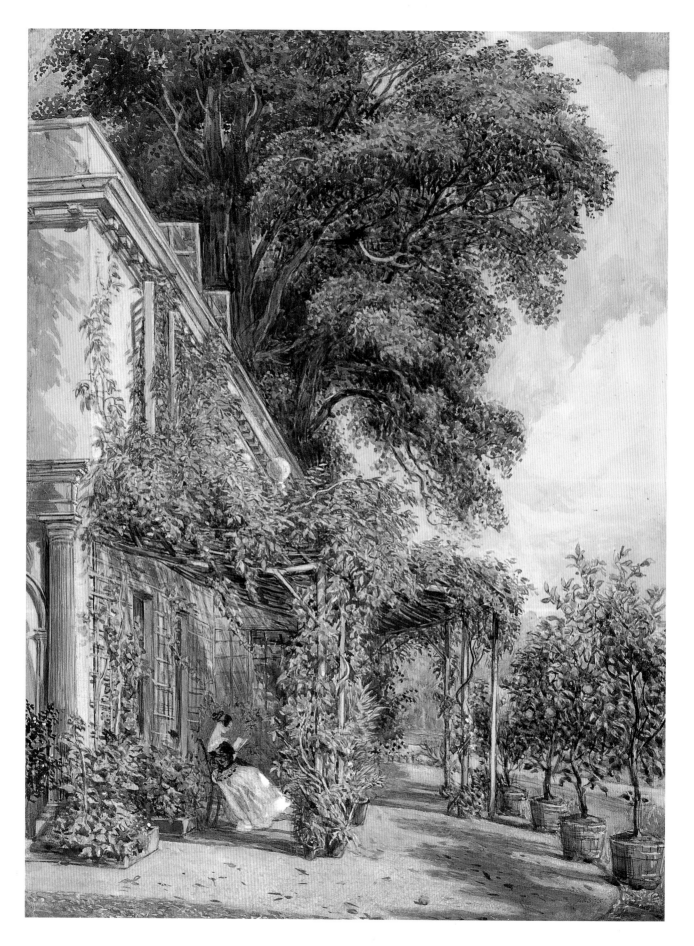

47. JOHN JAMES CHALON R.A. (1778–1854)

The Garden Front of Mr Robert Vernon's House at Twickenham,
c.1840

51.1 x 37.7 cm. Purchased 1875. 455-1875

Marble Hill Cottage at Twickenham, Middlesex, on the River Thames, no longer exists, but was the summer residence of the great art collector Robert Vernon (1774–1849). He collected contemporary British paintings, and two years before his death he gave 157 works to the nation, which are now mostly housed in the Tate Gallery.

Chalon showed three oil paintings of Marble Hill Cottage at the Royal Academy summer exhibitions of 1839 and 1840, and presumably this watercolour dates from the same time. The woman sitting and reading on the terrace must be Vernon's wife.

The artist was the older brother of the artist Alfred Edward Chalon, also a Royal Academician, and painted landscapes, marine views, animal and figure subjects in watercolours as well as in oils. This is one of the best examples of his watercolour painting. The freshness of colour and intimacy of mood are remarkable and must have delighted Vernon, who presumably commissioned the painting. It conveys the pleasures of country life, but in a location near to the city of London. Many people with money, such as Vernon, whose business was in the city centre, wanted to escape to the country while retaining contact with London. The link was the River Thames, which explains why so many houses, great and more modest, were built on its banks. Usually to the west, they appeared especially frequently in Richmond, Twickenham and Hampton, creating what were perhaps the first suburbs. As the word 'suburb', deriving from the Latin, suggests, the idea was based on the villas constructed outside the city of ancient Rome.

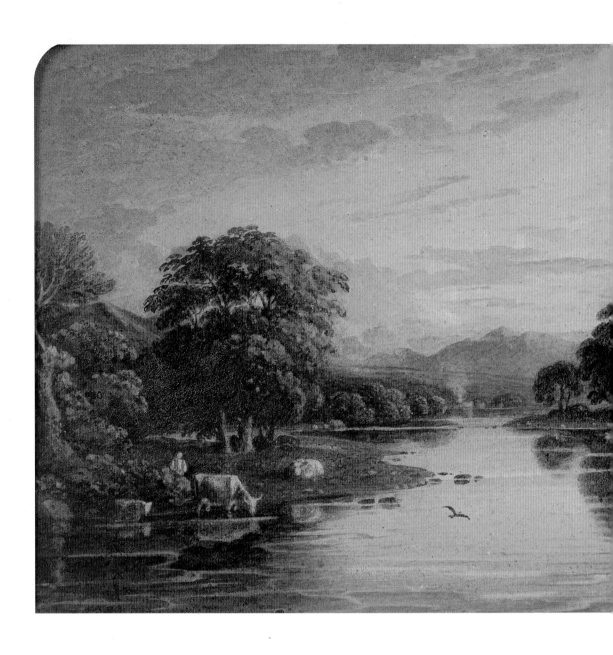

48. JOHN VARLEY (1778–1842)

Bolton Abbey, Yorkshire, 1842

Exhibited at the Old Watercolour Society, 1842. Signed and dated *J. Varley 1842*.
28.7 x 60.4 cm. Ellison Gift 1873. 1057-1873

Varley, like George Barret (plate 49), was a founder and prominent member of the Old Watercolour Society, and he was the most important teacher of his generation; he wrote the very influential *Treatise on the Principles of Landscape Design*, published between 1816 and 1818. His pupils notably included Cox, De Wint, Linnell and Mulready. His technique and style bridged the conventional eighteenth-century 'picturesque' theories – of the overall idealised compositional structure and the golden glow derived from earlier old masters in oils – and the fresher, more glittering palettes of the younger generation of Turner and Bonington. He experimented, as here, by using copal or gum to varnish

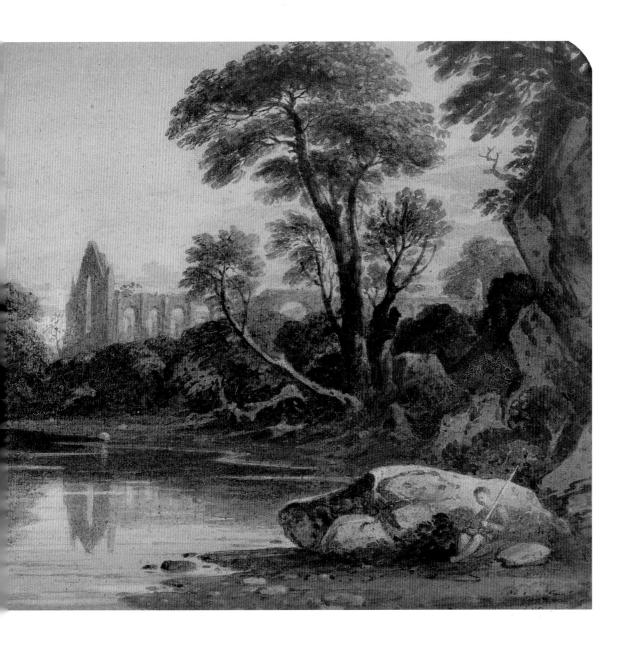

the darker tones and give the richness of an oil painting, and by scraping out with the end of his brush to increase the atmospheric effects.

Varley had visited Bolton Abbey during a sketching tour of Yorkshire in 1803, almost 40 years before he painted this watercolour, and he exhibited several watercolours of this famous subject. It is one of the most beautiful sights in Britain, principally because of the situation of the abbey on the lovely River Wharfe, about ten miles south-west of York. The ruins of the thirteenth-century priory church are reflected in the waters, giving the composition a classical balance and feeling of tranquillity that attracted painters for some 200 years.

The story of the abbey also lends the scene a further 'Romantic' dimension; the benefactor founded the building to mark the place where a beloved son had drowned in a tragic accident. The story is most memorably told in William Wordsworth's poem of 1807, published in 1815, *The Force of Prayer, or The Founding of Bolton Priory: A Tradition.* The narration, in the form of a lament, describes the young Romilly's sad fate and his mother's vow to build a priory dedicated to his memory.

Thoughts in a Churchyard – Moonlight, 1842

Exhibited at the Old Watercolour Society, 1842.
40 x 50.8 cm. Ellison Gift 1873. 1010-1873

———————————

This was the last work painted by the artist before his death. Given the subject-matter, this seems an appropriate tribute to one of the most famous and prolific watercolourists of his time. He forged a long and successful career almost exclusively in the medium of watercolour and was a founder and prominent member of the Old Watercolour Society, which was established in 1804. He showed over 600 watercolours at their exhibitions, also exhibited elsewhere and published an influential manual, *The Theory and Practice of Water-Colour Painting*, in 1840.

Ever since the publication in 1750 of Thomas Gray's celebrated poem 'Elegy in a Country Churchyard', the setting of a graveyard, preferably as here in the moonlight, was popular as a subject for painters. Unusually, Barret ignored the text of Gray's poem and appended lines of verse written by himself to the title of his watercolour in the O.W.S. exhibition catalogue. In this he may have been imitating the example set by Turner, whose epic poem 'The Fallacies of Hope', which never existed in its entirety, was on several occasions quoted by Turner in Royal Academy exhibition catalogues. Barret's lines are:

> 'Tis dusky eve, and all is hush'd around,
> The moon sinks slowly in the fading west,
> The last gleam lingers on the sacred ground,
> Where those once dear for ever take their rest.

The watercolour itself is an excellent example of one medium attempting to be another: Barret is aiming to produce the same effects as an oil painting. Heavy layers of pigment, overlaid with varnish, result in a rich picture surface quite unlike that of earlier water-colours. The effect is enhanced by the gilt mount and the elaborate, and in this case original, gilded stucco frame.

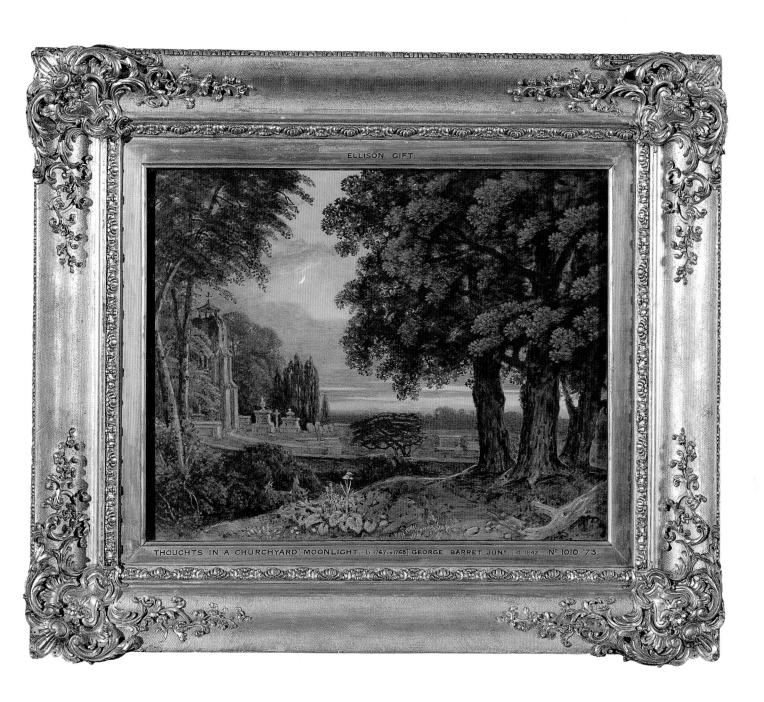

ELLISON GIFT.

THOUGHTS IN A CHURCHYARD: MOONLIGHT. [b.1767 or 1768] GEORGE BARRET JUNᴿ [d 1842] Nº 1010-'73.

50. JOSEPH NASH (1808–1878)

The Porch at Montacute House, Somerset, 1842

Signed and dated *Joseph Nash 1842*. 75.5 x 53.4 cm. Ellison Gift 1873. 1039-1873

Joseph Nash, like many of his contemporaries, specialised in specific subjects for his watercolours: in his case they were architectural views of well-known country houses. Many of his watercolours were intended to be reproduced in lithographic prints that he made himself. His illustrated book *The Mansions of England in the Olden Time*, published between 1839 and 1849, was immensely popular; such books were the nineteenth-century equivalent of what today we would call a 'coffee-table' book. Nash added much more in the way of information, in the form of research, scholarship and visual material.

Montacute House, built for Sir Edward Phelips around 1600, was an unusual choice of subject. A more famous great house nearby – Haddon Hall – was painted by both watercolourists and oil painters over and over again. But Montacute had a special and different appeal, and Nash matched its somewhat eccentric design with the elaborate 'Exhibition' frame, which attempts to emulate the details of the architectural style of the Elizabethan exterior depicted in the watercolour.

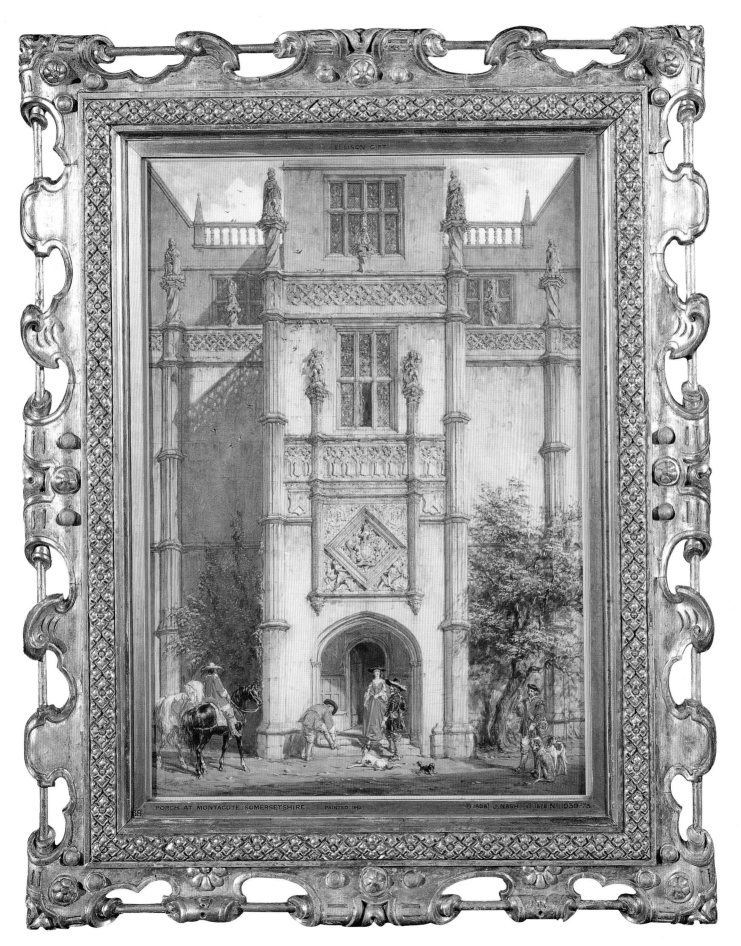

ELLISON GIFT

PORCH AT MONTACUTE. SOMERSETSHIRE. PAINTED 1842 (b.1808) J. NASH (d. 1878) Nº 1039·'73

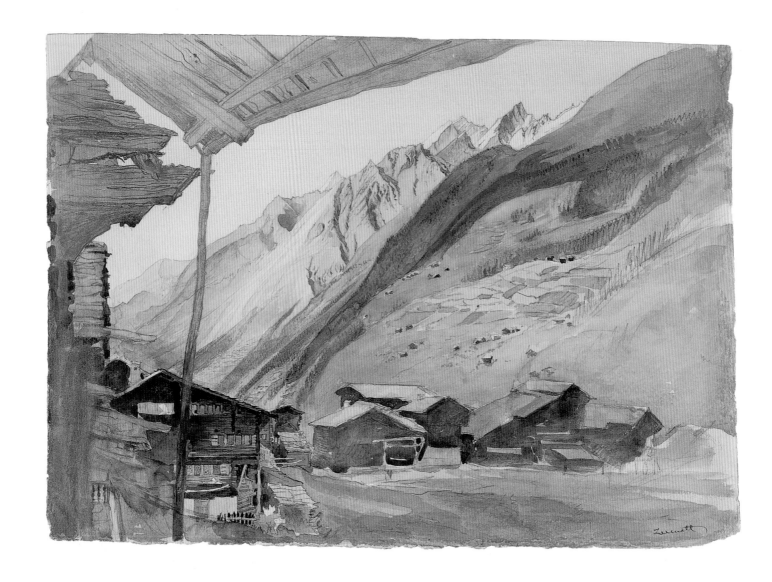

51. JOHN RUSKIN (1819–1900)

Zermatt, prob. 1844

Inscribed by the artist *Zermatt*. 27.3 x 38.2 cm. Purchased 1921. P.15-1921

———————————

In the summer of 1844 Ruskin visited Switzerland with his parents. They arrived in Zermatt, about ten miles from the Matterhorn, early in August. Although he visited Zermatt again in August 1849, he was by that time more interested in the geological structure of the mountains rather than, as here, in the careful recording of a view. Ruskin was also evidently entranced by the clear light and atmosphere. But even in 1844 Ruskin conveys the different physical forms of the slopes, from the lower gently grassed pastures dotted with small chalets, past the densely wooded hillside, to the glaciers and jagged summits. The cursory watercolour treatment of the foreground buildings serves to emphasise the more intricate observation of the distant mountains.

As an art critic, Ruskin advised painters to go directly to nature, 'rejecting nothing, selecting nothing', and here he has followed his own dictum.

52. WILLIAM DYCE R.A., A.R.S.A. (1806–1864)

Goat Fell, Isle of Arran, date unknown

23 x 34 cm. Purchased 1888. 447-1888

Born in Aberdeen in the north of Scotland (the city's airport is named after him), Dyce first studied medicine and theology at the Marischal College there and then, for a few months only, studied art in the Royal Academy Schools. He visited Rome, where he seems to have become acquainted with the group of German painters known as the 'Nazarenes', who, with their mission of reviving the purity and 'truth to nature' of early German and Italian art, were precursors of the English Pre-Raphaelites.

His career was that of a typical Victorian polymath. Not only a painter of mythological, historical and biblical subjects, portraits and landscapes, he was an ecclesiologist and musicologist, was involved in the extensive plan for decorating the walls of the new Palace of Westminster with massive frescoes, was superintendent of the School of Design and helped plan the re-organisation of national art education.

His landscapes, in both oil and watercolour, are meticulous in detail and fresh in colour. His attention to the minutiae sometimes reaches a hallucinogenic degree, as in the famous oil of Pegwell Bay now in the Tate Gallery. Here, although there is precision in the foreground grasses and plants, there is a freedom of handling that is unfamiliar in Dyce's work but that creates a fresh and breezy atmosphere very characteristic of the western islands of Scotland.

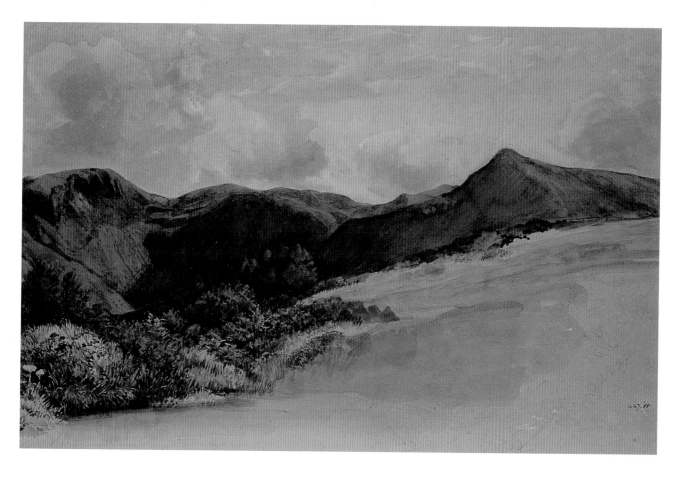

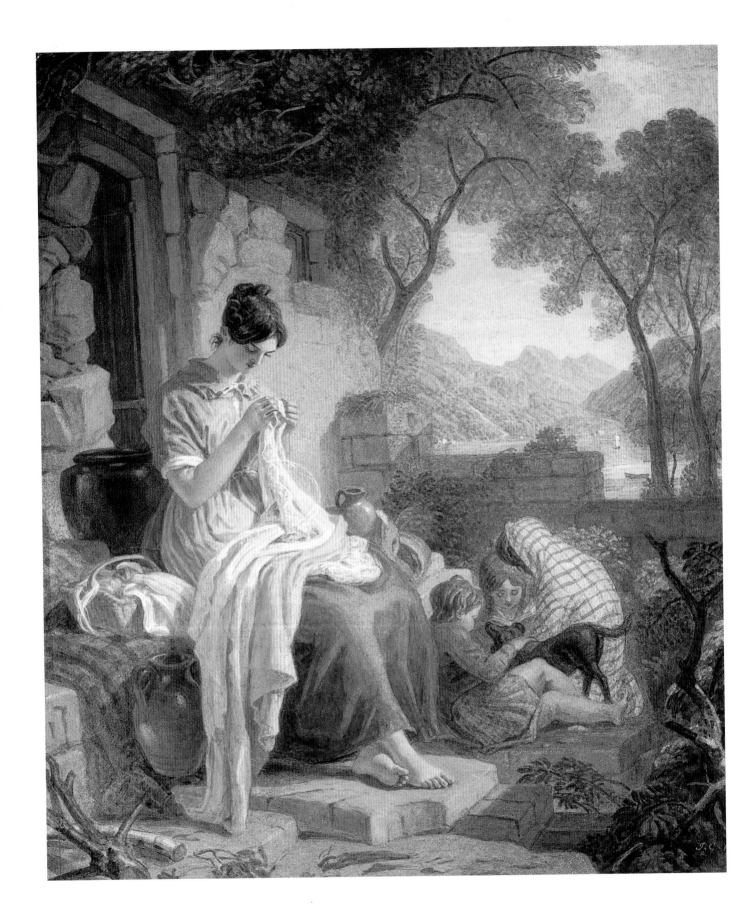

53. JOSHUA CRISTALL (1768–1847)

A Scottish Peasant Girl embroidering Muslin at Luss, Loch Lomond, Scotland, 1846

Exhibited at the Old Watercolour Society, 1847. Signed and dated *J.C. 1846*.
56 x 47.9 cm. Bequeathed by Miss Jessy Mabel Pott, 1962. P.7-1962

———————

A prolific artist – Cristall exhibited 376 works at the Old Watercolour Society, of which he was a founder-member – he was born in Cornwall and worked first as a painter on ceramics before studying in the Royal Academy Schools and entering an apprenticeship with Thomas Monro (see text of plate 27). The first exhibition of his work was shown at the V&A in 1975; at first this seems surprising for such an important figure in the history of watercolour painting. But Cristall was a very unassertive and quiet man, and there are very few records of his life in the form of journals and letters.

Cristall's subject-matter was wide, ranging from coastal scenes and landscapes to history and literature and from portraits to rustic figures. This is an excellent example of the last. Cristall visited Scotland in 1818. He made landscape drawings during this tour, but the more important results were the watercolours of Scottish people at their work. By this time Scotland was popular as a source of wonderful scenery, dramatic history and romantic literature.

This was mainly due to the poetry of Robert Burns and the novels of Sir Walter Scott. In the advertisement for his novel *The Antiquary*, first published in 1816, Scott proclaimed that he had 'sought my principal personages in the class of society who are the last to feel the influence of that general polish which assimilates to each the manners of different nations'. Cristall, who admired the writings of both Burns and Scott, depicted the workers of Scotland in a direct and unaffected manner. There is no picturesque artificiality, no theatrical appeal to the viewer of the painting. Instead there is a quiet dignity rendered in soft and gentle watercolours.

54. WILLIAM HENRY HUNT (1790–1864)

Primroses and Birds' Nests, c.1850

Signed *W. Hunt*. 34.3 x 35.3 cm.
Bequeathed by the Rev. Chauncey Hare Townshend, 1869. 1525-1869

———————

Hunt specialised in this kind of microscopic view of hedgerows, resulting in his nickname of 'Birds' Nest Hunt'. He exploited the watercolour technique by meticulous detail in his brushwork and using clear bright pigments. He was one of the most prolific exhibiting watercolourists of the nineteenth century, showing nearly 800 works at the Old Watercolour Society.

His range of subjects was very extensive, despite his nickname. His special contribution to the history of watercolour painting was his use of body-colour. Purists would say that *true* watercolour consisted in the use of transparent washes of pigment, but opaque white had always been employed to give increased 'body' to the painted surface. The 'Chinese' white body-colour was used in three ways: as an alternative method of rendering highlights to leaving the white or cream paper unpainted; as a mixture with the transparent watercolour to produce an opaque effect similar to that of gouache; and – this was Hunt's speciality – as a base ground on which the transparent watercolour was applied in order to give a greater degree of brilliance.

Not only prolific, Hunt was probably the watercolourist most highly regarded in his day for his virtuoso technique and, historically, is the artistic bridge between such late eighteenth-century painters as George Barret (plate 49) and mid-nineteenth-century artists such as J.F. Lewis (plate 55).

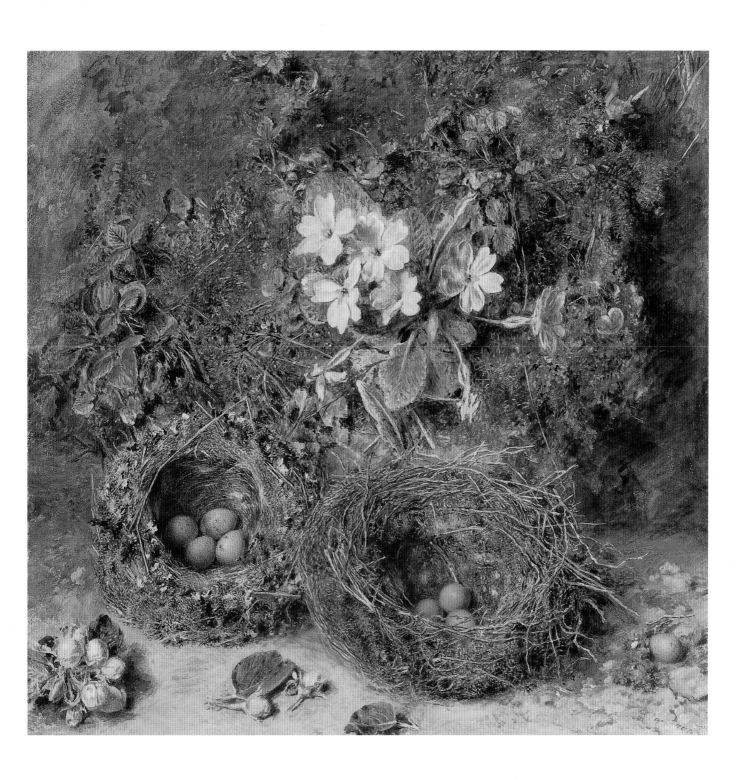

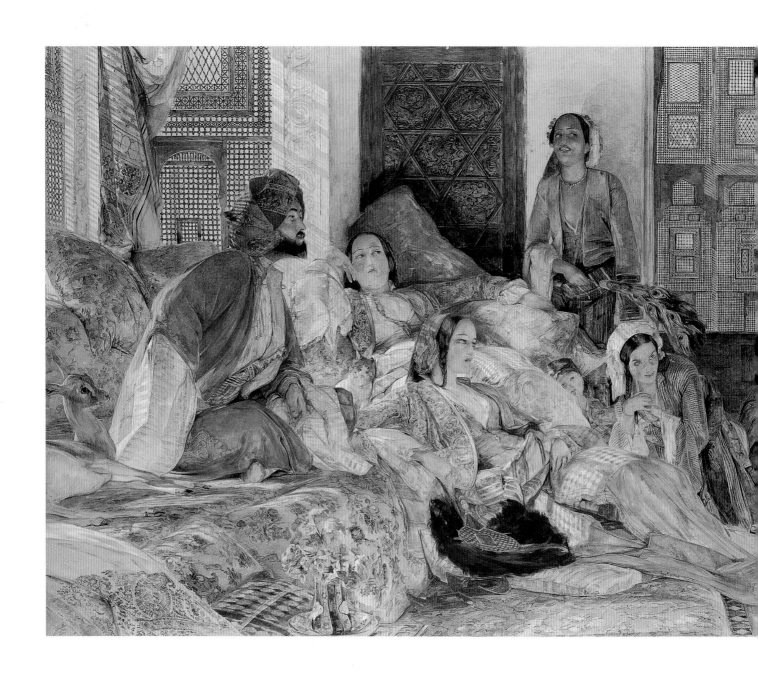

55. JOHN FREDERICK LEWIS R.A. (1805–1876)

The Hhareem, c.1850

47 x 67.3 cm. Purchased 1949. P.1-1949

———————————

This spectacular watercolour is a version of a work exhibited at the Old Watercolour Society in 1850, a work of which the whereabouts were unknown since its sale at auction in 1909 until it was 'discovered' in an office block in Japan in 1986. The showing of *The Hhareem* in 1850 caused a sensation; it was the picture of the year. The leading art magazine, the *Art Journal*, called it the greatest and most extraordinary watercolour they had ever seen. The V&A version is also great and extraordinary. Lewis was the most talented artist of his time to visit and record the Middle East. He lived in Cairo in Egypt for some ten years, adopting oriental dress and renting from the Coptic patriarch the actual house shown in the watercolour. He had the knowledge, and genius, both to record the intricate details of exotic settings and to convey the hermetic atmosphere of palatial Eastern interiors.

Here, in a gorgeous setting, the Pasha reclines on his divan, surrounded by members of his family, women from his harem and his pet gazelle. The sumptuous colours of the costumes and fabrics are set against the brilliant points of light piercing the elaborate lattice-work at the windows. The subject of the watercolour is somewhat ambiguous in the V&A picture, but a photograph of the first version shows the composition extended on the right to reveal another group of figures, and another pet gazelle, including a new member of the harem being displayed before the Pasha by a Nubian eunuch. This explains the alert interest shown in the Pasha's posture and facial expression and the other four women's expressions, ranging (left to right) from doubt, sullen and world-weary lack of interest, cynical amusement to intense examination.

The watercolour once belonged to the painter Myles Birket Foster (plate 63). The models for the picture included Lewis's wife, Marian, as the slim dark-haired woman on the right, and Lewis himself as the Pasha.

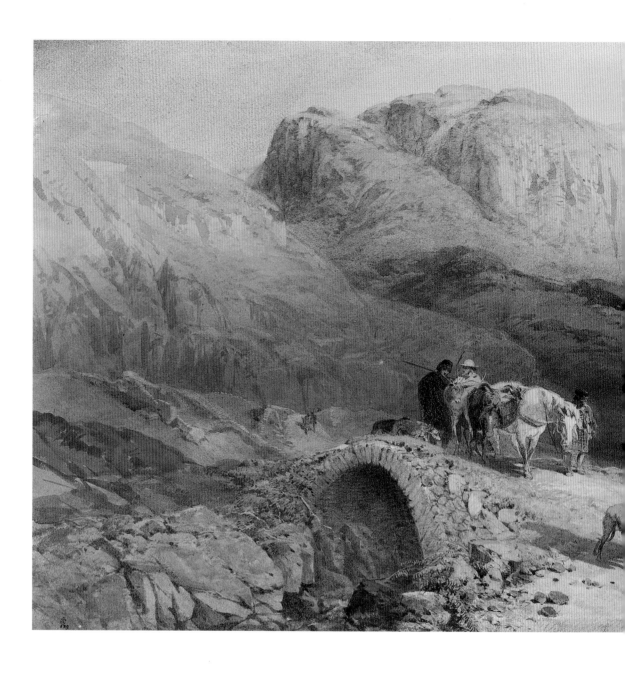

56. THOMAS MILES RICHARDSON the younger r.w.s. (1813–1890)

On the Clunie, Aberdeenshire, 1852

Signed and dated *T.M. Richardson 1852.* 43.2 x 91.5 cm. Ellison Gift 1873. FA 539

In 1435 the man who was later to be elected Pope Pius II was sent to Scotland on a diplomatic mission. His life was to be recorded some 50 years later in a series of frescoes in a library attached to Siena Cathedral named after his family, the Piccolomini. In the background of one of the frescoes is the first visual recording of a Scottish landscape. The subsequent history of views of Scotland goes mostly in tandem with the history of English landscape painting. But the 'discovery' of some of the most beautiful and spectacular scenery in Europe, including that of Scotland, really occurred in the eighteenth and nineteenth centuries by poets, novelists, composers and, of course, painters.

One Scottish landscape artist, Alexander Fraser, writing in 1872, twenty years after Richardson painted this watercolour, described a 'summer tide of tourists' visiting the Highlands of Scotland because they hoped to escape 'the prose of life to something of its poetry, in the land of the mountain and the flood'. Richardson was born in the north of England, in Newcastle, and made extensive sketching tours across the border in Scotland. Although he travelled to continental Europe, in his watercolours he seems to have responded best to the mountains of Scotland, the deep valleys and lochs and strange colours created by the ever-changing climatic conditions, which ranged from brilliant sunrises to rich sunsets, the light tinting the whole landscape with rich orange, cerise and purple. His figures seem only added for extra visual interest, much in the way eighteenth-century watercolourists would include a peasant returning from market or a worker trudging home at the end of the day. In this watercolour the figures may be in the centre of the composition, but they are not allowed to dominate it; they play a subsidiary role to the magnificent natural scenery which surrounds them.

57. DAVID COX (1783–1859)

The Challenge: A Bull in a Storm on a Moor, date unknown

Probably exhibited at the Old Watercolour Society, 1856. 45.4 x 64.8 cm.
Bequeathed by the Rev. Chauncey Hare Townshend, 1869. 1427-1869

———

Cox began his career as a painter of scenery at the Theatre Royal in Birmingham before moving to London to study with John Varley (plate 48). He went on to become one of the most popular of all British watercolourists, with both collectors and critics.

He often depicted, as here, landscapes assaulted by driving rain and strong winds. This watercolour is inscribed on the back: *on the Moors near Bettws y Coed – N.W.* The artist painted three versions of this subject, of which this is the last. The image is of a lone animal confronting the brute force of nature; in a vast flat landscape, the bull withstands the devastating storm raging about him. When Cox exhibited five of his watercolours at the Old Watercolour Society in 1856 two, of which this may have been one, hung either side of an intricate Eastern landscape by J.F. Lewis (see plate 55). The eminent art critic John Ruskin admired the intricate detail of Lewis's work and noted the contrast of Cox's 'excessive darkness and boldness … the two drawings of English moors … gain in gloom and power by the opposition to the Arabian sunlight; and Lewis's finish is well set off by the impatient breadth of Cox'.

Cox certainly matches the intensity of this subject with the vibrant and violent treatment of the watercolour medium. Almost in the manner of an abstract expressionist painter such as Jackson Pollock, Cox attacks the sheet with his brush, achieving an aggressive and threatening effect. The lack of distinct detail and the saturnine colours enhance the overall drama of this late work.

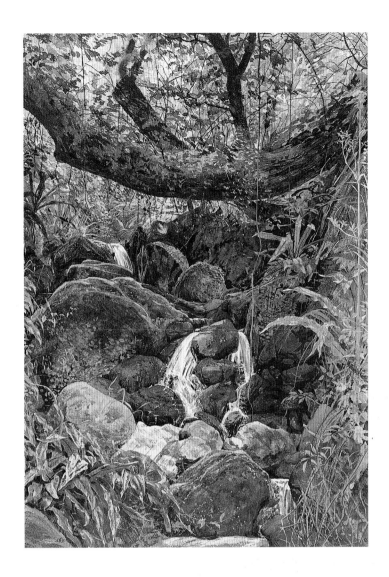

58. HENRY ALEXANDER BOWLER (1824–1903)

Lucoombe Chine, Isle of Wight, 1860

35.4 x 25 cm. Purchased 1860. FA 562

This artist combined a professional career as a painter, exhibiting works at the Royal Academy summer exhibitions and elsewhere, with a parallel career as a teacher and administrator. He worked for the Science and Art Department in London, which was to become the Royal College of Art, for over 30 years, and for nearly 40 years he was teacher of perspective at the Royal Academy. He is perhaps best known today as the artist of the 1855 oil painting *The Doubt: 'Can these Dry Bones Live?'* presented to the Tate Gallery by his family in 1921. But he was an accomplished watercolourist, as this painting shows.

Bowler followed the precepts of the Pre-Raphaelites, obeying the 'truth to nature' in painting and drawing that was promoted and supported by the leading art critic of the day, John Ruskin. Consequently this rare watercolour is carefully observed, intricate in detail and clear and bright in colour.

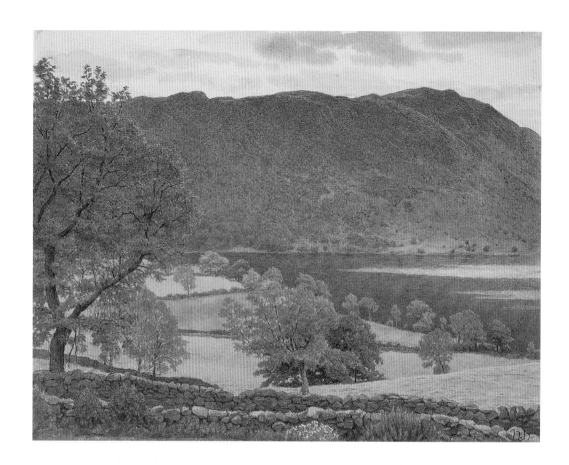

59. HENRY GEORGE ALEXANDER HOLIDAY (1839–1927)

Hawes Water, c.1860

Signed *hh*. 22.8 x 29.2 cm. Purchased from the daughter of the artist, 1927. P.48-1927

Hawes Water is the easternmost of the famous Lakes, in Cumbria. Although not principally known as a painter of landscape, Holiday here brings to the scene the same careful observation of nature and brilliance of light achieved by his better-known Pre-Raphaelite contemporaries.

Having studied at the Royal Academy Schools, Holiday made his career as a designer of stained glass, mosaics and murals for new buildings, such as the Town Halls of Bradford and Rochdale. He also painted easel pictures, his most famous being *The Meeting of Dante and Beatrice* (for which the V&A has the preparatory drawing) now in the Walker Art Gallery, Liverpool.

In this watercolour we see an early and rare example of his work as a landscapist. His colours are very high-key; that, together with the precision of his handling of the medium, must owe much to the work of G.P. Boyce (plate 72). Holiday's pictorial composition is deceptively simple: the sheet is divided horizontally almost exactly into two halves by the foot of the mountain, the immediate foreground is filled from left to right by a dry-stone wall (its shape balanced by the sky), and a tree frames the view across the fields to the water. But more horizontal features, of other walls and hedges and of the lake itself, create a syncopated visual rhythm that contrasts with the solid and flatter mass of the mountains behind.

The Grave of Little Nell, 1860s?

37.1 x 49.2 cm. Forster Bequest 1876. FA 53

Cattermole was a prolific artist who exhibited extensively at the Old Watercolour Society and elsewhere, including abroad. He painted landscapes, seascapes and architectural interiors, but he remains most famous for his historical genre and literary subjects.

This watercolour illustrates a passage from Charles Dickens's early novel *The Old Curiosity Shop,* first published in 1841. After many tribulations and much travelling around the country, Nell and her grandfather find refuge in a small village. But Nell, worn out from her hardships, dies, an event that stunned Dickens's vast readership both in Britain and in the USA. Here Cattermole shows the affecting scene in chapter 72, where the old grandfather visits Nell's grave in the local church:

> They found, one day, that he had risen early, and, with his knapsack on his back, his staff in hand, her own straw hat, and little basket ... was gone.... And thenceforth, every day, and all day long, he waited at her grave for her.

A wood-engraving very similar in composition and detail to this watercolour was published in the 1867 edition of the novel, and it is likely Cattermole painted this work in preparation for the print.

The watercolour belonged to Dickens and was bought at his auction sale in 1870 by his great friend and biographer, John Forster. At his death six years later Forster bequeathed it to the Museum, along with many other works of art and Dickens's manuscripts.

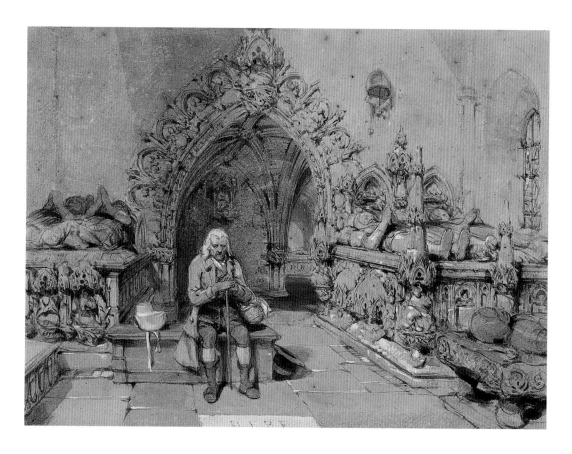

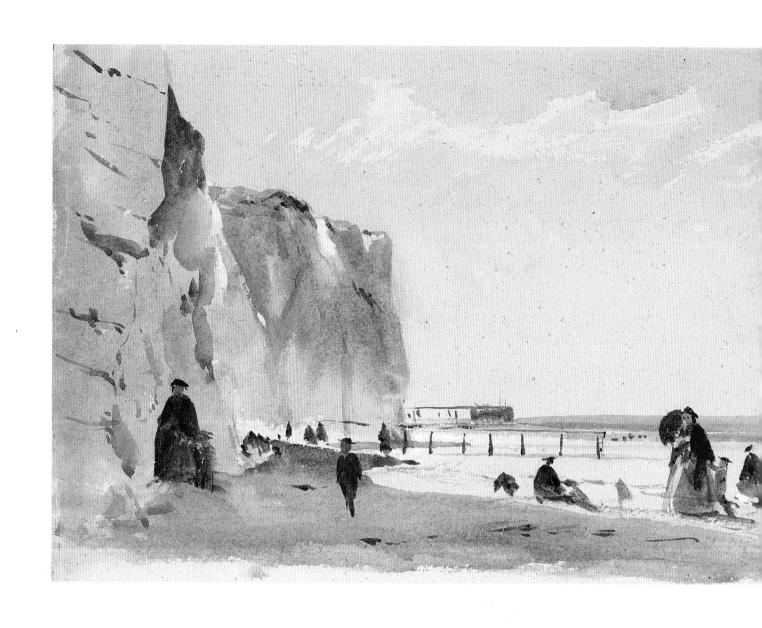

61. JOHN ABSOLON R.I. (1815–1895)

Coast Scene, Normandy, c.1860

23.7 x 37.9 cm. Purchased 1895. D.154-1895

After working as a portrait painter, and as a miniaturist in Paris in 1838, Absolon was employed painting stage scenery and dioramas and as a book illustrator. However, his fame rests on his watercolour landscapes, many of which he exhibited at the New Watercolour Society.

This coast scene shows him at his very best; it is reminiscent of the work of the French proto-Impressionist Eugène Boudin and prophetic of the English follower of the Impressionists, Wilson Steer, some twenty years later. The technique is startling in its clarity and rapidity. The thin washes of colour are applied with utmost confidence and verve in broad sweeps of the brush. The delicate colours are set against the use of brilliant green in two small passages in the costume, and – even more dramatically – the use of pure dense black, silhouetting the figures against the sun-drenched beach. Like so many of the Impressionists in France, Absolon here relishes the depiction of everyday life: a marine pier in the background, the bathing-huts and mothers with their children strolling on the beach, simply enjoying the sea and sunshine. It is worth comparing this happy image with the almost contemporary beach scene in oils by William Dyce, *Pegwell Bay*, now in the Tate Gallery, which has a complex subject-matter quite different in kind from that of Absolon.

It is an example of how an artist who, talented but not of the first rank, was able to achieve a masterpiece in his chosen medium.

62. FLORENCE ANNE CLAXTON (c.1840–?)

The Choice of Paris: An Idyll, c.1860

13 x 17 cm. Purchased 1976. E.1224-1989

———

Very little is known about Claxton but this, her most famous watercolour, was the most celebrated satire of the work and ideas of the Pre-Raphaelite painters. She was the daughter of the painter Marshall Claxton (1813–1881), two of whose oil paintings are in the V&A collections.

The watercolour was first exhibited at the Portland Gallery (where the Pre-Raphaelite painters themselves had shown their works). It caused a sensation and was reproduced as a full-page spread in the weekly high-circulation magazine *The Illustrated London News*.

The satire is packed with references to the Pre-Raphaelite painters and their pictures. Millais (plate 66) plays the part of Paris, the Trojan prince who had to choose the most beautiful of the three Graces: Venus, Juno and Minerva. Claxton represents the Graces

as a Raphaelesque Madonna, a woman in contemporary costume and an angularly drawn medieval figure, who represents the Pre-Raphaelite ideal. Of course, Millais/Paris awards the the golden apple to the last.

There are various other references to famous Pre-Raphaelite paintings, and the 'truth-to-nature' ideal is parodied by the man examining the surface of the outside wall through opera-glasses.

63. *(overleaf)* MYLES BIRKET FOSTER R.W.S. (1825–1899)

The Milkmaid, 1860

Signed and dated *B F 1860*. 29.7 x 44.5 cm. Jones Bequest 1882. 520-1882

For the biographical notes Foster supplied to the Royal Academy in Berlin in 1874, he wrote 'mine has been a very uneventful life, but one which my art has made very pleasant to me'. Actually, his life was rather interesting. Born into a prosperous Quaker family, Foster was given permission by his father to study as an artist, beginning as an apprentice to the engraver Ebenezer Landells, a one-time pupil of Thomas Bewick, whom Foster had admired from an early age. Landells seems to have been a very liberal teacher, encouraging Foster to sketch out-of-doors; another interesting connection is that Foster's fellow-pupil in Landells's studio, John Greenaway, was the father of the celebrated Kate Greenaway.

Foster's work for Landells led to his employment with the leading magazine *The Illustrated London News*, making drawings for reproduction, mainly topographical. But by 1850 he had established himself as an independent watercolourist specialising in rural scenes that conveyed compelling images of English life. His meticulous technique and high-key colouring were, and remain today, of considerable appeal to collectors of watercolours. Dealers asked for a good deal of work from him, as the demand for his paintings steadily increased; Foster is supposed to have said that 'I have as a rule made a good income for an artist by hard work'.

In reality, Foster invented a countryside inhabited by people happy and contented in their work. This is not the 'dark side of the landscape', showing the harshness and grind of rural life. But for an urban audience, especially in the metropolitan, commercial and industrial centres of London, Manchester and Birmingham, Foster provided a vision of an English Arcadia which they wanted to see and which they could believe actually existed in the real world.

64. WILLIAM BELL SCOTT (1811–1890)

Iron and Coal: The Industry of the Tyne, c.1861

Signed *W.B. Scott*. 24.5 x 23.8 cm.
Purchased from the executors of the artist, 1891. 362-1891

Many of the patrons of Pre-Raphaelite painters, and other purchasers of their works, were not based in London but in the midlands and the north of England, being newly rich industrialists and manufacturers. In 1856 Sir Walter Trevelyan, whose ancestors had founded the family fortune in the coal and lead mining industry, commissioned Scott to decorate the large hall of their house, Wallington, some 30 miles north-west of Newcastle. The eight large panels narrated the history of Northumberland, from the story of St Cuthbert (d.687) through the Roman conquest to the then modern triumph of technology, *Iron and Coal*. The artist wrote that: 'Heaven knows whether it is the best or not. I hope it is. The canvas is as full as it can hold. Everything of the common labour life and applied science of the day is introduced somehow'.

This is a watercolour version of the Wallington composition, a celebration of the contemporary success of the city of Newcastle, its industry and commerce. The young girl in the foreground, looking away from the workmen and clutching her school arithmetic book would, like others of her generation and social class, eventually benefit from the new prosperity brought by mining, engineering and invention.

362.91

65. DANTE GABRIEL ROSSETTI (1828–1882)

The Borgia Family, 1863

Signed and dated *Borgia D.G.R. 1863*. 36.2 x 37.8 cm. Purchased 1902. 72-1902

A first version of this composition simply illustrated the lines from William Shakespeare's play *Richard III*: 'to caper nimbly in a lady's chamber, to the lascivious pleasing of a lute'. But Rossetti became more attracted to the exotic and dangerous subject of life with the dissolute and murderous Borgia family.

The innocence of the pretty children dancing in the foreground is countered, indeed threatened, by the three figures gazing at their performance: the villainous Pope Alexander VI, his son Cesare Borgia and, most notorious of all, his daughter Lucrezia Borgia. It is likely that the three are plotting the eventual murder of the dancing children. It is probably not a coincidence that infanticide featured in the original subject set at the court of King Richard III.

Rossetti revels in the rich colours and textures of the clothing. He had visited Hampton Court Palace to inspect the royal collection of Italian Renaissance portraits. From such portraits as the Giulio Romano painting of Isabella d'Este, Rossetti was inspired by the elaborate costumes which were enhanced by the hermetic interior setting, which was broken only by a small window opening on to a fresh and different outside world.

66. SIR JOHN EVERETT MILLAIS Bt p.r.a. (1829–1896)

My Second Sermon, 1864

Signed *JM* in monogram. 24.2 x 17.2 cm. Purchased 1901. 399-1901

This is a fine version in watercolour of the oil painting Millais exhibited at the Royal Academy in 1864. The year before he had shown a painting of his daughter, called Effie after her mother, dressed in her best clothes sitting upright and attentive in church listening to the preacher's message. That was entitled *My First Sermon*. It was a tremendous success, was engraved for a wider audience and was mentioned in a speech by the Archbishop of Canterbury at the annual Royal Academy banquet as a paradigm of 'the piety of childhood'. Millais, with his young family, was at this time in search of more popular success and capitalised on the 1863 painting with this sequel, where the novelty of a church service for a young child has waned. The phenomenon of sequential paintings could be likened to that of today's movie production.

For *My Second Sermon* there was again a great deal of comment and publicity; the painting was seen as a warning to preachers to keep their sermons short and to the point. Millais, despite seeking popularity, remains true to the Pre-Raphaelite principles of 'truth to nature'. The model is an accurate portrait of his own daughter, the pew is one in the west end of St Thomas's Church, in Winchelsea, Sussex. In the biography of Millais written by his son and published in 1902, the mid-1860s are described as a time when the artist was 'at the summit of his powers in point of both physical strength and technical skill, the force and rapidity of his execution being simply amazing'.

This is one of a pair of watercolours: the other is *Spring,* exhibited in 1864 and now also in the V&A. Despite the fact that both watercolours were in various private collections before the Agnew bequest of 1911, they achieved great fame through exhibition and, especially, reproduction in the form of engravings. *Spring* had been bought at auction by William Agnew, of the celebrated firm of art dealers which still exists today, in 1887 for the high price of £2,100, more than the cost of a good oil painting by an old master. Agnew believed the two watercolours to be Walker's masterpieces.

Spring shows a young girl picking primroses with a boy companion; his rather tremulous facial expression is echoed by the foliage of the trees just bursting into leaf. Here *Autumn* depicts a young woman, on her own, holding an apple: the fruit of the biblical Tree of Knowledge. The mood is languorous and reflective. It seems probable that Walker is referring not only to the passage of the seasons, but also to the passage of human life, and it may be that the woman in *Autumn* has lost and pines for her early love.

The subject is taken from the famous epic poem by John Keats, 'Endymion', first published in 1818, and based on the story told by the classical Greek writer Lucian. Selene, the goddess of the moon, fell in love with Endymion, a beautiful youth: in Keats's poem a 'brain-sick shepherd-prince'. In return for the promise of eternal youth, Endymion is transported by the gods into a permanent sleep, 'a sleep full of sweet dreams, and health, and quiet breathing', giving us today one of the most quoted lines in English literature: 'a thing of beauty is a joy forever'. But Keats wove many other episodes into the story of Endymion, such as that depicted in this watercolour where Endymion has shot a hind.

69. WILLIAM HOLMAN HUNT (1827–1910)

The Ponte Vecchio, Florence, 1867

26.7 x 54.2 cm. Purchased 1894. 196-1894

Like Millais and Rossetti (see plates 66 and 65), Hunt was a founder-member of the Pre-Raphaelite Brotherhood in 1848. After they disbanded in the 1850s, the 'brothers' very much went their separate ways, with Hunt the only member to pursue the 'truth to nature' that was the central aim of the young artists. Hunt married Fanny Waugh at the end of 1865, and they embarked on a tour of the East, beginning in Egypt. But Fanny was already pregnant, and by the time they reached Florence on their return home it was clear they would have to remain there for some time. Although the birth was a difficult one, a son survived; Fanny, however, died of a fever at the end of 1866. Hunt returned to London the following September, having designed his wife's tomb and painted this view of the Ponte Vecchio in the city where the newly married couple had spent such a happy, if brief, time.

The Ponte Vecchio and the banks of the River Arno have a special significance in European culture. Most notably, it was here that Dante had first cast eyes on his beloved Beatrice and began one of the most potent love stories in history. Beatrice, too, died within a year or so of her meeting with Dante, and it may well explain why Hunt painted this – for him – uncharacteristic work. With its rich and resonant colouring, and glittering evening light, the watercolour imparts a deeply melancholic mood. Hunt may also have remembered at this time Elizabeth Siddal, who had died in 1862 after a brief marriage to Rossetti. Having as a first name 'Dante', Rossetti compared himself to the Italian poet and saw Lizzie as his Beatrice.

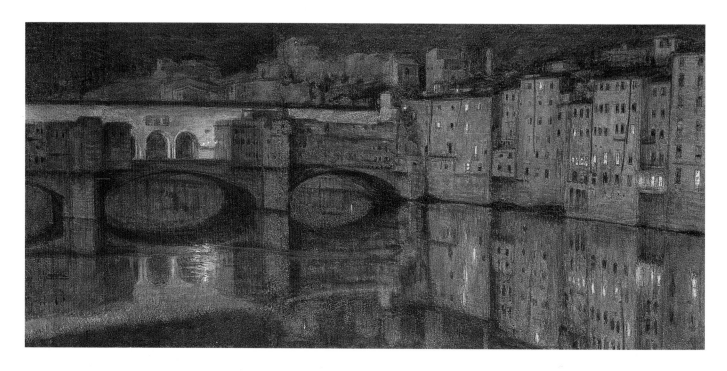

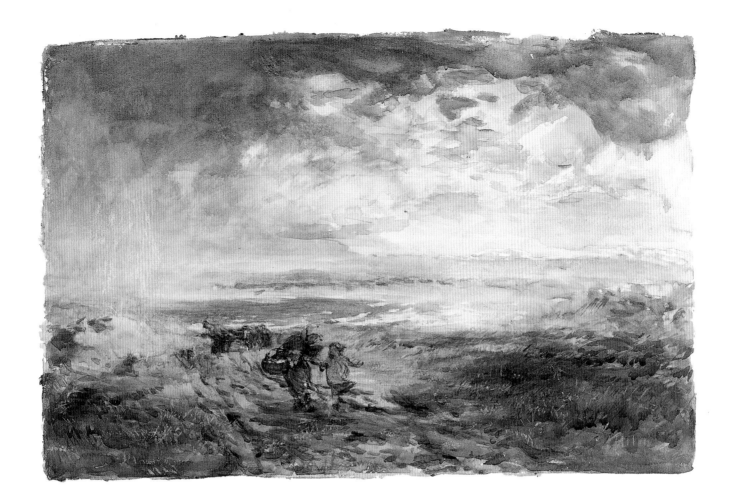

70. SIR WILLIAM McTAGGART P.R.S.A., HON. R.A., A.R.A., F.R.S.E. (1835–1910)

On the Scottish Shore, Coast Scene with Figures, date unknown

35 x 52.7 cm. Purchased 1927. P.60-1927

Just as the boyhood scenes of Constable's beloved Suffolk 'made me a painter', so the coastline of north-west Scotland determined McTaggart's career. After studying with Robert Scott Lauder at the Trustees Academy in Edinburgh during the 1850s, McTaggart had a long and distinguished career as a landscape painter in both oil and watercolour. His bright colours and swift brushwork astonished contemporary art critics, and are reminiscent of the work of the French Impressionists. But it seems that he did not see any of their paintings until the 1890s.

He may be termed the Scottish Turner as well as the Scottish Monet. He understood the dramatically ever-changing light and atmosphere of the sea and sky, responding with his brush and pigment to the view before him. Although his later works are mainly in the oil medium, his vibrant and evocative rendering of coastal scenes are more powerfully evident in his watercolours.

Here McTaggart shows two children returning from the shore, followed by others (presumably members of the same fishing family), while a sudden storm seems about to break. The purplish sky is threatening, there are rushing clouds, crashing waves and wind-blown grasses; all are painted with characteristic vigour and enthusiasm.

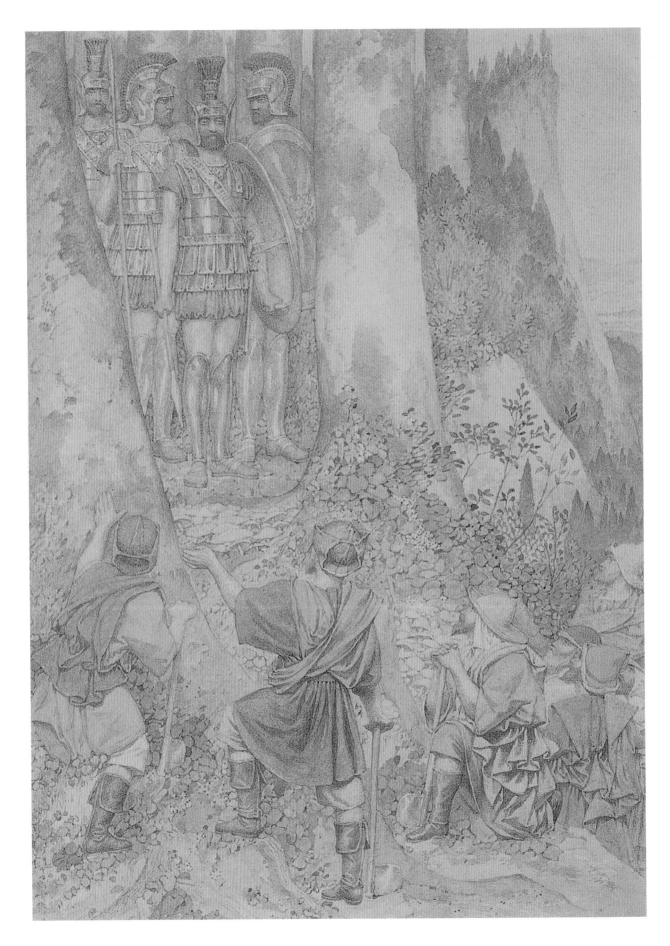

71. RICHARD DADD (1817-1886)

Leonidas with the Woodcutters, 1873

Signed and dated *Rd. Dadd. 1873*. 18.2 x 13.1 cm.
Bequeathed by John Forster, 1876. F.58

In his time this artist was more famous for his private life than his work. *The Art Union*, the leading magazine of the day, in 1843 referred to the 26-year-old Dadd as 'the late Richard Dadd. Alas! we must so preface the name of a youth of genius that promised to do honour to the world; for, although the grave has not actually closed over him, he must be classed among the dead'.

It seems that by 1843 his family and friends had realised Dadd was clinically insane. His behaviour had become increasingly unpredictable, and a climax occurred during a trip from London with his father to Cobham, in Surrey. Dadd had brought a knife with him, with the intent of murdering his father, supposedly on the instructions of the Egyptian goddess Osiris. He succeeded; he escaped to France where he was arrested, and in the following year he was committed to Bethlem Hospital and then to the new hospital at Broadmoor, where he remained for the rest of his life.

In actuality, most nineteenth-century asylums were prisons, but Bethlem and Broadmoor were more liberal to the extent of encouraging inmates within the confines of the buildings and grounds to pursue their interests and hobbies. Consequently Dadd was able to continue painting. This watercolour, painted in Broadmoor, depicts an obscure episode from the life of Leonidas, King of Sparta in the fifth century BC, as related in a poem, published in 1737 in nine volumes, by Richard Glover (1712–1785). It illustrates the lines from book VII of the poem:

> Melissa, pointing, spake:
> I am their leader. Natives of the hills
> Are these, the rural worshippers of Pan,
> Who breathes an ardour through their humble minds
> To join you warriors.

The watercolour is typically detailed. The figures are rigid, the setting verges on the hallucinogenic, and the handling of paint is intricate to the point of obsession. His use of a small brush and bright watercolours, rendering in microscopic detail recondite subjects which presumably meant a great deal to him personally, appeal today to a wide audience. We are able to enter the bizarre world he invented, not for us, but for himself.

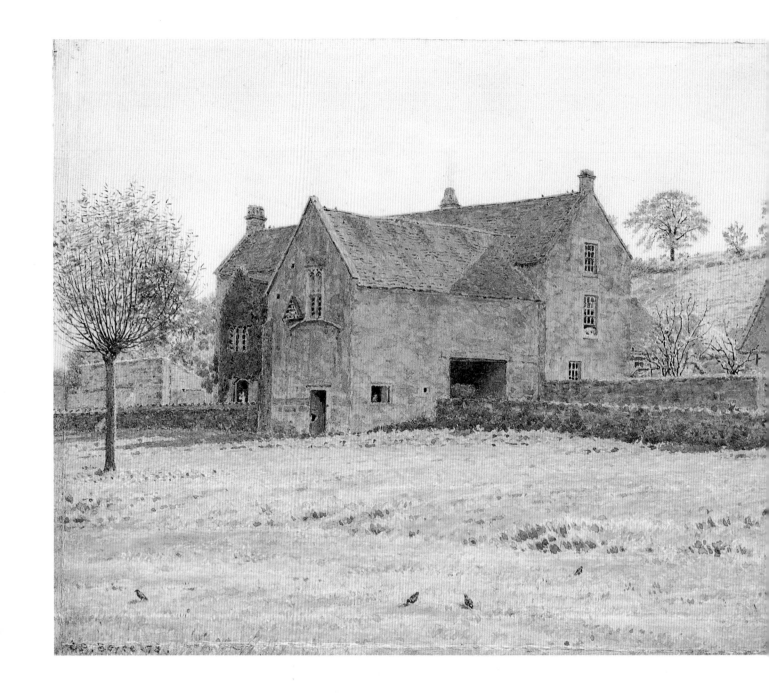

72. GEORGE PRICE BOYCE (1826–1897)

An Ancient Tithe-Barn and Farm Buildings,
near Bradford-on-Avon, Wiltshire, 1877

Exhibited at the Society of Painters in Watercolour, 1878.
Signed and dated *G.P. Boyce '78.* 21.6 x 53 cm. Purchased from the artist, 1894. 175-1894

An inscription on the back identifies the scene and states that it was 'painted on the spot in the autumn of 1877'. The architect Philip Webb, who accompanied Boyce on his visit to the tithe-barn, wrote to him fifteen years later: 'this drawing I thought to be one of

your best pieces of good work, work in truth which was always good, and often quite perfect of its kind … an historic representation of what the architects and others will soon destroy'. In fact this important structure is now a protected building and is open to the public.

Boyce was a great friend of Rossetti and other Pre-Raphaelite painters; indeed we know a good deal about them from his diaries. He derived from them his minute and meticulous treatment of landscape and architecture, and his brilliant and luminous colouring. The year of this painting's first exhibition, 1878, was significant for the artist, as he was finally elected a full member of the Old Watercolour Society. As a gentleman of independent means, he was not considered a 'professional' painter.

73. EDWARD KILLINGWORTH JOHNSON R.W.S. (1825–1913)

A Young Widow, 1877

Signed and dated *E.K. Johnson 1877.* 52.1 x 34.6 cm.
Given by James Laver, 1959. E.808-1959

The second half of the nineteenth century had a dominant popular image of the state of widowhood in the person of Queen Victoria. Indeed the Victorians made something of a cult of mourning, and the rules it produced placed a restrictive burden on women in particular. A properly observed widowhood entailed a prolonged period of absence from social events and activities, and rules on dress meant that all colour and ornament were proscribed until a proper (and long) interval had elapsed. In Johnson's poignant narrative, a beautiful young woman in a severe black dress gazes sadly at a rather more elaborate gown, her wedding dress. A symbol of her recent loss, it also represents the youthful pleasures and future happiness that are now denied to her.

Johnson was a self-taught painter who specialised in contemporary scenes of everyday life. His intricate technique in watercolour owes much to such contemporary continental European artists as Meissonier. He has been criticised in the past on the grounds that his virtuoso handling of the watercolour medium masks a lack of true feeling for his subject-matter, but this work, probably his masterpiece, conveys a genuine pathos and arouses our sympathy for the plight of the young widow.

74. ELLEN CLACY (active 1870–1916)

Marigolds: The China Closet, Knole, c.1880

46.9 x 35 cm. Purchased 1990. E.1908-1990

In the history of British watercolour painting one extraordinary phenomenon was the work of the amateur artist. In the eighteenth century it was fashionable for upper-class gentlemen to study drawing, particularly under the instruction of a professional companion artist while making the 'Grand Tour' of continental Europe. But – especially in the medium of watercolour – it was the female amateur artist who achieved the greatest successes. Denied in most cases a professional career of any kind, women were expected to marry and bear children and acquire 'accomplishments', such as playing a musical instrument, singing, embroidery or painting in watercolour. These amateurs rarely exhibited their works, which is the reason why so little is now recorded of them, but their level of accomplishment could be very high, in some cases exceeding the talents of professional painters as with Ellen Clacy.

Clacy did exhibit her work, at the Royal Academy and the Society of British Artists between 1870 and 1900, but little else is known about her. This delightful watercolour shows a woman, in the 'Aesthetic' dress of the time which had been made fashionable by William Morris and the Liberty store, dress that was loose and flowing and vaguely medieval; she is inspecting a piece of porcelain at the window. The setting is the famous china cabinet of Lady Betty Germain at Knole, the great fifteenth-century house in Kent; she was an avid collector of blue and white china and had rooms in Knole in the first half of the eighteenth century. Clacy echoes the subtle blues of the china throughout the composition. It is interesting to compare this painting with that of Mary Ellen Best (plate 37), which also shows blue and white china, but humble earthenware rather than fine porcelain, and in a modest kitchen rather than in an elegant room in a great house.

75. JOHN WILLIAM INCHBOLD (1830–1888)

View above Montreux, 1880

Signed and dated *J W Inchbold Montreux 1880*. 30.8 x 50.5 cm.
Given by Lady Church in fulfilment of the wishes of her late husband,
Sir Arthur Herbert Church, 1915. P.18-1915

––––––––––––––

An almost exact contemporary of members of the Pre-Raphaelite Brotherhood,
Inchbold adopted their Ruskinian 'go to nature, rejecting nothing, selecting nothing'
attitude to depicting landscape. This is surprising, as he was first a pupil of David Cox,
who although devoted to out-of-doors painting was not allied to the meticulous treat-
ment of detail that John Ruskin demanded.

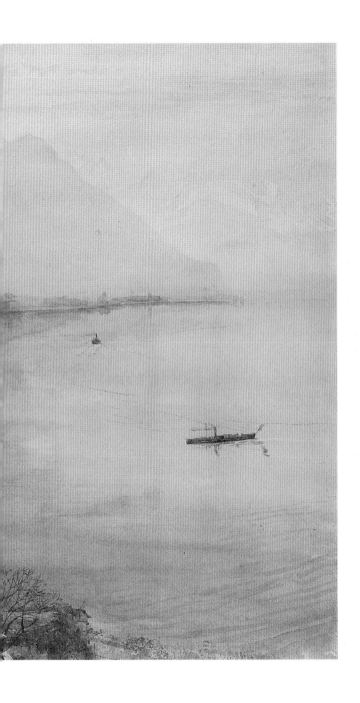

Although it must have been Ruskin who encouraged Inchbold to make a tour of Switzerland and the Alps, their friendship was short lived. Inchbold's earlier watercolours of Swiss landscape were highly detailed, but he seems later to have moved away from a Pre-Raphaelite manner of painting in favour of the more impressionistic style of Turner's later work, which he presumably saw in Ruskin's own collection.

This watercolour, partly closely observed and partly atmospheric in treatment, has an unconventional composition; the buildings in the foreground, the high viewpoint, the leafless trees silhouetted against the background, the boat on the lake and the famous Castle of Chillon in the distance should not result in a coherent whole by usual standards, but the work is curiously satisfying in visual terms.

It is interesting that the previous owner, Sir Arthur Church, was president of the Mineralogical Society and, like Ruskin, an avid collector of geological specimens.

76. SIR EDWARD COLEY BURNE-JONES Bt (1833–1898)

Love, 1880s

211 x 107 cm. Given by the Hon. Mrs Margaret Post, 1937. E.838-1937

This watercolour is inscribed with a line from Dante's *Divine Comedy*: 'L'amor che muove il sole e l'altre stelle' ('The love that moves the sun and the other stars'). It is a highly finished design for a large needlework panel but may now be considered as a great watercolour in its own right.

Burne-Jones made several such designs, often worked up into tapestry or needlework by the young Frances Graham, whose niece was the donor of this watercolour to the V&A. She was also the model for the beggar-maid in Burne-Jones's famous oil painting *King Cophetua and the Beggar-maid* now in the Tate Gallery. The artist had fallen in love with her, but in 1883, to his great dismay, Frances announced her impending marriage. Burne-Jones added to the King Cophetua picture anenomes, the symbol of rejected love, around the figure of the maid. Here too in *Love* the colours of anenomes predominate: rich scarlets and purples against cobalt blue and turquoise. It may be that the artist is exorcising his feelings, the loss of his heart to someone who could not return his love.

Love shows Burne-Jones at the height of his powers, in its meticulous design and its ravishing colours. Unlike most of the watercolours in this book, the handling of paint and the technique of applying pigments to paper, are not so important. It is the overall effect, the complex design and the hieratic image that for us are so visually impressive and arresting.

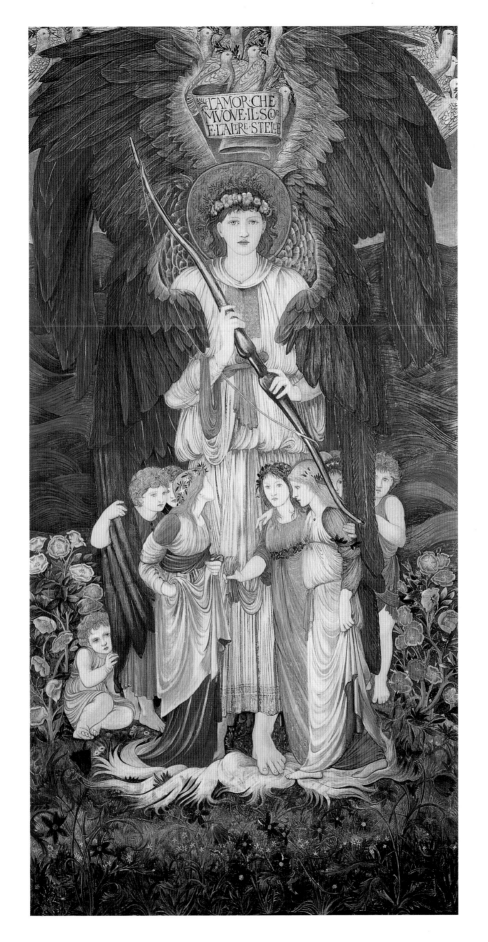

L·AMOR·CHE
MVOVE·IL·SO
E·L·ALTRE·STELLE

77. HELEN ALLINGHAM R.W.S. (1848–1926)

A Cottage at Chiddingford, Surrey, date unknown

Signed *H. Allingham*. 39.3 x 33 cm. Bequeathed by Henry L. Florence, 1916. P.20-1917

Helen Allingham remains one of the most famous, widely popular and prolific painters in watercolour as well as one of the most successful women artists in British history. She began her career when she was 22 years old as an illustrator for *The Graphic* (the only woman on that magazine's staff) but went on to specialise in painting watercolours of English cottages and country gardens. Most of her scenes were painted in the south of England, particularly Surrey, where she lived from 1881; she settled in Witley, where Birket Foster (plate 63) was already established, and her work can be seen as part of the same tendency to romanticise the rural past.

Working in an eighteenth-century pictorial tradition, she deliberately sought out picturesque subjects which she 'improved' by emphasising their dilapidated charm: worn thatch, moss-covered roofs, broken fences, overgrown gardens. This backward-looking world is peopled almost exclusively by women and children, whom she dressed in a style that was clearly old-fashioned. Like Birket Foster she was re-presenting rural life for an urban audience, as a place of simple healthy lives, where older, and better, values still pertained. These cottage scenes, with the women engaged in domestic pursuits – childcare, laundry, feeding poultry – signified social order, a place where the established proprieties of class and gender were still observed.

Another influence on her delicate, high-key colouring and meticulous attention to detail must have been the work of the Pre-Raphaelite painters of the 1850s and 1860s, and it is interesting that her father-in-law was William Allingham, a close friend of Rossetti. The Pre-Raphaelite Brotherhood was founded in 1848, the year of Helen Allingham's birth.

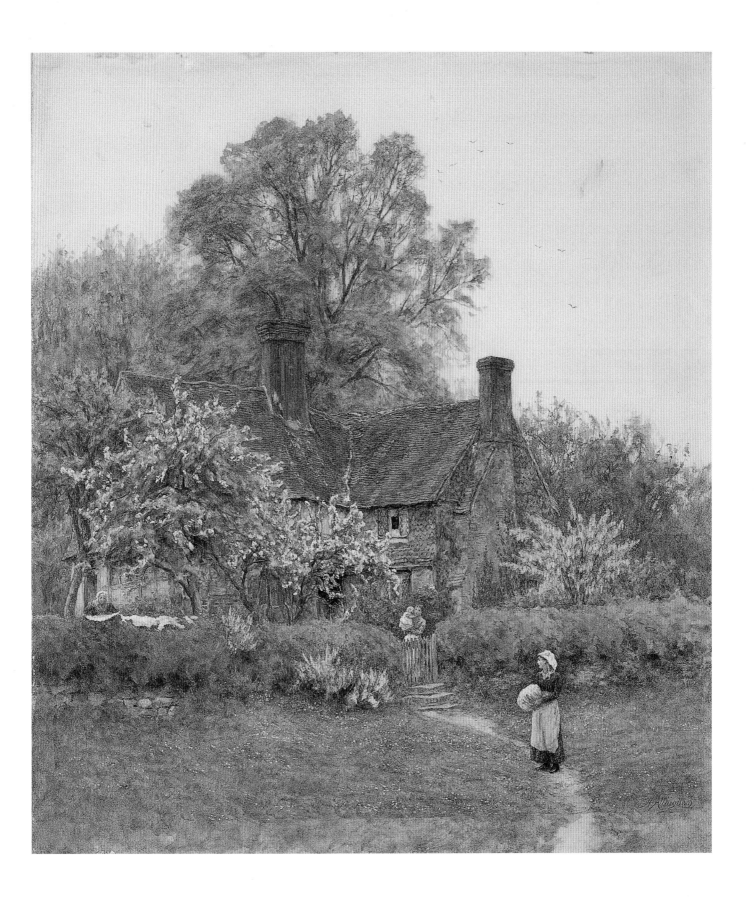

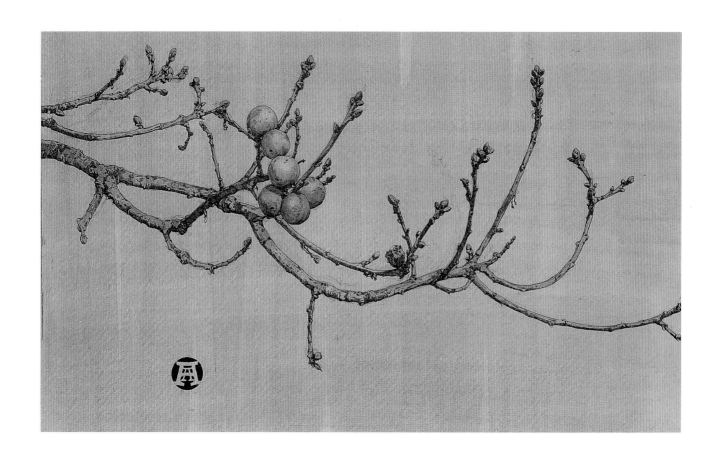

78. ANNA AIRY R.E., R.O.I. (1882–1964)

Oak Apples, date unknown

Signed *AA* in monogram. 26 x 42 cm. Given by A.E. Anderson, 1916. P.3-1916

―――――――――

Anna Airy was a child prodigy and achieved fame before she graduated from the Slade School of Art at the age of 21; she won several prizes for her drawings, etchings and watercolours. In 1920 the *Sunday Times*, reviewing an exhibition of her work at the Fine Art Society in Bond Street, named her 'not only one of the most gifted of our women artists, but [she] is the inventor of a distinctive genre in which she has attained supreme excellence'. This genre was the depiction of 'fruitful branches … unique among contemporary pictures, possessing a flavour of Japan in the decorative charm of their composition, while the substructure of pen-and-ink drawing is Düreresque in its intensity and precise fidelity to fact'.

This watercolour is an early work. It has a flavour of the period; the composition is elegantly spare and reflects the pervasive influence of Japanese art on Europe at the end of the nineteenth century. Though she went on to work as an Official War Artist, and also painted figure subjects and portraits, Airy specialised in flowers and botanical studies. Flower-painting was thought to be a 'quiet, unpretending womanly employment' (according to the novelist Mary Russell Mitford) and was consequently devalued by being seen as simply a genteel accomplishment rather than a professional occupation. Nevertheless a number of women worked successfully as illustrators of the many botanical periodicals published in the nineteenth and early twentieth centuries.

The Children by the Fireside, recounting their Adventures, 1911

Signed and dated *Cayley Robinson 1911*. 40.6 x 33 cm.
Bequeathed by C.D. Rotch, 1962. P.81-1962

Having studied at the Royal Academy Schools in Paris and in Italy, Robinson embarked on a career as a painter, a designer of posters (notably for the London Midland Scottish Railway) and of theatrical scenery and costumes, but principally as a book illustrator.

One of his most important achievements, this is one of a set of illustrations to Maurice Maeterlinck's play *L'Oiseau Bleu* (*The Blue Bird*). He had designed the sets and costumes for its first production in London at the Haymarket Theatre in 1909. The book of the play was first published in London in 1912 with illustrations by Robinson. Maeterlinck, who won the Nobel Prize for Literature in the same year as Robinson's watercolour, is today best known for his *Pelléas et Mélisande*, translated into an opera by Debussy. But *The Blue Bird*, both in play and book form, was more popular in its own day.

Maeterlinck was a Belgian Symbolist writer, and Robinson seems to have been his ideal designer and illustrator. Mysterious, sometimes sombre, dream-like, even nightmarish, Robinson's watercolours convey the unique qualities of Maeterlinck's writing. Their strange compositions and refined colouring, the washes carefully outlined in pen and ink, owe something to such early Italian Renaissance painters as Fra Angelico and perhaps more to contemporary French painters such as the Symbolist Puvis de Chavannes.

80. PAUL NASH (1899–1946)

The Old Front Line, St Eloi, Ypres Salient, 1917

Exhibited at the Goupil Gallery, 1917. 22.2 x 20.3 cm.
Given by Mrs Paul Nash, 1960. P.22-1960

The mystical quality that pervades Nash's work belongs to the tradition of William Blake, Samuel Palmer and David Jones. He was born in Kensington and described in his autobiography, *Outline* (1949), how much the early memories of time spent in the open landscape of Kensington Gardens had meant to him. He studied painting at the Slade School of Art alongside Stanley Spencer, Ben Nicholson and Edward Wadsworth. He designed for Roger Fry at the Omega Workshops and indeed was to have a flourishing career as an illustrator, designer and wood-engraver. But he is also remembered as a remarkable watercolourist.

At the outset of the First World War in 1914 he enlisted in the Artists' Rifles, was posted to France and, as a result of such stunning and moving watercolours as this example of the Ypres Salient, was appointed an Official War Artist in 1917. He made a number of watercolours and drawings at the front. He wrote to his wife in April 1917, about a month before he painted this watercolour: 'Imagine a wide landscape flat and scantily wooded and what trees remain blasted and torn, naked and scarred ... Nothing seems to bear the imprint of God's hand ...'.

He was to be an Official War Artist again, in 1940. Between the wars he produced amazing landscape watercolours, for example at Dymchurch, where he captures the wide flat Kent coast, which is similar to that of Flanders, and at Avebury, near Stonehenge in Wiltshire, where the celebrated standing stones seem to have moved his tendency to approach the natural world with a sense of the mystical towards a dream-like Surrealism.

81. WILLIAM ROBERTS R.A. (1895–1980)

Soldiers erecting Camouflage at Roclincourt near Arras, France, 1918

Signed *William Roberts*. 40.6 x 35 cm. Given by E.M.O'R. Dickey C.B.E., 1962. P.94-1962

The scene shows a working party putting up camouflage screens at night in the village of Roclincourt, near the front line in the First World War. The artist wrote in 1962 to Michael Kauffmann, then assistant keeper of paintings at the V&A, that the watercolour was painted towards the end of 1918 and recorded the camouflage work in which he took part, when the attack on Arras was imminent.

Roberts was apprenticed as a commercial artist, at the same time as attending evening classes at the St Martin's School of Art; he went on to the Slade School and travelled in France and Italy, looking at contemporary art there, recording later that his friend and fellow-student at the Slade, David Bomberg (plate 82), had already 'provided an additional stimulant to my interest in abstract art'. For two years between 1916 and 1918, Roberts served in the Army and was appointed an Official War Artist. This powerful image of soldiers constructing defences, partly representational, partly abstract in form and composition, is one of the most vivid evocations of the bravery displayed by soldiers at the front line. The physical exertion is expressed in the strong diagonal lines, of the limbs of the men as well as the ladders and sheets of camouflage material.

The donor, Mr Dickey, bought the watercolour from the artist in 1919.

82. DAVID BOMBERG (1890–1957)

Stairway No. 1, 1919

Signed and dated *Bomberg 1919*. 26.7 x 20 cm. Purchased 1937. E.285-1937

Born in Birmingham, the fifth child of a Polish-Jewish leather-worker, Bomberg was taken to London with his family when he was five years old. He was first apprenticed to a commercial lithographer but attended evening classes in painting and eventually studied full-time at the Slade School of Art, with Stanley Spencer, William Roberts and Edward Wadsworth. When he left the Slade in 1913, he knew that his future was to be an abstract artist: more specifically, a follower of the Paris Cubists. He was a founder-member of the London Group in 1914 and enlisted in the army the year after. On his return to London, he made a series of drawings in pen and ink and wash, of which this is one, and then travelled for much of his life, first in Palestine, then in Spain.

Although he continued to exhibit his increasingly more naturalistic landscapes, and to teach, it is his early works on which his fame rests, with their fervent visual proclamation of a new and revolutionary art. This watercolour is a fine example of his technique, but it was even more a compositional challenge to the spectator in 1919, and still is for many today: perspective is distorted, the links with actual appearance are minimal. The appeal for us lies in the rhythm of lines and colours, the shapes that seem to move before us as in a kaleidoscope. At the same time the image has an authority, a sculptural quality. But it is the sense of motion that is more central to Bomberg's concept. The title itself indicates the artist's intent; the only reason for the existence of a staircase is our use of it to ascend and descend through space.

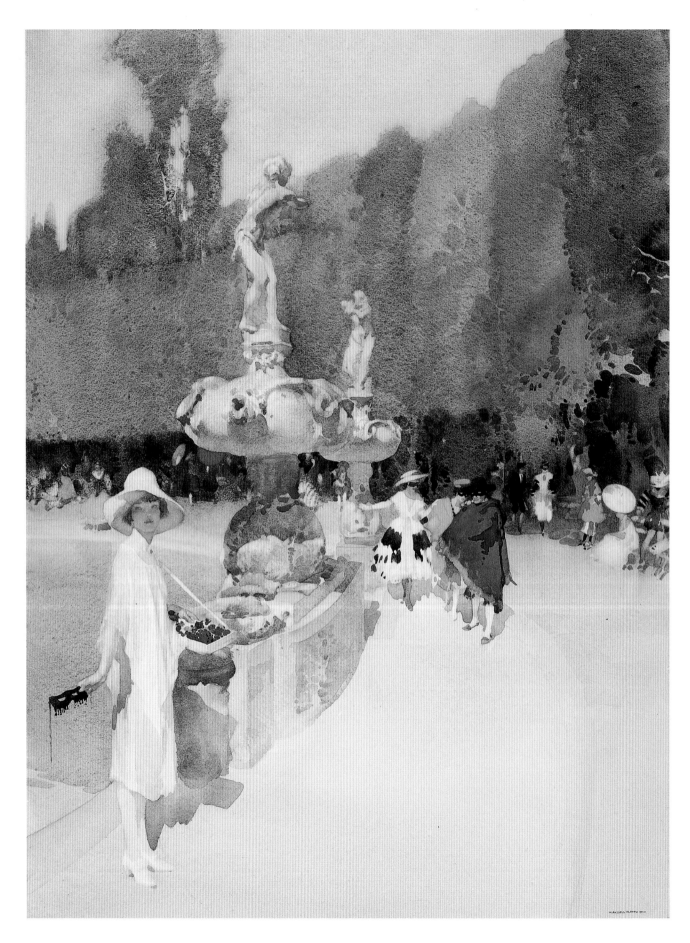

83. SIR WILLIAM RUSSELL FLINT R.A., R.W.S., R.S.A. (1880–1969)

A Florentine Masquerade, 1920

Signed and dated *W. Russell Flint 1920.*
68.3 x 50.5 cm. Given by the artist, 1920. P.111-1920

The setting is the Vasco dell'Isolotto in the Boboli Gardens in Florence. The artist was one of the most successful watercolourists of the first half of the twentieth century, and he remains popular today through colour reproductions of his work. After studying art in Edinburgh and a six-year apprenticeship to a lithographer, he worked as an illustrator for *The Illustrated London News* before travelling on the continent, painting in France, Switzerland, Italy and Spain. In Spain he found the subject-matter that was, and remains, the principal source of his popular appeal: young women, sometimes gypsies, usually reclining in languorous and sometimes frankly erotic poses. These works, which found a ready market in the original watercolours and later in colour prints, have drawn critics' attention away from his other watercolours, such as the *Florentine Masquerade* which is a fine example of his great talent. It is significant that the artist chose to present to the Museum this particular watercolour, with its virtuoso handling of paint and sophisticated (rather than vulgar) subject-matter.

It has been perhaps disconcerting for critics in recent years that Russell Flint's watercolours have been so popular. This work shows his true talent in his favourite medium at his best. The bold composition, half of the foreground remaining empty, the background a simple wall of trees, is dominated by the two sculptures and the promenading figures. The figure of the woman on the left, in particular, who has removed her mask and with a careless and provocative gesture offers it to us, sets the atmosphere of the scene. The figures in the centre, still masked, will no doubt follow her example. As at any party, some of the seated and standing masqueraders, at the periphery of the path but forming the central horizontal link of the composition, shrink into the background.

Through a Cornish Window, date unknown

Signed *C. Ginner.* 43.8 x 28.5 cm. Purchased 1928. P.8-1928

The artist was born in Cannes, in the south of France, and studied painting in Paris. He moved to London in 1910, and the following year was one of the founders of the Camden Town Group, the members of which were devoted to depicting everyday scenes in London in a post-Impressionist style. But Ginner's manner of painting, particularly in watercolour, was different from that of his contemporaries, being individual and distinctive. His use of intense watercolours, the subject outlined in thick black pen and ink, creates a vivid image which, as in this painting, confronts us with a startling and haunting view that verges on the dream-like. At the same time, Ginner's work in watercolour has a decorative appeal; he transforms the landscape into a pattern of line and colour, unrelated to the view itself.

In this watercolour Ginner's translation of the scene has a somewhat surreal effect: the brown curtains, the armchair upholstered in cretonne, the glass float hanging in its net from the curtain rail, the bowl containing a flourishing shrub, all this shows us

simultaneously an apparently comforting and ordinary domestic interior and an alarmingly dramatic view through the window – which dominates the composition – of the outside world.

Perhaps it was Ginner's greatest talent to arouse such mixed feelings in the viewer of his watercolours. For one person the scene might seem pleasant, for another, sinister. With that talent for enigmatic interpretation, together with his highly original use of watercolour, Ginner has won a special place in the history of the medium.

Preparing for the International Theatre Exhibition at the Victoria and Albert Museum, 1924

Signed and dated *Max 1924*.
37.8 x 32.1 cm. Purchased from the artist, 1924. E.1382-1924

Sir Henry Maximilian Beerbohm – 'Max' – belonged to the generation of the Aesthetic Movement, which he first encountered as an undergraduate at Oxford and fully joined in London in the 1890s with Oscar Wilde. There was a fashion for portrait caricatures, published in such magazines as *Vanity Fair*, and Max produced images of a wide range of society figures, from the Prince of Wales and the Rothschilds to H.G. Wells and Rudyard Kipling. These appeared in several books which were published, along with his novels, between 1896 and 1946. In many ways he looked back to an earlier age, compiling *Rossetti and his Circle* in 1922, and, certainly in artistic style, remained at heart completely of the period 1890–1910. Yet he also adopted very up-to-date technologies, such as broadcasting on the wireless.

He described the 'most perfect caricature' as one which 'with the simplest means, most accurately exaggerates ... the peculiarities of a human being, at his most characteristic moment, in the most beautiful manner'. On another occasion, in a tribute to his friend Aubrey Beardsley, he wrote that 'all the greatest fantastic art postulates the power to see things, unerringly, as they are'.

This watercolour, typical of Max's own ability to see things as they are and transform them into an amusing and telling image, shows Martin Hardie on the left. Keeper of the V&A department responsible for paintings, drawings, illustrations, designs and engravings, he was also one of the greatest writers on the art of watercolour, an art he himself practised. With him are the celebrated stage designer Edward Gordon Craig and Craig's son, Gordon. The International Theatre Exhibition had been held at the V&A in 1922.

Sketch of a Seated Cat, 1920s?

Stamped with facsimile signature *Gwen John*. 15.6 x 11.8 cm. Purchased 1946. P.15-1946

———————————

The artist made several drawings and watercolours of cats, of which she was very fond, and this is probably the most famous; she exhibited two watercolours, one of which may be the V&A work, at the Société du Salon d'Automne in Paris in 1920. She was the elder sister of the more famous painter Augustus John, whose blustery style is very different from her quiet and meditative approach to painting. Augustus realised the quality of her work, saying 'fifty years from now I shall be known as the brother of Gwen John'.

She studied at the Slade School of Art, which concentrated on the skills of figure drawing, and won two prizes for her work. Her choice of subject-matter throughout her career remained based on the figure – usually a single figure and usually a woman – in an interior. The colours are muted and the compositions are almost always immediately arresting, allowing us to enter her own private world. Just as her watercolours of women are intimate and concentrated, this study similarly captures the remote self-possession and unconcern of the cat.

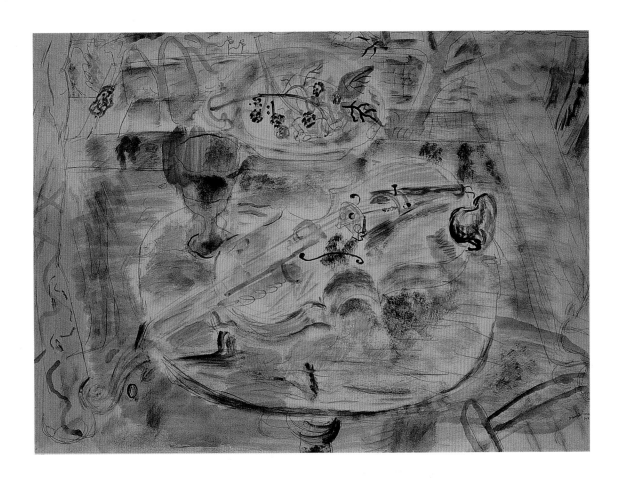

87. DAVID JONES C.H., O.B.E. (1895–1974)

The Violin, 1932

Signed and dated *David Jones 1932*. 57.2 x 78.8 cm. Purchased 1940. P.1-1940

The then owner of the Redfern Gallery, from which this watercolour was bought, said that it was the artist's favourite work, and the art critic of the *New Statesman* wrote that it was an 'astounding masterpiece'. Jones studied at the Camberwell School of Art and, after war service, at the Westminster School of Art. He first worked as an engraver, spending some time with Eric Gill, but turned to painting and writing. As with William Blake, his deeply held beliefs – Jones was converted to Catholicism in 1921 – were the foundation of his art.

This apparently simple and immediately attractive watercolour implies a more profound meaning. In the early 1930s he painted several still-life subjects, of which this is probably the best example. His calligraphic style of drawing, probably the result of his work as an engraver in the Gill workshop, creates a swirling and energetic surface. Jones endows the violin with mystery, pale colours indicating the curtains on either side, the window-ledge bearing a bowl full of leaves with berries and the view through the window to a garden. The application of the colours orchestrates the basic rhythm of the drawing, creating a gentle composition that is at the same time alluring and remote. Jones involves the viewer in a very direct way, mainly by the device, used by the French Cubists, of tipping the table up towards us.

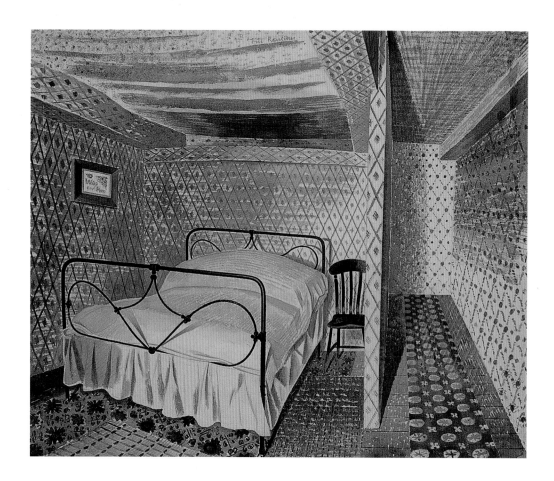

88. ERIC RAVILIOUS (1903–1942)

A Farmhouse Bedroom, 1930s

Signed *Eric Ravilious*. 45.1 x 54 cm. Purchased 1939. Circ.284-1939

The artist studied at the Royal College of Art and enjoyed a varied career. He was one of the leading decorative designers and wood-engravers of the 1930s, designing illustrations for the surfaces of pottery produced by the Wedgwood company, and for books, notably for a fine edition of Gilbert White's *Natural History of Selborne*.

His decorative and illustrative impulses are evident in his individual watercolours. The plethora of pattern here, in the wallpapers, in the carpeting and rugs, is contrasted with the plainness of the bedspread. The curves of the iron bedstead and the wooden bedside chair also contrast with the linear geometry of the architecture of the room. His colouring is exceptionally clear; sometimes he applied very pale tints next to richly saturated pigment of unusual hue.

There is a gentle intimacy about his paintings, which may explain his continuing public appeal, and his interiors and landscapes are places the viewer would enjoy seeing in reality, because Ravilious offers his own very idiosyncratic response to the real world. Whether painting the interior of a railway carriage, or of a garden shed, or the extraordinary 'Wilmington Giant' (also in the V&A collection) carved into a chalk hill, he exerts his inventiveness in composition and imaginative expression of mood in a way that transforms the actual image before him into something lucid but strange.

Dux et Comes IV, c.1932

38.4 x 58.4 cm. Purchased from the artist's widow, 1960. P.5-1960

———————

The artist Wyndham Lewis said that 'Wadsworth was an important artist ... as Old [John] Crome was a genius of agricultural England, Wadsworth was a genius of industrial England'. Like Wyndham Lewis, Wadsworth was a leading member of the Vorticists, signing the manifesto of that movement in the publication *Blast* in 1914. Vorticism was a style based on French Cubism, but also shot through with a good measure of Italian Futurism; the result was a deliberately aggressive challenge to the viewer, both visually and intellectually. Wadsworth studied at the Slade School of Art, and his early works were inspired by the destruction caused by the First World War and the desolation of the industrial landscapes. He made woodcuts, for example, of slag heaps, steelworks and blast furnaces. But around 1930 his style of painting dramatically changed, and he espoused the cause of European Modernism, particularly the works of the Surrealists, notably de Chirico, and the neo-Cubism of Léger.

This painting is in tempera, a denser type of watercolour, with a Latin title that may be translated as 'Leader and Follower', and is one of a series. Wadsworth wrote at the time that a painting is 'primarily the animation of an inert plane surface by a spatial rhythm of forms and colours'. This attitude resulted in his abandonment of figurative representation in favour of a purely abstract image. Wadsworth adopted not the linear forms of, say, Mondrian, but fluid biomorphic shapes, amoeba-like forms, which seem to float on the picture surface.

90. KENNETH ROWNTREE (1915–1997)

Interior of SS Peter and Paul, Little Saling, Essex, 1940

Signed *Kenneth Rowntree*. 48.3 x 29.7 cm. Acquired 1949. E.1412-1949

———————————

This watercolour was commissioned for the 'Recording Britain' project (see text of plate 91). Rowntree's contribution was a series of exteriors and interiors of Essex churches. He lived in Great Bardfield, Essex, one of a group of painters resident there, including Edward Bawden and Eric Ravilious. These artists specialised in the art of watercolour and brought a new freshness of colour and brushwork, as in the example here.

The church of SS Peter and Paul, Little Saling, dates from the fourteenth century. Here we see one of the pews by the font, with the jug, accentuated by the brilliant white pigment, usefully at hand for christenings. The colours are very high-key, the wood, stone and flaking plaster illuminated by brilliant sunshine. Rowntree gives us all the necessary topographical detail; the consecration cross on the wall above the pew (the circular motif painted in red, supposedly a defence against the devil), for example, and the carving of the pew itself. But with his use of colour, shape and texture, the watercolour also takes on an abstract quality, quite different from the principal aim of the 'Recording Britain' project.

Kenneth Rowntree.

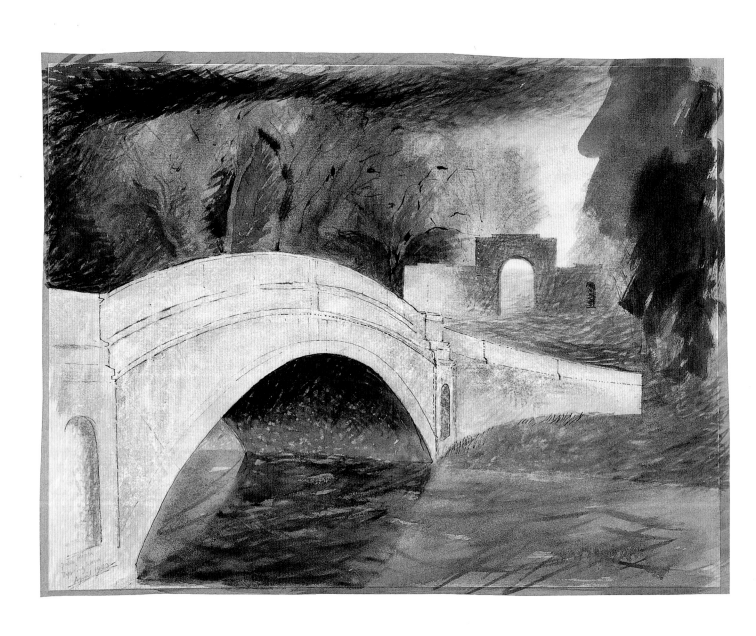

91. JOHN PIPER (b.1903)

The Bridge at Tyringham, Buckinghamshire, 1940

Signed and dated *John Piper April 1940.* 36.8 x 48.9 cm. Acquired 1949. E.1159-1949

In 1940 the Ministry of Labour, in association with the Pilgrim Trust, established a project to commission artists to provide a record of the changing face of Britain. This remarkably ambitious scheme was known as 'Recording Britain'. The secretary of the Central Institute of Art and Design recommended in 1939 that 'artists should be appointed to make drawings, paintings and prints at the war fronts, in factories, workshops, shipyards and on the land, and of the changed life of the towns and villages, thus making a permanent record of life during the war which would be a memorial to the national effort, and of particular local value'. The impetus behind the project was the threat of extensive bomb damage, particularly in the cities, but also in the countryside.

Among the artists commissioned for the project were such celebrated watercolourists as John Piper and Kenneth Rowntree (plate 90). Piper's early work was inspired by the European avant-garde, and consequently abstract in style, but in the late 1930s his paintings were more representational. He had begun designing for the theatre, and his watercolours for 'Recording Britain' of church interiors, landscape gardens and country house parks have, as in this painting, the dramatic quality of stage scenery.

Tyringham was designed by John Soane and built between 1793 and 1797; the house, bridge and screen were conceived as an ensemble. Piper emphasises the drama of Soane's concept, lighting – as on a stage – the bridge itself and silhouetting the screen against the 'backcloth' of the sky. The handling of watercolour is equally dramatic, with energetic sweeps of paint from a broad brush and rapid strokes applied with complete confidence, finished with the minimum of pen and ink outlines for the details of the architecture of the bridge. The vibrant colours seem autumnal rather than spring-like (the watercolour was painted in April), but convey the warmth of a sunny spring day, perhaps late in the afternoon.

92. GRAHAM SUTHERLAND O.M. (1903–1980)

Blast Furnace, 1941

22.8 x 19.7 cm. Purchased 1959. Circ.80-1959

Sutherland, having studied at the Goldsmiths' College of Art, worked as an etcher and, as was usual in the 1920s, followed the example of Samuel Palmer, particularly his aim to convey the spirit of a place. In the 1930s Sutherland designed posters, notably for Shell, and ceramics. He had also arrived at a very personal style in landscape water-colours, using very saturated colour and vigorous over-drawing with a brush or pen and ink. The images he created are the result of close study of the later works of Turner, with their free treatment of colour, and of Blake, particularly the illustrations to Dante's *Divine Comedy*, which Sutherland greatly admired. He was to become one of the leading artists in Britain in the 1950s and early 1960s, creating such striking and controversial works as the portrait of Sir Winston Churchill (which the sitter hated and whose wife had it destroyed) and the altarpiece tapestry for the new Coventry Cathedral.

Like so many painters of his generation, he was appointed an Official War Artist; he produced very moving images of the ruins of bombed buildings and of scenes in the mines. This watercolour celebrates the 'war effort', the determination to utilise the forces of industry. The confidence and power of Sutherland's image are similar to Scott's watercolour *Iron and Coal* of the previous century (plate 64).

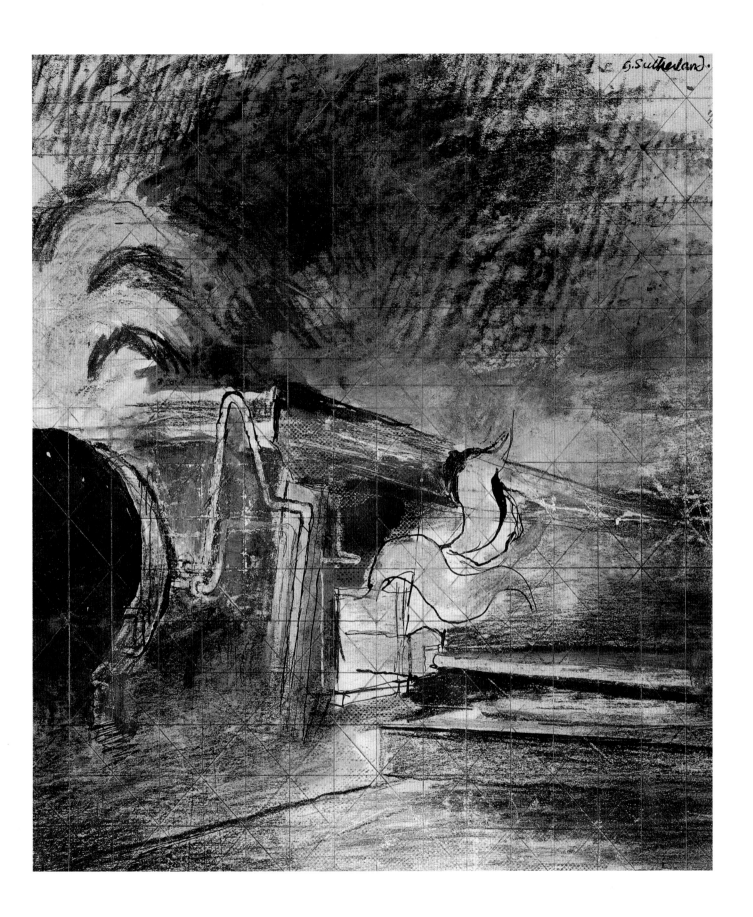

93. JOHN TUNNARD (1900–1971)

Descent, 1942

Signed and dated *John Tunnard 42*. 37.7 x 55.8 cm. Purchased 1958. P.10-1958

This was probably the watercolour exhibited in the Tunnard Exhibition at the Redfern Gallery in 1942. Tunnard studied at the Royal College of Art between 1919 and 1923 and worked first as a commercial artist. In 1930 he moved to Cornwall and painted in the style of the English Surrealists, mostly landscapes.

This work has much of the quality of a modernistic stage set: transparent layers created by the washes of colour are in passages drawn over with pencil in decorative patterns, and the three prominent foreground shapes act as the principal characters in a surreal drama. The abstract shape to the left of the centre in particular, balanced like an acrobat on the top of a small drawn arch, defies any sense of real space. The sparsely drawn outline over the watercolour suggests a theatrical gauze defining the front plane of the composition. The 'descent' of the title is of (presumably) seed sacks fluttering down on the left side of the picture: again, their exact spatial relationship to the other elements of the composition is made deliberately unclear. The end result, like so many works by Tunnard and his contemporaries in the 1930s and 1940s, is enigmatic and mysterious in terms of subject-matter and hermetic in atmosphere.

The visual delight of the unusual colours Tunnard employs, and the strangeness of the pictorial construction, produce an effect that may be at first sight satisfying, but in the end unsettling, which seems to have been the effect that Tunnard intended.

94. EDUARDO PAOLOZZI (b.1924)

Mask with Motorcar, 1958

Signed and dated *Eduardo Paolozzi May 1958*. 47.8 x 38.4 cm. Purchased 1977. P.31-1977

The artist, who studied at both the Edinburgh College of Art and the Slade School, is one of the most distinguished sculptors of his generation. His colossal adaptation of William Blake's image of Newton is a centrepiece for the new British Library. He also works in many other media, often as here combined with each other: this is part collage, part gouache. The commission from London Transport to design mosaics to decorate Tottenham Court Road station resulted in one of the most unusual and impressive interiors on the London Underground. From the later 1940s he rejected the traditional subjects for art; at both Edinburgh and the Slade, modern artists such as Picasso were considered highly dangerous role models, but Paolozzi was firm in his conviction that what he was doing was right. He did not care to sit for the Slade Diploma examination at the end of his course.

While Paolozzi has a distinguished place in the great tradition of European sculpture, at the same time he has always been fascinated by the popular culture of advertisements, in newspapers and magazines of all kinds, incorporating images from them in the form of cut-out photographs and re-presenting them in the different context of a work of art. In *Mask with Motorcar,* one of several images of a similar kind created around 1957 in different media – collage, silkscreen print, bronze sculpture, for example – he deliberately and shockingly reduces the human face to an unrecognisable form: without the title, we would not discern the subject, such as it is. The image is primitive in its force, unnerving in its fetishistic power.

MAY 1958

95. WILLIAM SCOTT C.B.E. (1913–1989)

Composition: Brown, Grey and Red, 1961

Signed *W. Scott*. 49.2 x 61.7 cm. Purchased 1961. P.5-1961

———————

Having studied in the Royal Academy Schools, at the same time copying paintings in the National Gallery, Scott departed from the mainstream styles of his contemporaries. He rejected the nineteenth-century ideas of the followers in the 1930s of Blake and Palmer, and after the Second World War aimed at simpler images that concentrated on pictorial space and proportion rather than on detailed representation. His personal impulse towards abstraction was further encouraged by his first visit to the USA, where he encountered the work of Jackson Pollock, Franz Kline and Mark Rothko. Such artists concentrated on the visual impact of the paint on the flat surface rather than on the subject-matter of the painting.

In his own oils and watercolours, Scott combined this modern North American interest in the painted surface with more old-fashioned European ideals of composition, particularly of the still-life as explored by such artists as Cézanne and Braque, and earlier masters such as Chardin. This watercolour represents a late stage in Scott's development: while his paintings of the 1950s still recognisably suggest the forms, for example, of a table or a saucepan, by 1960 he was purely interested in the shapes and colours inherent in a still-life rather than in what he presumably thought was the mere representation of objects. The three shapes in this watercolour float against a richly painted background, and the influence of Rothko's work is evident.

GEOMETRY ?

Tieson/1965

96. JOE TILSON (b.1928)

Geometry?, 1965

Signed and dated *tilson – 1966*. 76 x 55.8 cm. Purchased 1966. Circ.405-1966

───────────────

Tilson studied at the St Martin's School of Art and the Royal College. He had worked as a carpenter, and some of his work in the 1960s incorporated carpentered shapes of wood, often painted. He was represented in the British Pavilion at the 1964 Venice Biennale, which first brought his work to public attention. He was linked in the years around 1960 with a group of young artists at the Royal College of Art, who formed an informal 'movement' soon to be called Pop-Art, including Ron Kitaj, Allen Jones, David Hockney and Tom Phillips.

His subject-matter is treated in a direct and confrontational way; he sometimes uses words or numbers as part of, and as a comment on, his chosen image. For instance, he would present a giant keyhole and letter it 'KEY', or depict an eye framed by spectacles with the word 'LOOK'. His works are usually brightly coloured, in the manner of the popular, mass-market images that inspired these young artists and often, as in this painting in which he uses coloured inks, have the nature of a diagram or blueprint. The sheet here is graph paper, the areas numbered from 1 to 21 at the top and on either side. But within the grid the lines and circles do not behave themselves: they overlap, or are displaced or are severed by one another. This must in part explain the question-mark after the title. Also, the network of strict and printed lines on the paper is deliberately at odds with the painterliness with which most of the shapes are treated. It creates the same kind of visual sensation as, say, when a word in newsprint is magnified many times and loses its crisp clarity.

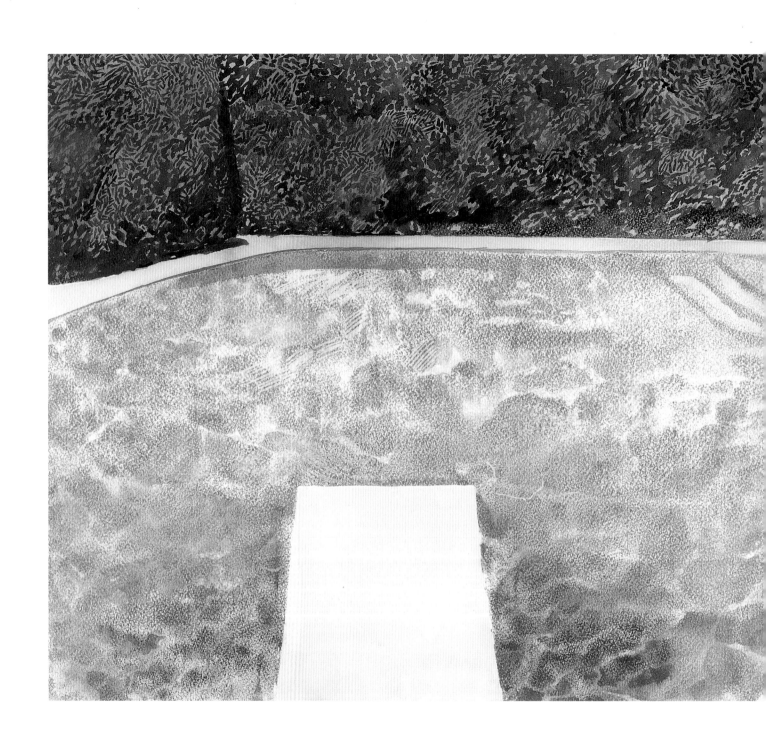

97. DAVID HOCKNEY (b.1937)

Untitled Study for a Painting, 1967

Signed and dated *D H 67*. 45.7 x 61 cm. Purchased 1972. Circ. 195-1972

One of the greatest British artists of the twentieth century, Hockney belonged to the generation that in the later 1950s and early 1960s, based primarily at the Royal College of Art, transformed the public attitude to painting. Loosely related to the Pop-Art movement, Hockney offered an art that was immediately accessible – and fun. Many of his early works inspire a smile in the viewer. He moved to Los Angeles and was instantly attracted by the way of life under the bright blue, cloudless, Californian skies, the constantly sprinkled lawns, the swimming pools, the cool air-conditioned interiors of the vast mansions.

This watercolour belongs with a group of paintings, in both oil and watercolour, that deal with the behaviour of water. The series culminated in the spectacular *A Bigger Splash*, also dating from 1967. In his autobiography (*David Hockney by David Hockney*, published in 1976), he wrote that the year from summer 1966 to summer 1967 was the only time he actually lived with a lover, Peter, noting that 'I think that year I painted more pictures than I'd ever done before'. He was fascinated by what he called the 'squiggly water' in swimming pools, how a breeze could shimmer the surface and how a dive could create 'a bigger splash'. In this watercolour he confronts the natural quality of the pool's surface with the man-made surrounding pavement and, especially, the intrusive diving board. Hockney's paintings are always fresh and bright, whether portraits, landscapes or still-life, but it is perhaps the 'splash' works that convey most vividly his exhilaration with life in California.

98. ALLEN JONES (b.1937)

Desire Me, 1969

Signed and dated *Allen Jones 1969*. In two parts, 38.1 x 22.3 and 47.8 x 35.4 cm.
Purchased from the artist, 1976. P.5-1976

The use of erotic material in Jones's work can be seen as far back as 1962, and although in the mid-1960s he became interested in other images, such as aeroplanes, buses and parachutes – not in the least erotic – his basic concern is with the human female form. Towards the end of the decade he turned once again to eroticism, finding particular inspiration in fetishistic and transvestite magazines. He became particularly interested in mass consumerism and the exploitation of images, especially of the female form, for commercial purposes.

Inspired by these magazines, Jones's interpretation of the female figure is deliberately erotic, but simultaneously loses all sensuality, instead becoming glossy and plastic, unpleasing and unbeautiful and irritatingly repetitive. As a result, at the end of the 1960s, his work – unsurprisingly – received much critical attention from the women's movement for representing the female form as nothing more than an object, a stereotypical image of male desire. In fact, Jones is treating the subject in such a way as to show how remote such consumeristic imagery is from true and real sensuality and sexuality.

The abstract forms of Jones's figures furthers this idea in that the figures are linear, simplistic and consequently anonymous, lacking anything other than a purely superficial attraction. Any attempt by the viewer to achieve intimacy is denied, despite the highly provocative poses and attire. The superficiality and unreality of the women are emphasised by the physical displacement of the upper and lower halves of the figure in *Desire Me*, making clear the two-dimensionality and unnaturalness of the woman. Likewise the marriage of media, technique and style, which is evident here and is a recurrent aspect in all Jones's work, which distinguishes between the illusion of the image and the substance of the paint, makes clear that the eroticism is just that: an illusion. Thus the title of the work becomes wholly ironic.

99. BRIDGET RILEY R.A. (b.1931)

Turquoise, Cerise, Mustard Twist with Black, 1971

Signed and dated *Bridget Riley '71*. 101.5 x 48 cm. Purchased 1971. P.8-1971

This artist was the leading exponent of 'Op-Art' in the 1960s. After training at Goldsmiths College and the Royal College of Art, she worked for an advertising agency, famously creating the 'woolmark', a simple and striking visual image. It was probably that experience of conveying an instantly attractive pictorial logo for the viewer that led to the 'geometric' paintings for which she has been internationally celebrated for over 30 years.

Apparently minimal and lacking in subject-matter, her paintings in oil and watercolour may be seen as empty in content; just a series of carefully drawn channels of colour. But they are extremely subtle in colouring and in arithmetic measurement. The result is an amazing visual experience: sensual, sensitive and sensational.

The other extraordinary effect of Bridget Riley's work lies in the fascination of the lines and colours, which can be hypnotic, combined with both a feeling of tranquillity and a reaction of energetic excitement. Her response to the sheet of paper or blank canvas is well expressed in the catalogue she wrote for the exhibition *The Artist's Eye*, curated by her at the National Gallery in 1989. She wrote of a painting by the seventeenth-century artist Nicolas Poussin that 'the thrust of this diagonal is encircled by a twisted curve of earth reds, apricots, pinks, oranges and rosy colours'. She could be describing one of her own paintings.

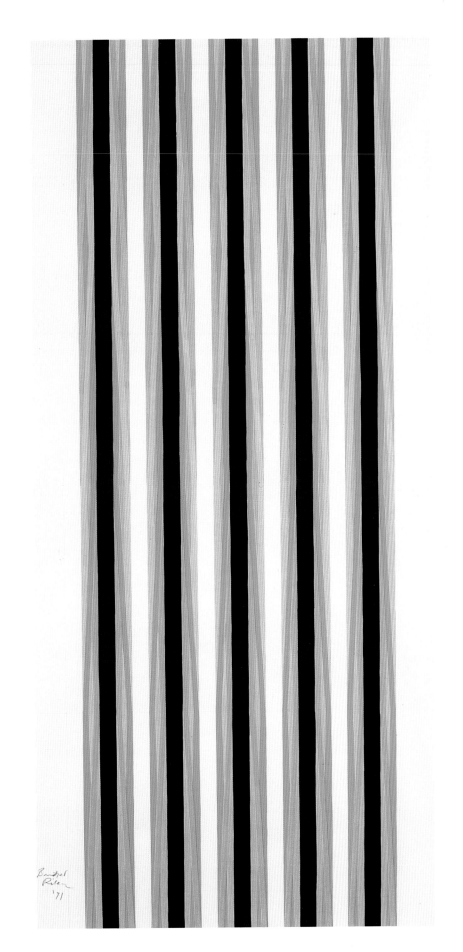

100. ANDY GOLDSWORTHY (b.1956)

Source of Scaur, winter 1991/2

235 x 121 cm. Purchased 1993. E.705-1993

The *Source of Scaur* shows a departure from most of the watercolours in the V&A collection, as the artist took nature not only as his subject, but as the medium and the process through which the image was created. A snowball was placed in the middle of the paper along with a pigment (in this case Goldsworthy used pulverised red stone, worn smooth by the river from which it came, the Scaur Water, to create the vibrant colour) and then left to melt. In other snowball drawings he used elderberries, slate and earth for different colour effects. Each drawing is therefore about a different place, and their titles are a reflection of this.

Natural phenomena, such as the weather and time, play a very important part in his work, and it is the transience of nature that so intrigues the artist. *Source of Scaur* captures this transience, as it not only records the snowball but also the process of thawing. Goldsworthy tilted the paper at an angle so that the idea of flowing down the hills was recaptured as the snow melted. This is further emphasised by the water causing the paper to buckle.

Goldsworthy uses nature as his sole subject and material, and although he does not restrict himself by any set of rules, his own intervention is kept to a minimum. He usually works in the countryside near his home in Dumfriesshire, constructing objects from anything he finds that inspires him. He uses no conventional tools and leaves his works in the environment from which they were born. As a result they are often mistaken for something 'found', because the viewer sees naturally occuring components arranged in a manner that adheres to the laws of nature but is not usual in reality. An essential part of Goldsworthy's art is the relationship between the material and its source, because he feels the surroundings explain the existence of the object and are part of it. For that reason *Source of Scaur* is unusual, as it was removed to a piece of paper.

For Goldsworthy his re-creation of the landscape is more complete than a purely visual representation, as the image is made with snow and stone taken from the source of the river. Consequently, it is that river. As a result, the drawing refers directly to the million-year processes by which the landscape has been formed; by the action of the freezing, thawing, flowing water and its path down the hillside.

Index of Artists